W9-AEX-334

SPECIES MATTERS

SPECIES MATTERS

HUMANE ADVOCACY
AND CULTURAL THEORY

EDITED BY

Marianne DeKoven
and Michael Lundblad

COLUMBIA UNIVERSITY PRESS NEW YORK

COLUMBIA UNIVERSITY PRESS
Publishers Since 1893
New York Chichester, West Sussex

Copyright © 2012 Columbia University Press
Chapter 5 copyright © Carol J. Adams

All rights reserved

Chapter 6 is a reprint of Martha Nussbaum, "Compassion: Human and Animal," in *Ethics and Humanity: Themes from the Philosophy of Jonathan Glover*, ed. N. Ann Davis, Richard Keshen, and Jeff McMahan (Oxford: Oxford University Press, 2010), 202–226.

Chapter 7 is a reprint of Frans de Waal, "Down with Dualism! Two Millennia of Debate About Human Goodness," in *The Ape and the Sushi Master: Cultural Reflections by a Primatologist* (New York: Basic Books, 2001), 337–357. The table is reprinted from Frans de Waal, *Primates and Philosophers: How Morality Evolved*, ed. Stephen Macedo and Josiah Ober (Princeton, N.J.: Princeton University Press, 2006), 168.

Library of Congress Cataloging-in-Publication Data

Species matters : humane advocacy and cultural theory / edited by Marianne DeKoven and Michael Lundblad.
 p. cm.
 Includes bibliographical references and index.
 ISBN 978-0-231-15282-2 (alk. paper) — ISBN 978-0-231-15283-9 (pbk. : alk. paper) — ISBN 978-0-231-52683-8 (e-book)
 1. Speciesism. 2. Animal rights. 3. Human rights. 4. Human beings. 5. Compassion.
I. DeKoven, Marianne, 1948– II. Lundblad, Michael.
 HV4708. S6255 2012
 179′.3—dc23

 2011033048

Columbia University Press books are printed on permanent and durable acid-free paper.
This book is printed on paper with recycled content.

Printed in the United States of America

c 10 9 8 7 6 5 4 3 2 1
p 10 9 8 7 6 5 4 3 2 1

References to Internet Web sites (URLs) were accurate at the time of writing. Neither the author nor Columbia University Press is responsible for URLs that may have expired or changed since the manuscript was prepared.

CONTENTS

ACKNOWLEDGMENTS

Marianne DeKoven would like to thank Manuel Betancourt for editorial assistance.

Michael Lundblad would like to thank Colorado State University for a Professional Development Program grant that helped to fund the preparation of the manuscript and thank the STINT Foundation and the Centre for Gender Research at Uppsala University, which provided research funding and support to complete this project. He would also like to acknowledge Christine Robinson and Lisa Ying-wen Yu for helping to prepare the reprinted chapters for this volume.

The editors would like to thank Basic Books and Princeton University Press for permission to reprint Frans de Waal's chapter and table, Oxford University Press for permission to reprint Martha Nussbaum's chapter, and Jeff McMahan, one of the editors of the volume in which Nussbaum's chapter was first published, for his help and support in that process.

The editors particularly wish to express their gratitude to Columbia University Press, especially to Wendy Lochner, senior executive editor, and Christine Mortlock, assistant editor, for their invaluable direction, encouragement, hard work, and steadfast support of this project.

SPECIES MATTERS

INTRODUCTION

Animality and Advocacy

Michael Lundblad and Marianne DeKoven

Why do species matter? What matters need to be discussed in rela-
tion to species among scholars in the humanities and social sciences?
The "question of the animal" has occupied an increasing number of
these scholars in recent years, with significant work being done in a
wide range of fields, from literary and cultural studies to philosophy,
history, religious studies, art history, cultural geography, sociology, an-
thropology, and media studies.[1] Despite all the important work that
has already been done, a key question has yet to be fully explored: why
has there been resistance in the academy to linking advocacy for ani-
mals with advocacy for various human groups? Within cultural stud-
ies, questions remain about how "species" might relate to race, class,
gender, sexuality, disability, and other categories of human identity as
a site for critical analysis. *Species Matters: Humane Advocacy and Cultural
Theory* addresses this kind of question by focusing not only on whether
cultural studies should pay more attention to animal advocacy but
also on whether animal studies should respond more broadly to the
cultural politics of animality and "the animal."[2]

This volume explores new and necessary questions about the relationship between animality and advocacy, including critical analyses of these terms themselves. Does advocacy for animals, for example, suggest prioritizing the suffering of animals over the suffering of human beings? In her contribution to this volume, Carol J. Adams draws attention to this kind of question, which is one that she is often asked: "Who comes first in activism: disenfranchised humans or animals?"[3] Many activists, including Adams, would reply that the question is far too simplistic—that they can be advocates for *both* humans and animals. But the question might also point toward a wariness in relation to animal rights discourse by various kinds of progressive activists. As Matthew Calarco points out in *Zoographies: The Question of the Animal from Heidegger to Derrida* (2008), "more so than perhaps any other mode of identity politics, animal rights has been largely abandoned by many progressive leftists, who often see animal rights either as a political issue of secondary (or tertiary) importance or as merely a luxury of the bourgeois activist."[4] A related problem might be the fact that animal rights activists, as Calarco notes, "have often adopted the attitude that animal rights issues trump all other political concerns, and in the process have engaged in a number of rather questionable and sometimes politically regressive and conservative strategies in the name of promoting animal rights."[5] The extent to which animal studies in the academy is associated with this kind of animal rights activism might justify the resistance of various forms of cultural studies, which have been reluctant, at best, to acknowledge that the suffering of various nonhuman animals might be as pressing a problem as the suffering of various human groups. The thread of advocacy for the treatment of nonhuman animals that runs through much of the recent work in animal studies, in other words, might make animality seem intrinsically less important to scholars interested primarily in *human* cultural politics.

But the question of the animal does not necessarily need to be tied to explicit advocacy for better treatment of actual animals. On the one hand, Marianne DeKoven has noted that a "central motivation for the study of literary animals is, of course, animal advocacy. Many literary, theoretical, and critical texts of the animal kind are moti-

vated by a desire to mitigate cruelty to animals."[6] On the other hand, Michael Lundblad has argued that a distinction can be made between animal and animality studies in relation to the question of advocacy: "If animal studies can be seen as work that explores representations of animality and related discourses with an emphasis on advocacy for nonhuman animals, animality studies becomes work that emphasizes the history of animality in relation to human cultural studies, without an explicit call for nonhuman advocacy."[7] This distinction might lead some to conclude that animality studies must be work that ignores "real" animals, but it can also be seen as engaging questions of advocacy in different ways. Animality studies might want to problematize an essentialist human/animal binary, for example, by focusing on that binary's violent history in relation to constructions of what it means to be "human" or how various human groups have been granted or denied "humanity." This kind of poststructuralist or posthumanist work could be seen as analogous to forms of gender and race studies, for example, that focus on constructions of masculinity or whiteness more than on the lives of women or people of color. The contributors to this volume generally emphasize intersectional analysis that can explore questions of animality in relation to constructions of human race, class, gender, sexuality, and disability. From our perspective, rather than establishing a binary between advocacy and no concern at all for "real" animals, it makes more sense to think of a continuum based upon the extent to which the work is explicit in its concern for the living conditions of actual nonhuman animals.

Much recent work has focused less on the treatment of animals and more on disrupting traditional philosophical distinctions between "the human" and "the animal" or on exploring literary and cultural texts that reinforce or disrupt various hierarchies that elevate the human over the animal. Perhaps more provocatively, at least from the perspective of human cultural politics, a critique of anthropocentrism has also been linked with other theoretical agendas traditionally associated with human subjects. As Neel Ahuja notes, for example: "Recent scholarship at the intersection of postcolonial studies, ethnic studies, and species studies acknowledges links between

species, race, and transnational power structures that underlie the production of culture."[8] Ahuja's own article illustrates this kind of work: "By tracing the circulation of nonhuman species as both figures and materialized bodies within the circuits of imperial biopower, species critique helps scholars reevaluate 'minority' discourses and enrich histories of imperial encounters."[9]

When this work veers toward a form of scholarship that pays less attention to the living conditions of nonhuman animals, it might seem to be at odds with a perspective that insists on advocacy for animals. This work can also raise the question whether human cultural studies of various kinds have an obligation to pay attention to the treatment of nonhuman animals. In the case of postcolonial theory, as Ahuja points out: "Such arguments risk perversely suggesting that because race and postcolonial critics possess special insight into the violence of humanism, they have a unique responsibility to speak for animals."[10] The ire of these critics might be raised at the suggestion that all forms of cultural studies should now be closer to animal studies: that the question of the animal should be seen as more important than other political or theoretical concerns.

Cary Wolfe has addressed this potential relationship between animal advocacy and cultural studies in general in much of his work. Wolfe insists that animal studies must be driven by a fundamental critique of both humanism and anthropocentrism, challenging cultural studies work that continues to be based upon traditional notions of the human subject. On the one hand, Wolfe has argued for a kind of posthumanism that would be relevant and even urgent for cultural studies in general, regardless of whether various scholars have any concern for nonhuman animals. In his introduction to *Zoontologies: The Question of the Animal* (2003), for example, Wolfe offers a significant reason for cultural studies scholars to take animality seriously: "It is crucial to pay critical attention to the discourse of animality quite irrespective of the issue of how nonhuman animals are treated . . . because the discourse of animality has historically served as a crucial strategy in the oppression of *humans* by other humans."[11] On the other hand, Wolfe would not appear to be satisfied with various forms of cultural studies that only go this far. Instead, he

emphasizes the point that "even though the *discourse* of animality and species difference may theoretically be applied to an other of whatever type, the consequences of that discourse, in *institutional* terms, fall overwhelmingly on nonhuman animals, in our taken-for-granted practices of using and exploiting them."[12] It becomes clear, then, that Wolfe does not merely want to add the category of "species" to more traditional categories of analysis in literary and cultural studies, such as race, class, gender, sexuality, ethnicity, and disability. In *Animal Rites: American Culture, the Discourse of Species, and Posthumanist Theory* (2003), he argues that "debates in the humanities and social sciences between well-intentioned critics of racism, (hetero)sexism, classism, and all other -isms that are the stock-in-trade of cultural studies almost always remain locked within an unexamined framework of *speciesism*."[13] The point, for Wolfe, is to challenge the speciesism that enables the very foundations of cultural studies.

From our perspective, the implication that speciesism is more foundational or more problematic than other "-isms" might explain some of the resistance to animal studies, particularly from scholars committed to other forms of human advocacy. But this does not need to be an either/or proposition. Donna Haraway's work in general has been a powerful example within animal studies that not only insists upon intersectional analysis—including the category of species—but also refuses to deny the complexities and situated histories that are sometimes oversimplified when the focus of analysis is exclusively or primarily upon speciesism. In *When Species Meet* (2008), for example, Haraway illustrates how one can be committed to a range of shifting and complex political agendas, with a general goal of "nurturing a more just and peaceful other-globalization."[14] In a representative discussion of food practices and policies, Haraway points out that "both vegan and nonvegan community food projects with a local and translocal analysis have made clear the links among safe and fair working conditions for people, physically and behaviorally healthy agricultural animals, genetic and other research directed to health and diversity, urban and rural food security, and enhanced wildlife habitat."[15] The goal for Haraway is not necessarily to find a universal principle that might explain one's activist stance in relation to all of

these issues: "No easy unity is to be found on these matters, and no answers will make one feel good for long."[16] Instead, the goal is finding "attachment sites for participating in the search for more livable 'other worlds' (*autres-mondialisations*) inside earthly complexity. . . . The point is not to celebrate complexity but to become worldly and to respond."[17]

We hope that this volume might suggest new ways that animality can be linked with cultural studies work interested in exploring a wide range of cultural politics. As our contributors illustrate, animal studies remains a broad field with no mandatory form of advocacy and no necessary correlation with animal rights activism, in particular. In fact, the discourse of animal rights has been explicitly rejected by Wolfe, for example, for its underlying humanism, in which the philosophical basis for rights of any kind, even if extended to nonhuman animals, is based upon the human as the quintessential model of subjectivity.[18] In order to explore new questions, we invited the contributors to this volume to address the discourse of "humane" advocacy in particular as a way of linking human and nonhuman advocacy. What are the possibilities (as well as the obstacles), for example, for coalitions among advocates for various forms of humane advocacy? What is the relationship between a construction of "the human" as the only animal capable of acting humanely and a desire to move beyond the limits of humanism or anthropocentrism? Our goal in this volume is to provide a range of perspectives on the question of "humane" advocacy—in relation to animality and "the animal" as well as human cultural politics—even if there are often significant tensions, if not conflicts, between these perspectives. Humane discourse—including the capacity for acting "inhumanely"—is explored in this volume in a variety of ways: as an argument for treating nonhuman animals better; as a logical link between advocacy for human and nonhuman groups; and as, on the one hand, a defensible characteristic of human/animal difference or, on the other hand, as a problematic form of human exceptionalism. The essays in this collection thus express a wide range of views on the topic of humane advocacy in cultural theory, opening up broader questions about the cultural politics of animality and advocacy.

In general, this volume begins with a challenge to and elaboration of the central terms being addressed in relation to humane advocacy. It then moves on to critiques of the pitfalls inherent in certain versions of this advocacy—critiques that are also aware of its vital importance. It ends with arguments for the importance of humane advocacy—arguments that are also aware of its possible pitfalls. In the opening essay, Donna Haraway explores the complexity and significance of what is at stake in key terms of our title: "species," "matter," "humane," and "advocacy." The next two essays of the volume, by Cary Wolfe and Paola Cavalieri, argue for a theoretically informed posthumanism for which humane advocacy is tainted by its rootedness in an unspoken but foundational separation of humans from other animals. This distinction is inevitably hierarchical in structure, situating humans above animals and granting them the power of choosing, or failing to choose, to act in a humane fashion toward both other animals and other humans. The next two essays discuss humane advocacy in cultural theory as it can be observed in actual cultural-historical practice. Michael Lundblad analyzes the ways in which humane advocacy for animals can do harm to oppressed human minorities, arguing that the humane movement in the United States has historically produced problematic constructions of human racial difference, particularly through new distinctions between animality, savagery, and blackness at the turn of the twentieth century. Carol J. Adams, in a detailed autobiographical account of her life as an activist, discusses the complex, inevitable interconnections among community activism, feminist advocacy for women's rights, animal activism, and humane advocacy in general. Adams bases her theoretical argument on the idea of the absent referent, in which the individual belonging to a subordinated group, of whatever species, becomes invisible or erased and therefore ineligible for standing before the law of rights.[19]

Essays by Martha Nussbaum and Frans de Waal then bring critical attention to the question whether human beings are like other animals in their capacity for cruelty. Nussbaum argues that humans can be distinguished from animals by their potentially pathological *lack* of compassion. De Waal argues against claims that neither human

nor nonhuman animals are naturally "good," suggesting instead that moral behavior is an evolutionary development rather than a human rejection of animal instincts. The final essay in this volume, by Temple Grandin, illustrates how advocacy for animals can take different forms in diverse academic disciplines, in this case animal science. Grandin argues, to put it in fairly simple, straightforward terms for the moment, in favor of humane advocacy for animals—at least for sentient, affect-bearing animals capable of feeling pain—while defending her right to continue eating meat from animals raised and slaughtered humanely.

<p align="center">★ ★ ★</p>

Donna Haraway opens this volume with "Species Matters, Humane Advocacy: In the Promising Grip of Earthly Oxymorons," which questions some of the book's central terms and explores multifarious contradictions deriving from the fact that "critters become with each other in many and marvelous forms and processes and in diverse, entangled, and nonetheless incommensurate times and places." "Becoming with" is a crucial concept for Haraway, along with the term "critters" itself, which refers to all living beings in a deliberately colloquial, characteristically comic way, defying expert, standardized, affectless official jargons and all terminologies of singularity and exclusivity. She sees critters as existing, surviving, developing, changing, and dying in mutual interaction with other, co-dependent living beings. Her "companion species" exist in this mutuality of sharing, change, and exchange that is "becoming with." The materialism of Haraway's own socialist feminism, as always, guides her work. In light of that materialism, alert throughout to the deformations of capital and the denigration of women and other subjugated critters, Haraway pays close attention to the derivations and multiple meanings of our key terms, untangling their contradictions (of separation and of merging confusion, for example), pointing to the incommensurabilities they contain, and adumbrating their possibilities for more terra-friendly forms of becoming with.

Cary Wolfe, having begun his relation to animal/animality studies with years as an animal rights activist, finds animal rights and humane advocacy discourses oversimplified and therefore misleading. In "Humane Advocacy and the Humanities: The Very Idea," Wolfe asks: "Is humane advocacy 'humane' when it reproduces 'a certain interpretation of the human subject' that has itself been the 'lever' of violence and exploitation toward our fellow creatures for centuries and in the most 'developed' nations on earth?" Through acute, penetrating readings of Jacques Derrida's work, not just on animality but also on writing, finitude, inheritance, and the obligations of the humanities, Wolfe elaborates a powerful version of posthumanism that offers an alternative to the humanist version of humane advocacy. It is this posthumanist vision of responsibility toward what Derrida calls "the other within us" that, as Wolfe says, constitutes "our 'inheritance' and opening onto a future that will exceed our presence, a 'to come' to which we are nevertheless responsible." In this future, responsibility is directed toward all beings, a responsibility that invalidates the species, and specious, distinctions humanism requires.

Paola Cavalieri attacks the humanism she sees as often implicit in mainstream versions of "humane advocacy" in her essay "Consequences of Humanism, or, Advocating What?" Using theoretical frames of reference different from Wolfe's Derridean posthumanism, Cavalieri first discusses how the politically progressive discourses of Holocaust studies, disability studies, feminism, and Marxism depend on, and are even founded on, a distinction of the human from the animal. These discourses invoke the common humanity of oppressed human groups, over against the subhumanity, or animality, attributed to them by those who denigrate or seek to destroy them. All of these politically progressive discourses are therefore, in Cavalieri's argument, inherently humanist. Cavalieri then argues that humanism itself is foundationally defined by its distinction between humans and animals: that this distinction is the "'disavowed underside' of humanism." Without a posthumanism that erases the distinction between human and animal, then, progressive political movements and their theoretical underpinnings are compromised,

and no arguments for animal rights or any humane advocacy for animals will do anything more than, as she puts it, demand "reforms around the edges of the status quo."

In "Archaeology of a Humane Society: Animality, Savagery, Blackness," Michael Lundblad argues that humane advocacy for animals can be and has been used as a way to further demonize already denigrated human groups. He shows how, in turn-of-the-twentieth-century America, African Americans were often associated with "savagery," rather than animality, and therefore placed even lower than animals on a racist hierarchical scale of value. This designation was used as a justification for the lynching of African Americans so rampant at the end of the nineteenth century: the same moment that the humane movement was born in the United States. Whites were seen as capable of compassion and advocacy for animals, but African Americans, as savage, were seen, conveniently, as incapable of such humane sentiment. Therefore, in light of this distinction between "animal," susceptible to humane advocacy, and "savage," incapable of feeling humane and unworthy of humane advocacy, the notion of humane advocacy for animals produced devastating social and political effects in its foundational moment.

Carol J. Adams, in a multilayered autobiographical account of her life as an activist, "What Came Before *The Sexual Politics of Meat*: The Activist Roots of a Critical Theory," discusses the complex, inevitable interconnections among feminist advocacy for women's rights and humane advocacy for animal rights. She discusses how she became an activist through working locally in community-based reform movements and how that led her to become an ecofeminist animal rights activist. She shows how the theory of the absent referent (also invoked by Cavalieri) allowed her to see the connection between the objectification of women and the objectification of animals, particularly food animals, which led to the writing of her enormously influential feminist animal rights books *The Sexual Politics of Meat* and *The Pornography of Meat*.

Martha Nussbaum argues in "Compassion: Human and Animal" that the compassion shown by certain species of animals is in many ways superior to human compassion.[20] While animal compassion, in

the circumstances within which it functions (Nussbaum focuses particularly on the compassion of elephants for others of their species), has no self-imposed limits, human compassion is subject to judgment that can not only negate its expression but can be distorted into a kind of cruelty Nussbaum argues is unknown in any species of animal other than *Homo sapiens*. Nussbaum uses the example of Theodor Fontane's 1894 novel *Effi Briest* to show how judgments based on exclusionary social norms, most often founded in misogyny, often not only block compassion but also substitute for it a repudiation so extreme that only the death of the woman offending against patriarchal sexual ideology can reinstate compassion, even in the subject's parents. Nussbaum argues from powerful instances of this phenomenon. For example, Tolstoy repudiates, with disgust, the "animal" sexuality his wife "forces" him to express, a repudiation he unleashes through violence against his wife. Nussbaum also presents Gujarati Hindu extremists' torture and murder of Muslim women as horrifically violent forms of the need to annihilate what is perceived by men as "animal," that which is common to us all but is subject to disgust— only in humans, not in other animals—and is displaced by dominant men exclusively onto women, particularly women of a despised ethnic or religious minority. While Nussbaum is one of the most visible proponents of humane advocacy, for animals and oppressed groups of humans, in this essay's analysis, humans can be seen as distinct from other animals in their capacity to act *inhumanely*.

Frans de Waal, one of the most influential ethologists of his generation and also one of the most influential advocates for humane treatment of animals, argues in "Down with Dualism! Two Millennia of Debate About Human Goodness" against the entrenched bias of the scientific community against acknowledging and celebrating the similarities between humans and other animals: the common animality posited by Wolfe and Cavalieri.[21] Mainstream scientists, over and over again, insist on finding ways in which humans are different from, and superior to, other animals, by identifying exclusively human attributes that no other species share and that make humans distinctly advantaged. (In this regard, de Waal shares the posthumanist orientation of Wolfe, Cavalieri, and Lundblad, to the extent

that he wants to break down, rather than fortify, the humanist distinction between humans and other animals.) As each of these claims to distinction and superiority is disproved, new claims are made. De Waal argues that we should learn, instead, from our commonalities with other animals, especially the great apes, in ways that will lead to humane treatment for all of us, human and nonhuman alike.

Temple Grandin argues in "Avoid Being Abstract When Making Policies on the Welfare of Animals" for a humane advocacy that lives on the ground, inside the feelings and cognition of animals forced to suffer unconscionably in massive numbers throughout the world, primarily as a result of current practices of factory farming. Grandin uses her insights as an autistic person to understand the ways in which animals see the world differently from nonautistic humans. She acknowledges the limitations of her work: many victimized animals, even including food animals whose lives she has not yet been able to improve, do not fall within the purview of her activism. (We would add that the improvement of the lives of factory-farmed animals does not address the enormous problem of factory farming itself.) Yet she shows how simple changes in the treatment of animals destined for slaughter, particularly cattle, can mitigate or even eliminate their suffering in ways that certainly qualify, from her theoretical point of view, as beneficial results of humane advocacy. Grandin argues against what she calls "abstractification": a move away from the very specific particularities of animal cognition, an understanding of which must be, according to her, the basis for humane advocacy. But she also defends her right, in more abstract terms, to eat humanely treated food animals, despite attacks on her position by some animal rights activists.

Grandin's perspective suggests a kind of advocacy that must always be focused on the *treatment* of living animals, even though it remains within a framework of human exceptionalism or even speciesism. Other contributors to this volume suggest different forms of advocacy. There is no unified definition of what advocacy is or should be, nor is there agreement on how advocacy for animals could or should be linked with various forms of advocacy within the acad-

emy. According to the *Oxford English Dictionary* (2nd ed., 1989), "advocacy" can be defined as "pleading for or supporting," suggesting an activist stance toward or for a clearly defined group. Questions to ask, though, are: Which group of animals might we be pleading for? What are the differences or commonalities in advocating for cattle, pigs, and chickens in contemporary factory farms, for example, as opposed to bonobos or dogs situated in particular historical and cultural contexts? According to Jacques Derrida, reducing the specificity and diversity of all animals to "the animal" is ultimately a kind of crime: "The confusion of all nonhuman living creatures within the general and common category of the animal is not simply a sin against rigorous thinking, vigilance, lucidity, or empirical authority, it is also a crime. Not a crime against animality, precisely, but a crime of the first order against the animals, against animals."[22]

A final key aspect of advocacy to consider (whether it is in support of human or nonhuman animals) is the suggestion of speaking for an other. Are humans the only animals capable of advocating for others? Does this framework represent another example of privileging human speech, particularly in relation to an other who might be constructed as incapable of advocating for *it*self? Advocating, again according to the OED, is the "action of publicly defending, maintaining, or standing up for." *Species Matters: Humane Advocacy and Cultural Theory* is ultimately an exploration of what it might mean to stand up for others who have been "animalized" or treated "inhumanely," whether those others are human or nonhuman. This volume thus suggests not only new forms of activism but also new ways of thinking about how to respond to the spectrum running from animal to animality studies within the academy today.

NOTES

1. The phrase "the question of the animal" is taken from the influential late work of Jacques Derrida on animality, much of which is now available as *The Animal That Therefore I Am*, ed. Marie-Louise Mallet, trans. David Wills (New York: Fordham University Press, 2008). Examples of recent work in animal studies can be found

in collections such as Cary Wolfe, ed., *Zoontologies: The Question of the Animal* (Minneapolis: University of Minnesota Press, 2003); Nigel Rothfels, ed., *Representing Animals* (Bloomington: Indiana University Press, 2002); Lorraine Daston and Gregg Mitman, eds., *Thinking with Animals: New Perspectives on Anthropomorphism* (New York: Columbia University Press, 2005); Jodey Castricano, ed., *Animal Subjects: An Ethical Reader in a Posthuman World* (Waterloo, Ont.: Wilfrid Laurier University Press, 2008); Stanley Cavell, Cora Diamond, et al., *Philosophy and Animal Life* (New York: Columbia University Press, 2008); and Paola Cavalieri, with Matthew Calarco, et al., *The Death of the Animal: A Dialogue* (New York: Columbia University Press, 2009). For links to bibliographies of additional work, as well as information about research centers, discussion groups, and journals, see the "Resources" page of Animality Studies at CSU, http://animalitystudies.colostate.edu/resources.htm; and the H-Animal Discussion Network, http://www.h-net.org/~animal/.

2. As Jodey Castricano notes in her introduction to *Animal Subjects*, "cultural studies" is difficult to pin down, in part because it has been used to describe different kinds of work, engaged with different kinds of histories and ongoing transformations. Nevertheless, to the extent that it can signify a coherent field or range of fields in the academy, "the borders of cultural studies have proved almost impervious to the question of the nonhuman animal" (2).

3. Carol J. Adams, "What Came Before *The Sexual Politics of Meat*: The Activist Roots of a Critical Theory," this volume, chap. 5, 000. Peter Singer takes up this question, in a sense, in his foreword to *Animal Philosophy: Essential Readings in Continental Thought*, ed. Peter Atherton and Matthew Calarco (London: Continuum, 2004). In response to the work of writers such as Heidegger, Foucault, Levinas, and Deleuze in relation to "the animal" or animality, Singer can only conclude that "the most significant question raised by this volume is why such an extensive body of thought should have failed to grapple with the issue of how we treat animals" (xii).

4. Matthew Calarco, *Zoographies: The Question of the Animal from Heidegger to Derrida* (New York: Columbia University Press, 2008), 8.

5. Ibid. Some critics might point to various tactics and campaigns of PETA (People for the Ethical Treatment of Animals), for example, such as using half-naked women to advocate for vegetarianism or against wearing fur. See http://www.peta.org.

6. Marianne DeKoven, "Why Animals Now?" *PMLA* 124, no. 2 (2009): 364.

7. Michael Lundblad, "From Animal to Animality Studies," *PMLA* 124, no. 2 (2009): 500. This article is part of a recent "Theories and Methodologies" forum on animal studies that includes several explicit calls for animal advocacy. Rosi Braidotti, for example, argues strongly for "biocentered egalitarianism" (530), while Nigel Rothfels calls for "simple thoughtfulness" (477) in relation to zoo animals. Kimberly W. Benston, in his discussion of guidelines supposedly designed to

protect laboratory animals, argues that "a critical animal studies should provide us the means of deepening our demand for an animal ethics that cannot be subsumed by the procedural agreements governed by regulatory structures" (553). And Laurie Shannon critiques what she identifies as a "double apartheid (a segregation in language and of bodies)" that links her discussion of the birth of "the abstract nominalizations of *animal, the animal,* and *animals*" with "livestock's banishment to a clandestine, dystopian world of industrial food production, where the unspeakable conditions of life depend on invisibility" (477). See Rosi Braidotti, "Animals, Anomalies, and Inorganic Others," *PMLA* 124, no. 2 (2009): 526–532; Nigel Rothfels, "Zoos, the Academy, and Captivity," *PMLA* 124, no. 2 (2009): 480–486; Kimberly Benston, "Experimenting at the Threshold: Sacrifice, Anthropomorphism, and the Aims of (Critical) Animal Studies," *PMLA* 124, no. 2 (2009): 548–555; and Laurie Shannon, "The Eight Animals in Shakespeare; or, Before the Human," *PMLA* 124, no. 2 (2009): 472–479. While these ideas do not necessarily represent the primary claims of their respective articles, a concern for the actual treatment of nonhuman animals can certainly be traced not only in this forum but also throughout much of the current work in animal studies in the academy today.

8. Neel Ahuja, "Postcolonial Critique in a Multispecies World," *PMLA* 124, no. 2 (2009): 557.

9. Ibid., 556–557.

10. Ibid., 558.

11. Wolfe, *Zoontologies,* xx.

12. Ibid.

13. Cary Wolfe, *Animal Rites: American Culture, the Discourse of Species, and Posthumanist Theory* (Chicago: University of Chicago Press, 2003), 1.

14. Donna Haraway, *When Species Meet* (Minneapolis: University of Minnesota Press, 2008), 3.

15. Ibid., 41.

16. Ibid.

17. Ibid.

18. See, for example, Wolfe's first chapter in *Animal Rites,* 21–43. Wolfe's alternative to rights discourse is what he calls "posthumanist ethical pluralism," which is still very much concerned about the treatment of actual nonhuman animals.

19. The idea of the "absent referent" comes from Margaret Homans's foundational feminist essay, "'Her Very Own Howl': The Ambiguities of Representation in Recent Women's Fiction," *Signs* 9, no. 2 (Winter 1983): 186–205.

20. This chapter is a reprint of Martha Nussbaum, "Compassion: Human and Animal," in *Ethics and Humanity: Themes from the Philosophy of Jonathan Glover,* ed. N. Ann Davis, Richard Keshen, and Jeff McMahan (Oxford: Oxford University Press, 2010), 202–226.

21. This chapter is a reprint of Frans de Waal, "Down with Dualism! Two Millennia of Debate About Human Goodness," in *The Ape and the Sushi Master* (New York: Basic Books, 2001), 337–357. The addendum has not been previously published.

22. Derrida, *The Animal That Therefore I Am*, 48. For further elaboration of Derrida's neologism of *"l'animot,"* see his discussion on pages 47–48.

Species Matters, Humane Advocacy

In the Promising Grip of Earthly Oxymorons

Donna Haraway

[handwritten margin note: Oxymoron fig (speech in wch contradictory terms appear together) "cruel kindness"]

Oxymorons give me sustenance as well as indigestion; they contain their own frictions, contradictions, and tensions in order to trip us into paying attention to what matters. Oxymorons are sharply foolish, and they are mortally vital. All of the title words of the collective book in your hands are oxymorons; no wonder these figures land us in consequential struggles for, with, and among terran critters, including each other who are the authors and readers inside the covers of this volume. Without friction, there is no heat; without heat, there is no mortal living; without mortal living, there is no hope for flourishing with each other. Oxymorons are Zen koans for animal-human commitments to more flourishing multispecies worlds in the practice of living and dying. I think the oxymorons of our book's title are troping figures to guide us critters in getting on together in defiance of the double death[1] of extinctions and exterminations in the polluted oceans of indifference that threaten to drown the ongoingness of terran generations.

[handwritten margin note: trope (lit device such as metaphor, irony, using wds in other than literal sense)]

Words and bodies commingle promiscuously in us all. Sign and flesh implode in an ordinary sacrament called mortal becoming.

Critters become with each other in many and marvelous forms and processes and in diverse, entangled, and nonetheless incommensurate times and places. We who are archived in natural history and cultural museums and genomic databases as Homo sapiens have never been human, at least not in any luminous, singular, self-making sense, no matter how popular that idea has been to rampaging cyclopean philosophers and not a few natural scientists, to all their shame. Comingling, in commensal orgies and symbiogenetic material semioses, is how all of us mortal critters on this planet get our purchase on living and dying. That, at least, is to our credit. We are a bundle of multispecies reciprocal inductions.[2] We are in debt and at risk to and with each other. That is how we are in company, not in a rank of angels, but on a merchant ship—that sort of "company" where the ties of queer love and unexpected food are daily bread, daily coin.

That is what I mean by "companion species"—those variously enduring, quasi-stabilized, co-constituted entities whose very being is forged in the contact zones of the fleshly practices of eating together, of consortia at table, of breaking bread in all the joy and terror of getting on together on terra, that sf space that is also earthly critters' only place.[3] We are all multispecies mutant fruit of Ursula K. LeGuin's science-fictional Hainish dispersion, a veritable seed catalogue of quasi species needed for recuperating an earth much blasted by the one calling itself human. LeGuin's Hainish species were all homo-types; mine are not. Mine are less arboreal, more fungal, and even more gregarious than hers. Companion species, the term and the fleshly knots, are relentlessly about "becoming with," and to focus on companion species is for me one way to refuse human exceptionalism without invoking posthumanism. In human-animal worlds, companion species are ordinary beings-in-encounter in the house, lab, field, zoo, park, truck, office, prison, ranch, arena, village, roadside, forest, ocean, wetlands, human hospital, slaughter house, vet clinic, stadium, barn, wildlife preserve, farm, city streets, factory, reservation, war zone, and more. I am committed to inhabiting both the trouble and the vitality of the contact zones of companion species, where the situated work and play of myriad critters, including people, make history. Terra is where the task of humane practice is

set, in the humus of historically situated multispecies compost, where
the questions of who can be humane and what counts as humane are
both far from clear and also never more urgent.

SPECIES

"Species," like all the old and important words, is richly promiscuous,
mostly in the visual register. The Latin *specere* has tones of "to look"
and "to behold." In logic, "species" refers to a mental impression or
idea, strengthening the prejudice that thinking and seeing are clones.
Referring both to the relentlessly "specific" or particular and to a class
of individuals with the same characteristics, species contains its own
opposite in the most promising—or special—way. Oxymorons always
get my attention; it's a feminist tic. Debates about whether species
are earthly organic entities or taxonomic conveniences are coexten-
sive with the discourse of biology—another dance linking kin and
kind. The ability to interbreed reproductively is the rough and ready
requirement for members of the same biological species; all those lat-
eral gene exchangers like bacteria have never made very good species.
It turns out that all the proud arboreally related metazoa like us are
full of lateral action too, in our most intimate tissues and crevices. Es-
chewing species platitudes, bacteria help us see all the consortia and
generative cohabitings that make up cells, organisms, genomes, and
ecologies. Now, biotechnologically mediated gene transfers redo kin
and kind at rates and in patterns unprecedented on earth, generating
messmates at table who do not know how to eat well and, in my judg-
ment, often should not be guests together at all. Which companion
species will—and should—live and die, and how, is at stake, perhaps
now, whenever that is, more than ever.

The word "species" also structures conservation and environmen-
tal discourses, with their "endangered species" that function simul-
taneously to locate value and to evoke death and extinction in ways
familiar in colonial representations of the always vanishing indigene.
The discursive tie between the colonized, the enslaved, the nonciti-
zen, and the animal—all reduced to type, all others to rational man,

and all essential to his bright constitution—is at the heart of racism and, lethally, flourishes in the entrails of humanism. Woven into all these categories is "woman's" putative self-defining responsibility to "the species," as this singular and typological female is reduced to her reproductive function. Fecund, she lies outside the shiny territory of man even as she is his conduit—or sewer. That African American men, as well as black fetuses in 2010 pro-life discourse, get labeled an "endangered species" makes palpable the ongoing animalization that fuels liberal and conservative racialization alike. Species reeks of race and sex, and where and when species meet, that heritage must be untied and better knots of companion species attempted within and across differences.

Raised a Roman Catholic, I grew up knowing that the Real Presence was present under both "species," the visible form of the bread and wine. Sign and flesh, sight and food, never came apart for me again after seeing-eating that hearty meal. Secular semiotics never nourished as well or caused as much indigestion. "The species" often designates "the human race," unless one is attuned to science fiction, where species abound. On terra and in other sf material-semiotic contact zones, it is a mistake to assume much about species in advance of encounter. Earth others and alien species have a rich commerce; they consort; they are companion species; they get down to business. Finally, we come to metal coinage, "specie," stamped in the proper shape and kind. Like "company," "species" also signifies and embodies wealth. I remember Marx on the topic of gold, alert to all its generative filth and glitter.

MATTER

It is hard not to know that "matter" is a powerful, mindfully bodied, maternal word, the matrix and generatrix of things. But in both sacred and secular Western patriarchal language and practice, matter gets demoted to something out of which something else, something important and real, is made by the more noble, less merely material causes. The figure of dark and moist matter is necessary but always

apt to get in the way, derail, and mess up the bright and airy projects of formal, final, and even the lesser airy powers called efficient causes. In those worlding practices, forms, ends, and instruments trump mere substance. However, it doesn't take much digging to get back to matter as source, grounds, reason, and consequential stuff—the matter of the thing, the generatrix that is simultaneously mathematical and fleshly—and by that etymological route to matter as timber, as hard inner wood (in Portuguese, *madeira*). Matter as timber brings me to reread Ursula LeGuin's *The Word for World Is Forest*, published in 1976 as part of her Hainish fabulations for dispersed native and colonial beings locked in struggle over exploitation and the chances for multispecies flourishing. Then, whispering insistently, the bumptiously oxymoronic word "matter" takes me back to earth with a thump, asking, "what's the matter with you?" Matter, mater, mutter make us stay with the multispecies trouble on terra, strengthened by the struggle for a world on LeGuin's planet of Athshea. So, it is time to return to the question of making humus for terraforming for a recuperating world of difference.

HUMANE

These days, with little Latin or Greek, even we global parochials challenged by Anglophone hegemony know that the word "humane" is a variant of "human." In the academy (or on the Internet), we might learn that the Latin *homo* ties us first to terra, through the Proto-Indo-European earthling called *guma* (pl. *guman*), and then ends up in later English tied to bridegroom, plowman, and man—those figures whose duty is reproductive husbandry. The intimations of hope for multispecies flourishing in the soil of humane, muddy earthlings get a rude curb from the civilizing bit of those three figures. In that story, earthlings become hobbyhorses, prostitutes, and playthings in love's labors, to be ridden to merciless productivity or extinction—or both—in the projects of Man. That sort of "Homo" needs Greek in the ideological, self-deluding, autochthonous, single-parent, self-birthing sense of the one true sacred image of the same, that Man

produced when situated?
formed when found?
present from earliest times?

who makes real the fabulation of double death. This is the figure of indifference that remembers that *homo in Greek* means "one and the same," not "earthling." Such Greek memories are not promising for multispecies humane flourishing on terra. But, refitted with recuperative human-animal loves and queer feminisms, the hobbyhorse seems quite ready to me to ride out again in all the flamboyant skill of small active border horses, those old Anglo-Scottish hobbies or hobblers who could cross boggy country to gain intelligence about danger and do something clever about it. Those resurgent hobbyhorses emerge from their late-medieval and early-modern roots to remember that they are still Robin, or molly dancers like Pig Dyke Molly, or revelers on May Day, Christmas, or All Souls' Day—i.e., those mummers mounted on their 'obby 'oss to salute the seasons and their earthlings. "Humane" is an oxymoron replete with its choice between the sacred image of the same and guman celebrating the seasons.

Advocacy

Advocacy is an act, a very particular kind of act. An advocate pleads the cause of another. This is a power relationship not unlike those of guardianship or parenthood. Critters need to tread cautiously around such Faustian bargains for care, nurturing, representation, and protection. Nonhuman animals who get the advocate's professional attention in city councils or courts are in a state of permanent legal minority, always children of whatever species, capable only of suffering, dependency, lack, passion, and need. In those frames, minority guman might win rights or redress, but they will at the same time get a lord protector. Such beings are before the bar, always accused of not being quite up to the mark, if not actually criminal in their very minority, and they always need representation. In one sense, to be an advocate is to make all others into those to be protected, to be pleaded for. Their cause is made the advocate's own, but the advocate is not the vulnerable one. Still, animal advocates of many kinds have an important job to do in our times, when familialized sentimen-

tality and institutionalized brutality seem bent on racing each other to a terrible finish line for all entwined mortal critters. Disciplined representation in such conditions is a flawed but often noble calling.

Calling; calling toward; ad-vocare. Advocacy is not just re-presentation; there is a sensual tension and rasping, noisy friction here. Who is calling whom? To whom does one turn? "Species" is promiscuous in the visual register; "advocacy" is promisingly overfull in the vocal and spatial registers. "Vox" is tone, voice, expression. The English idiomatic word "vouch" points to the sort of thing companions do with and for each other, in full throat and with full voice, in the face of bullies and authorities. "Vouching for" is about a risky contact zone of trust and responsibility. Advocates can call toward each other and toward what can and must come to be, in active passion that spirals out of the control of predisciplined representation. Then worlds open up, and getting on together is newly at stake and newly imagined. We can use such vouchers! Double death can be held at bay, perhaps by the baying of advocates, hounds for us all. To no one's surprise, scent hounds and all barking dogs bring me quickly to devils and rascals.

My favorite sort of advocate in the tissues of the more-than-human world is the devil's advocate. In these debased and globalized times, when the transnational animal-industrial complex and the accessorized pet compete for top dollar, the devil's advocate has been reduced to the one who pleads a cause that is not only not one's own but not even believed in, not in shared passion with the represented but just for the sake of argument. But in the more faithful, or maybe just more credulous, days of medieval Catholicism, the devil's advocate was the appointed skeptical one who doubted miracles, dragged down saints, and argued against Church authority in favor of the mundane, material nature of marvels. The more-than-human, indeed the human as guman, are material marvels, and I am with the devil's advocates who plead their finitude, unchurched ordinariness, and common terran fate.

Demonic rather than saintly, devil's advocacy is active, passionate espousal that is wary of the marriage bed of the bridegroom. With those tones of voice we enter more interesting oxymoronic territory

in responsible, responsive multispecies contact zones. Devil's advocates can work within uncertainty, doubt, and skepticism and still remain passionate and committed, open to knowing more and acting better, without losing respect for doubt. Devil's advocates plead and "call toward" without the awful warrant of the saintly and overly sure among us in our movements for flourishing animal-human worlds (I am not forgetting plants, fungi, bacteria, and all their ilk). Devil's advocates can take the heat of conflict, contradiction, and overflowing complexity. They can stay with the trouble of passionate, flawed, humane advocacy in the contact zones of queer-espoused quasi species. Spouses are betrothed, promised to each other, in a relationship of mutual sponsorship; i.e., they take each other up in a life-and-death-long practice of mutual support. Vulgar critters do that all the time, and only Homo-Man and God's creatures fail to get the implications. Let Him go; let them go; sign on with the devil; welcome the trouble. Guman have a future in the more-than-human world. Letting go of the odd notion that spouses are authorized reproductive, heterosexual (or homosexual, for that matter) marriage partners, I think of the espoused as commensal, as companions, as attached to each other in multispecies, guman-earthling, power-fraught relations of becoming with. People archived as *Homo sapiens* are the recipients of the life-and-death-long support of other critters, without which there would be no human nature. Advocacy is not a one-way calling. Spouses in these senses share food; they are each other's bread and meat, and they—we—had better figure out how to handle the devilish gestation, digestion, and indigestion.

I finish with passion. Pathos, pathology, pain. Can they—those others, whoever they are in a situated history—suffer? That has been a topic-changing question for all earthlings, and the answer is, simply, yes. All critters suffer in many senses; it is built into the protoplasm and not just into ganglia and brains. Passion is the tropism that leads the most elemental, as well as the most elaborate, living beings to turn away from noxious and dangerous provocation. Passion is the utter vulnerability of every living thing to noncapacity; to the mortal nontranscendence of matter, mutter, mother; to dying in the end, but not necessarily in the outrage of double death. Understanding

that passion is not just positive pain but the openness of being itself to the relentless finitude of becoming with is a big matter. Maybe, just maybe, Westerners, whoever and wherever those mythic beings are, can hear this call at last. Still, I hear in passion an oxymoron; the promise of friction and heat. "Can they suffer?" to my ear does not call for some weird reduction of all of us to an indulgent sort of lack and incapacity. Passion and skill, passion and accomplishment, passion and the vivid heat of love and rage—these do not exclude each other. Indeed, passion and action do not exclude each other except in the binary cyclopean airiness of noncontradiction. Sharp dullards—idiots—know better.[4] Misery and joy are both passion. Lack and fullness are both passion; neither pretends control. Love and rage are the queer anarchists' demonic heritage. Positive pain, whether of human beings or of more-than-human beings, is not the chief prod of humane advocacy. The promise of flourishing, of living and dying in guman becoming with—that is the serious prod when species matter. With that kind of passion, terran critters might endure.

Notes

1. A concept developed in Deborah Bird Rose, "What If the Angel of History Were a Dog?" *Cultural Studies Review* 12, no. 1 (2006): 67–78. "Double death" signifies the killing of ongoingness and the blasting of generations. Not just individuals but whole kinds, whole ways of conjoined being in the world die off or are actively killed in practices of double death. Instructed by Australian Aborigine teachers over many years of field work as well as by her support work in Aborigine land-title claims and in the ecological humanities, Rose presents double death as the kind of disaster that makes it impossible any longer, in Anglo-Aboriginal idiom, "to take care of country," i.e., to face those who come before by fulfilling the obligations of the care of generations so as to leave more quiet, less wild country to those who come after. "Wild" in this context means no longer bearing the marks of generations of care. A ruined land is wild; it can no longer sustain ongoingness; it has become no place, mere space where even extraction hits bottom. Rose also writes about the need for recuperation more than reconciliation or restoration. See Deborah Bird Rose, *Reports from a Wild Country: Ethics for Decolonization* (Sydney: University of New South Wales, 2005).

2. For the fundamental importance of multispecies reciprocal inductions to biological development, ecology, and evolution, see Scott F. Gilbert and David Epel, *Ecological Developmental Biology: Integrating Epigenetics, Medicine, and Evolution* (Sunderland, Mass.: Sinauer, 2008); and Margaret McFall-Ngai, "Unseen Forces: The Influence of Bacteria on Animal Development," *Developmental Biology* 242 (2002): 1–14. Natural-cultural multispecies reciprocal inductions in situated histories at every level of the onion that is terra are no less ubiquitous and consequential.

3. For a fuller development of the notion of "companion species," see Donna Haraway, *When Species Meet* (Minneapolis: University of Minnesota Press, 2008), especially chap. 1, 3–42.

4. Isabelle Stengers stresses the importance of the figure of the idiot, the one who slows us down in all the ways that matter to the practices of terran recuperation. She writes in solidarity with Dostoyevsky and Deleuze. See Isabelle Stengers, "The Cosmopolitical Proposal," in *Making Things Public*, ed. Bruno Latour and Peter Weibel (Cambridge, Mass.: ZKM Center for the Arts/MIT Press, 2005).

Humane Advocacy and the Humanities

The Very Idea

Cary Wolfe

The question of humane advocacy is a complex one, not least of all because advocacy is not a one-size-fits-all proposition. That is to say, advocacy always takes place within a highly contingent, situated, and densely configured context, one that involves different constituencies, institutions, audiences, strategic considerations, and rhetorical necessities. For the would-be advocate (in this or any other cause), ignoring this is not just intellectually hasty; it is also pragmatically unwise. To put it another way, though the ideals and ethical imperatives to which advocacy aspires may seem (in this and other cases) lofty and, as it were, "above" the messy domain of the social and the ethnocentric in the way that ideals by definition tend to be, the pragmatics of actually making change on behalf of one's ideals depend very directly upon a streetwise ability to anticipate what will "turn" (in the *mafioso* sense of the word) one's audience toward a desired point of view.

As I have often recalled from my years of experience as an animal rights activist, the language and rhetorical toolbox that one uses to

lobby for humane advocacy when speaking to the local newspaper or television station is very different—and often, in fundamental ways, opposed—to the language one would use to address a conference full of, let's say, specialists in contemporary continental philosophy. In the former instance, my experience suggests, the discourse of universal rights, drawn from the liberal justice tradition in philosophy and from a very historically specific set of philosophical, political, and legal coordinates, isn't just handy but is in many ways as indispensable as it is unavoidable (the coin of the realm, as it were, when raising in our society issues of ethical standing and the legal safeguards needed to protect it). But in the latter instance—speaking to a roomful of people who cut their teeth on Lacan, Foucault, Lyotard, and others of that ilk—suggesting that the rights framework is a satisfactory way (much less the last word) for thinking about the complexities of subjectivity and ethics and how those might be retooled to include nonhuman beings will mark you as a backsliding humanist who skipped too much class when intellectual history from 1950 forward was being taught.

The point here, of course, is not that one discourse is "right" and the other is "wrong." Rather, the point—to borrow the sociologist Niklas Luhmann's terminology—is that to live in modernity (and with it, postmodernity—the distinction is for him of little moment) is to live in a context of "functional differentiation," of highly differentiated social systems that process ever-increasing social complexity by filtering it through their own particular vocabularies, their own terminologies, and so on:[1] different constituencies, different audiences, and different "language games" (to use the phrase Lyotard famously borrows from Wittgenstein).[2] To ignore this point in an understandable but wrong-headed desire for a Final, Single Vocabulary is to rob oneself of strategically crucial information for making social and political change in the historical context we inhabit.

To contextualize the question in this way is to realize that you can't really talk about the question of humane advocacy in the context in which I work—the humanities classroom of a university dedicated to the broad goals of a liberal arts education—without also discussing a

set of directly related questions: What is the mission of the university in this day and age? What are universities for? What is the role of the humanities within that particular institutional site? What constitutes the specific intellectual and perhaps even ethical and political charge of the humanities in a way that is different from the sciences, the social sciences, and the increasingly dominant regimes of technical training and expertise? In raising these questions, I hasten to add that it is entirely likely that they will gloss differently on different institutional sites, even within higher education, where the mission and responsibilities of the small, private liberal arts college or the Ivy League school may well be construed quite differently from those of the large state university or the urban commuter university, not to mention the community college or junior college. Again, as Luhmann would say, we find here what we find everywhere we look in modern society: increasing differentiation (or what some would call, using more moralistic language, "specialization" or "fragmentation"). But be that as it may. To raise these questions is to realize that those who engage in humane advocacy in a context such as mine have duties and responsibilities that may or may not obtain on other sites—a protest at a rodeo, say, or an interview before a governmental body. And those duties and responsibilities may or may not be in tension, even conflict, with the role of advocate as it might otherwise be practiced on another site.

Here, I think the work of Jacques Derrida can be of some help, not only because of his well-known later writings on nonhuman animals and our responsibilities to them[3] but also—and perhaps more unexpected in this context—because of his searching discussions of the place of the university and the role of the humanities in contemporary society. What is seldom articulated, I think, is precisely how these two strands of Derrida's thinking intersect and how that intersection bears upon the question that occupies this volume. As is well known, Derrida has carried out his own form of "humane advocacy" by writing movingly and incisively not just of animal suffering but also of the "*unprecedented* proportions" and perverse forms it has taken in contemporary society (*Animal* 25). Characterizing this

situation baldly as both a "holocaust" and a "genocide," he writes, in a now famous passage, that

> the annihilation of certain species is indeed in process, but is occurring through the organization and exploitation of an artificial, infernal, virtually interminable survival, in conditions that previous generations would have judged monstrous, outside of every presumed norm of a life proper to animals that are thus exterminated by means of their continued existence or even the overpopulation. As if, for example, instead of throwing a people into ovens and gas chambers (let's say Nazi) doctors and geneticists had decided to organize the overproduction and overgeneration of Jews, gypsies, and homosexuals by means of artificial insemination, so that, being continually more numerous and better fed, they could be destined in always increasing numbers for the same hell, that of the imposition of genetic experimentation, or extermination by gas or by fire. In the same abbatoirs. *(Animal* 26)

Aside from the very charged analogy to holocaust and genocide—an analogy I have examined in some detail elsewhere[4]—two points should be emphasized here. First, as I've noted in my earlier writings, in his confrontation with the "question of the animal," Derrida returns, interestingly enough, to the *locus classicus* that grounds the animal rights philosophy of Peter Singer and Tom Regan: namely, Jeremy Bentham's famous assertion that the fundamental question here is not "can they talk?" or "can they reason?" but rather "can they *suffer?*" (*Animal* 27).[5] But what Derrida does with Bentham's formulation is quite unique; he insists that "once its protocol is established, the form of this question changes everything. It no longer simply concerns the *logos* . . . nor does it concern, more radically, a *dynamis* or *hexis*, this having or manner of being, this *habitus* that one calls a faculty or 'capability.'" Instead, he continues, "the question is disturbed by a certain *passivity*. It bears witness, manifesting already, as question, the response that testifies to a sufferance, a passion, a not-being-able" (*Animal* 27). "Being able to suffer," he concludes, "is no longer a power; it is a possibility without power, a possibility of the impos-

sible. Mortality resides there, as the most radical means of thinking the finitude that we share with animals, the mortality that belongs to the very finitude of life, to the experience of compassion, to the possibility of sharing the possibility of this non-power" (*Animal* 28). Yet we should notice that Derrida's point here is a double one, for as he suggests, this question of suffering, of finitude, of not-being-able, "determines so many others concerning *power* or *capability* [pouvoirs] and *attributes* [avoirs]: being able, having the power or capability to give, to die, to bury one's dead, to dress, to work, to invent a technique, etc." (*Animal* 27)—hence, I think, his emphasis in the earlier passage I quoted on the modern animal "holocaust" on the particularly perverse *techniques* of animal exploitation that we humans practice. That process depends upon a very *active* "disavowal" (as he puts it) of the finitude we share with our fellow creatures. And to expose that disavowal, as Derrida aims to do, is to call into radical question a certain schema of the human itself, "*this* auto-definition, *this* auto-apprehension, *this* auto-situation of man or of the human *Dasein* . . . this auto-biography of man"—or even more precisely, "the *being* of what *calls itself man*" (*Animal* 24, last emphasis mine).

I am lingering for a moment upon Derrida's conjugation of the twin hierarchies of human/animal and being-able/not-being-able to make my way toward a second, more complex, and more difficult to discern level on which this radical finitude is operative, and it is a level that will provide an important bridge to his writings on the university and the humanities. For in Derrida's work, the first kind of finitude we have been discussing (the capacity for suffering shared by embodied beings, our physical vulnerability and finally mortality as fellow creatures) is paradoxically made *unavailable* to us by the very thing that makes it available: namely, the finitude we experience in our subjection to the radically inhuman technicity and exteriority of language itself (understood in the broadest and, if you like, most "primitive" sense as grapheme, trace, and semiotic *grille*). As I have tried to elucidate elsewhere in more detail, this is one of the reasons that we do not and cannot have a "concept" of death and our own mortality—a presumption that has often been used, of course, to drive an ontological wedge between human and nonhuman beings.

Derrida makes this point most decisively, perhaps, in his critique of Heidegger's existential of "being-toward-death." For Heidegger, our finitude *is* appropriable by us in a way that is finally empowering *to* us, a kind of existential carpe diem, if you will, in which a "being-able" once again overcomes the "not being able" of our finitude.[6] But for Derrida, that ontological recontainment of finitude is in bad faith (to use Sartrean language), because the notion of language and its relationship to ontology that makes the recontainment possible in Heidegger cannot survive the deconstruction that Derrida brings to bear upon it. For Derrida, then, "we" are not "we"; we are not the "auto-" that the human "believes he gives himself" (*Animal* 12), because we are always already radically other to ourselves—not just in our evolutionary inheritance (our involuntary biological animality, if you like) but also because what we call the "subject" is made possible by the ahuman technicity of language that always antedates us. The genesis of concrete individuals becoming "subjects" (and not just for Derrida, of course—think of Lacan, for example) is thus dependent upon not just the exteriority of language in the most fundamental sense but also on the subject's essentially prosthetic relationship to that language. And hence, for Derrida what "we" call "we" covers over a more radical, second form of finitude: of "not-being-able."

It is worth recalling here one of the more trenchant passages in Derrida's "Signature Event Context," which gathers these threads of the argument—semiotic, phenomenological, ontological—together:

> The possibility of repeating and thus identifying the marks is implicit in every code, making it into a network [*une grille*] that is communicable, transmittable, decipherable, iterable for a third, and hence for every possible user in general. To be what it is, all writing must, therefore, be capable of functioning in the radical absence of every empirically determined receiver in general.[7]

Equally important, as Derrida makes clear in a well-known passage from the interview "Eating Well," is that this radical exteriority and technicity is in force not just for humans but for *any* form of life that begins to communicate recursively by means of any semiotic

system of marking, even the most basic *grille*. For as he puts it there, "these possibilities or necessities, without which there would be no language, *are themselves not only human*," and the principles of trace, iterability, and so on apply to "'animal languages,' genetic coding, all forms of marking within which so-called human language, as original as it might be, does not allow us to 'cut' once and for all where we would in general like to cut."[8] The issue is not, of course, whether and which nonhuman animals possess a form of writing; the issue is rather that to communicate *at all* with another, human or nonhuman, requires a semiotic system of some kind, a working archive of differences, of which "writing" in Derrida's sense is the maximal example.

This means that there is a relevant, indeed important, differentiation within and among the "animal kingdom" (which includes *Homo sapiens*, of course), a differentiation that we need to note in Derrida's work. *All* animals are, of course, bound by their biological finitude in the form of their evolutionary inheritance and embodiment. But only *some* animals engage in the sort of recursive semiosis we have been discussing; only some are able to "respond," as Derrida puts it in his critique of Lacan, rather than merely "react." We need to be able to pay attention to, for example, "the infinite space that separates the lizard from the dog, the protozoon from the dolphin" (*Animal* 34). It is "a matter of taking into account," he writes, "a multiplicity of heterogeneous structures and limits: among nonhumans, and separate from nonhumans, there is an immense multiplicity of other living things that cannot in any way be homogenized" under the "asinine" rubric of "*the* animal" (*Animal* 48).

Yet, as Derrida makes clear in a brilliant engagement with Lacan's notion of "the subject of the signifier," the line between "responding" and "reacting" cannot be drawn with any certainty. While I cannot trace here the intricacies of Derrida's analysis in detail, the essential point is this: where Lacan wants to reserve for the human—the "subject of the signifier"—the ability to demonstrate intentional mastery of a metacommunicative context (his famous thesis that only the human can lie by telling the truth or by pretending to pretend), Derrida holds that pretending (as some animals demonstrably do) and pretending to pretend cannot be rigorously distinguished, much less

bear the ontological freight that Lacan wants it to carry. "How could one distinguish," Derrida writes,

> for example, in the most elementary sexual mating game, between a feint and a feint of a feint? . . . One can conclude that every pretense of pretense remains a simple pretense (animal or imaginary, in Lacan's terms) or else, on the contrary, and just as likely, that every pretense, however simple it may be, gets repeated and reposited undecidably, in its possibility, as pretense of pretense (human or symbolic in Lacan's terms). (*Animal* 133)

What this means is not that there can be no "response" but only that there can be no "response" that is not always already fatefully inscribed with the "reaction" associated with "animal" and "instinct," a "reaction" that cannot now be rigorously excluded from any "proper" response. "It is *not just* a matter," Derrida writes, "of asking whether one has the right to refuse the animal such and such a power. . . . It *also* means asking whether what calls itself human has the right to rigorously attribute to man . . . what he refuses the animal, and whether he can ever possess the *pure, rigorous, indivisible* concept, as such, of that attribution" (*Animal* 135).

Derrida's point, then, is that, in the interest of the clarity and rigor of thought, we *should* pay attention to the enormous differences between, say, dolphins or wolves and grasshoppers or amoebas. But that difference, and the ability to "respond" as some animals (but perhaps not all) clearly do, does not and cannot do *the philosophical and ontological work* that the tradition running from Aristotle to Lacan wants it to do, namely, securing the ontological privilege of "responders" versus "reactors" (since "we humans," too, are also "reactors," because of the exteriority and technicity of language, our embodied "involuntary" and "instinctive" reactions, and so on).

Equally radical (though often overlooked in these discussions) is that this second form of finitude—subjection to the force of the trace and iterability—destabilizes not just the boundary between the human and animal but also between the organic or biological and the mechanical or technical. As he puts it in a more recent interview,

"Beginning with *Of Grammatology*, the elaboration of a new concept of the *trace* had to be extended to the entire field of the living, or rather to the life/death relation, beyond the anthropological limits of 'spoken' language. . . . At the time," he continues, "I stressed that the 'concepts of writing, trace, gramma, or grapheme' exceeded the opposition 'human/nonhuman.' "[9]

In Derrida's view—and this will have important consequences for what we might think of as the ethical charge of the humanities—this radically inhuman character of any semiotic system, any archival technology, exercises a "spectralizing" force upon all who utilize it. This is so, as he argues in "Signature Event Context," because "a writing that was not structurally legible—iterable—beyond the death of the addressee would not be writing. . . . Let us imagine," he continues,

> a writing with a code idiomatic enough to have been founded and known, as a secret cipher, only by two "subjects." Can it still be said that upon the death of the addressee, that is, of the two partners, the mark left by one of them is still writing? Yes, to the extent to which, governed by a code, even if unknown and nonlinguistic, it is consti-tuted, in its identity as a mark, by its iterability in the absence of whoever, and therefore ultimately in the absence of every empiri-cally determinable "subject". . . . And this absence is not a continuous modification of presence; it is a break in presence, "death," or the possibility of the "death" of the addressee, inscribed in the structure of the mark.[10]

As Derrida argues in many places but perhaps with the greatest range of implication in *Specters of Marx*, this spectralizing force of any semiotic or archival system installs a fundamental and fateful asym-metry or imbalance—an indebtedness—at the very heart of the ethi-cal relation, in at least two senses. First, it "prohibits us more than ever . . . from opposing 'real time' to 'deferred time,' effectivity to its simulacrum, the living to the non-living, in short, the living to the living-dead of its ghosts."[11] And this "unreasonable" or, better, "incal-culable" difference impels us, in turn, "beyond present life . . . its em-pirical or ontological actuality; not toward death but toward a *living-*

on [sur-vie], namely a trace, of which life and death would themselves be but traces. . . . [A] survival whose possibility in advance comes to disjoin or dis-adjust the identity to itself of the living present" (*Specters* xx). The "living present," in other words, is always *haunted* by the ghosts or specters of *what will have been* once any kind of archival or semiotic system is activated.

At the same time—and this is the second aspect of that fundamental asymmetry at the heart of ethics that I mentioned a moment ago—it is not just a matter of our debt to those who come later, who will understand us in our absence and to whom we cannot respond and are yet responsible. It is also a matter of our *inheritance* of what came before. As Derrida describes it in a late interview, developing the implications of the double sense of "finitude" we discussed earlier,

> Only a finite being inherits, and his finitude *obliges* him. It obliges him to receive what is larger and older and more powerful and more durable than he. But the same finitude obliges one to choose. . . . Precisely in order to respond to the call that preceded him, to answer it and to answer for it—in one's name as in the name of the other. . . . One is responsible before what comes before one but also before what is to come and therefore *before oneself.* (*For What* 5–6)

And in this double responsibility, this double asymmetry, there are no formulae that will tell me how I should respond, dictate to me the proper course of action. Indeed, in Derrida's view, such a formula or directive would itself be unethical in relieving us of the burden and duty of decision. As he asserts in a famous passage from the essay "Force of Law": "A decision that didn't go through the ordeal of the undecidable would not be a free decision, it would only be the programmable application or unfolding of a calculable process. It might be legal; it would not be just."[12] And this is why—to return now to the relation between finitude in Derrida's sense and ethics—

> if decision is not only under the authority of my knowledge but also *in my power*, if it is something "possible" for me, if it is only the predicate of what I am and can be, I don't decide then either. That is why

I often say, and try to demonstrate, how "my" decision is and ought to be the *decision of the other* in me, a "passive" decision, a decision of the other that does not exonerate me from my responsibility.

(*For What* 53)

This opposition of responsibility and "calculation," passivity and power or "being-able," will be crucial, as we will see in a moment, to Derrida's conjugation of the specific differences between the humanities and other forms of knowledge in the university. Beyond that, it will be central to the role of the humanities in the larger context of a globalization (or *mondialisation*, to use the French term he prefers) that is made possible by a directly related kind of "calculation"— namely, the standardization and commodification of knowledge via information technologies, economic measures of performativity, and so on. As he observes (and in this he reaches back to Heidegger's critique of technology): "The concept of information or informatization is the most general operator here. It integrates the basic [as in "basic science"] to the oriented, the purely rational to the technical"; it is "in this sense the most economic, the most rapid and the clearest (univocal, *eindeutig*) stockpiling, recording and communication of news. . . . Computer technology, data banks, artificial intelligence, translating machines, and so forth, all these are constructed on the basis of that instrumental determination of a calculable language."[13]

What is the role, then, of the university and of the humanities in this context? For Derrida, it has to begin with interrogating a certain notion of "reason" and of "truth" that remains in force, one that "has always been linked to the question of man, to a concept of that which is proper to man, on which concept were founded both Humanism and the historical idea of the Humanities."[14] For if we ask, with Derrida, "does the university, today, have what is called a *raison d'être*?"—and this question has never been less rhetorical than at present—then we must also ask after the institution's primary cause, one "explainable according to the 'principle of reason' or the 'law of sufficient reason'" (to borrow Leibniz's phrasing) ("Principle" 129). ("As far as I know," Derrida humorously observes, "nobody has ever founded a university against reason. So we may reasonably suppose

that the University's reason for being has always been reason itself, and some essential connection of reason to being" ["Principle" 135].) As we already know, this "essential connection" of reason to being, of an analytical procedure or attribute to an ontological condition, is a grounding—indeed perhaps *the* grounding—distinction between human and nonhuman animals in the Western philosophical tradition. But "'Thinking,'" Derrida observes—in a formulation that reaches back to our earlier discussion of how the essential dynamics of trace and iterability undo the "auto-" that the human "gives to itself"— "requires *both* the principle of reason *and* what is beyond the principle of reason, the *arche* and an-archy" ("Principle" 153). And it is here that the university finds its reason for being, one that is also (given what has traditionally been thought "proper" to man) a kind of *unreason*. "The university," he writes, "demands and ought to be granted in principle, besides what is called academic freedom, an *unconditional* freedom to question and to assert . . . all that is required by research, knowledge, and thought concerning the *truth*. . . . The university *professes* the truth, and that is its profession" ("Condition" 202).

But then we must ask—in a move intended to underscore the specificity of the *professor* in at least a double sense—what does it mean to *profess*? ("Condition" 214). First of all, when one professes—rather than merely calculating or applying a formula of some sort—one professes *faith*: in this case, faith in thought, wherever it may lead. As he writes in "The University Without Condition," "the university should thus also be the place in which nothing is beyond question, not even the current and determined figure of democracy, not even the traditional idea of critique" ("Condition" 205). In other words, one professes faith in the possibility of the as yet *unthought* and also in the possibility of other *forms* of thought—what Derrida often calls the "event" of thought or (to use a formulation invoked earlier) the thought "to come." And second (to revisit our discussion of ethics, inheritance, and legacy), to profess is to make a pledge or promise, a "declaration of responsibility" for thought ("Condition" 222).

Crucially, however, "the declaration of the one who professes is a *performative* declaration in some way" ("Condition" 214), in the strict sense described by J. L. Austin and further refined in important ways

by Derrida in "Signature Event Context." "One must underscore," he continues, "that constative utterances and discourses of pure knowledge, in the university or elsewhere, do not belong, as such, to the order of the profession in the strict sense. . . . The discourse of profession is always, in one way or another, a free profession of faith; in its pledge of responsibility, it exceeds pure techno-scientific knowledge" ("Condition" 215). And "because the act of professing is a performative speech act and because the event that it is or produces depends only on this linguistic promise,"[15] Derrida shrewdly observes, "its proximity to the fable, to fabulation, and to fiction, to the 'as if' "—that is to say, to the possible and the "to come"—"will always be formidable" ("Condition" 215). This means, in turn—though he doesn't quite spell it out—that the humanities, and one might even say literature and philosophy in particular (given their focus on the imaginative and the speculative), have an especially important place in the professoriate.

This understanding of the "place" of the humanities as the free profession of faith in thought and in thought's unconditional futurity (the as yet unthought) thus changes the concept of the humanities' responsibility. Appropriately enough, then, Derrida begins "Mochlos; or, The Conflict of the Faculties" with a conditional—a conditional that looks forward to his later questioning of "what *calls itself man*." "If we could say *we*," he writes, then we might ask,

> *What* do we represent? *Whom* do we represent? Are we responsible? For what and to whom? If there is a university responsibility, it at least begins in the moment when a need to hear these questions, to take them upon oneself and respond to them, imposes itself. . . . One can always not respond and refuse the summons, the call to responsibility. But the structure of this call to responsibility is such—so anterior to any possible response, so independent, so dissymmetrical in its *coming from the other within us*—that even a nonresponse a priori assumes responsibility.[16]

Now, we already know from our earlier discussion of Derrida's critique of the "respond"/"react" opposition and his analysis of the

"spectralizing" force of iterability why we find this "dissymmetry" of responsibility. And I highlight that particular phrase—*"coming from the other within us"*—to underscore that the "response" is strangely inhuman, even alien, though it cannot be called "animal" per se because, as we know, the very condition of its possibility exceeds not just the human/animal relation but also the life/death relation. It is what binds fellow creatures who communicate with one another in time, constituting our "inheritance" and opening onto a future that will exceed our presence, a "to come" to which we are nevertheless responsible.

These various strands—the dismantling of the intentional subject and the ego via the performative and professing, the asymmetry of an unappeasable ethical debt—are braided together later in "Mochlos," where Derrida writes,

> would it not be more interesting, even if difficult, and perhaps impossible, to think a responsibility—that is, a summons requiring a response—as no longer passing, in the last instance, through an ego, the "I think," intention, the subject, the ideal of decidability? Would it not be more "responsible" to try to think the ground, in the history of the West, on which the juridico-egological values of responsibility were determined, attained, imposed? There is perhaps a fund here of responsibility that is at once "older" and—to the extent it is conceived anew, through what some would call the crisis of responsibility in its juridico-egological form and its ideal of decidability—is *still to come*, and, if you prefer, "younger." (91)

We have not, for all that, left behind the question of "the animal" and the human/animal relation, for in order to rethink that "ground," the

> new Humanities would treat the history of man, the idea, the figure, and the notion of "what is proper to man." They will do this on the basis of a nonfinite series of *oppositions* by which man is determined, in particular the traditional opposition of the life form called "human" and of the life form called "animal." I will dare to claim, without being able to demonstrate it here, that none of these traditional

concepts of "what is proper to man" and thus of what is *opposed* to it can resist a consistent scientific and deconstructive analysis.

("Condition" 231)

And he is also aware, as we are about to see however briefly, of the links between that discourse of species difference and the question of sexual difference. (When Derrida says "man," here, in other words, we need to hear it precisely in the sense in which the philosophical tradition he is examining has used it—capitalized, as it were.)

That both of these are grounded in and reproduced by a certain schema of the knowing subject is teased out in a fascinating if passing engagement of Aristotle in "The Principle of Reason: The University in the Eyes of Its Pupils." As Derrida notes there, from its very beginnings "metaphysics associates sight with knowledge, and knowledge with knowing how to learn and knowing how to teach" (4). Here is the relevant passage from the opening of Aristotle's *Metaphysics*:

> All men by nature desire to know. An indication of this is the delight we take in our senses; for even apart from their usefulness they are loved for themselves; and above all others the sense of sight. For not only with a view to action, but even when we are not going to do anything, we prefer seeing (one might say) to everything else. The reason is that this, most of all the senses, makes us know and brings to light many differences between things.
>
> By nature animals are born with the faculty of sensation, and from sensation memory is produced in some of them, though not in others. And therefore the former are more intelligent and apt at learning than those which cannot remember; those which are incapable of hearing sounds are intelligent though they cannot be taught, e.g. the bee, and any other race of animals that may be like it; and those which besides memory have this sense of hearing can be taught.[17]

As Derrida observes, what is interesting here is that there are *two* forms of "being-able" associated with knowledge in this passage: sight, linked with knowledge, but also knowing how to *learn*, which

is associated not with sight but with hearing. "I might suggest somewhat playfully," Derrida writes, "that we have to know how to shut our eyes in order to be better listeners"—that is, to know how to learn ("Principle" 131). He then places alongside this text of Aristotle's another, *De Anima*, where Aristotle "distinguishes between man and those animals that have hard, dry eyes [*ton sklerophtalmon*], the animals lacking eyelids [*ta blephara*], that sort of sheath or tegumental membrane [*phragma*] which serves to protect the eye and permits it, at regular intervals, to close itself off in the darkness of inward thought or sleep. What is terrifying about an animal with hard eyes and a dry glance," Derrida continues, "is that it always sees. Man can lower the sheath, adjust the diaphragm, narrow his sight, the better to hear, remember, and learn" ("Principle" 132).

"Opening the eyes to know, closing them—or at least listening—in order to know how to learn and to learn how to know: here we have a first sketch of the rational animal," Derrida writes ("Principle" 132). Though he takes this figural *topos*, which is also an ontological one, in a rather Heideggerian direction as the essay unfolds, what I would like to emphasize is that we have stumbled upon here an absolute aporia between seeing and hearing that extends as well to reason and nonreason and, beyond that, to "being-able" and "not-being-able," "responding" and "reacting," one that anchors the human/animal distinction in the philosophical tradition. For seeing is the act of an intentional subject who, from that space of intentionality and directed attention, compares differences (as Aristotle puts it); it is an "activity" par excellence. But listening is an act of radical *passivity*, an act of becoming *subject-to*, because what one hears, what "befalls" one's hearing (to put it as Wittgenstein might), comes unbidden and from without. As Stanley Cavell reminds us, aren't we "fully accustomed to hearing things that are invisible, not present to us, not present with us? We would be in trouble if we weren't so accustomed, because it is the nature of hearing that what is heard comes *from* someplace, whereas what you can see you can look *at*."[18]

Now we are in a position to better appreciate Derrida's contention later in the essay—and it is one that applies as directly to sexual difference as to species difference—that "the modern dominance of

the principle of reason had to go hand in hand with the interpretation of the essence of beings as objects, an object present as representation [*Vorstellung*], an object placed and positioned *before* a subject. This latter, a man who says 'I,' an *ego* certain of itself, thus ensures his own technical mastery over the totality of what is" ("Principle" 139). Such a concept of "representational man," Derrida writes, "would readily endow him with hard eyes permanently open to a nature that he is to dominate, to rape if necessary, by fixing it in front of himself, or by swooping down on it like a bird of prey" ("Principle" 139). But what is more "reasonable," Derrida urges us to consider, is to ask if we can learn to *listen* to that which is not before us as an "object" of sight and knowledge but rather is behind us, beside us, and, as it were, *with* us—that which is unbidden, to come, and befalls us as an "event" of learning, of thought from the outside.[19] Can we see the terrible price of a knowledge that would "see all," Derrida forces us to ask? Can we listen to what is around us and learn how to learn?

Here, Derrida gives us a rather different way of triangulating the relations between the humanities, "the animal," and advocacy. And he suggests that in "learning how to learn"—learning how to become a "listening" rather than "seeing" animal, not a "rational animal" as Aristotle and his inheritors would have it but something actually far more *reasonable*—the humanities have a very specific role to play, and in two ways. First, against that which is "controllable and programmable within a horizon of anticipation or precomprehension," the humanities provide a place for countering the hegemonic performatives (think of disciplinary habits and conventions, for example) with a "perhaps" that is (perhaps) most readily associated, as I have already suggested, with literature and philosophy and the existential challenges they pose. It is in the humanities, as a *constitutive* commitment, that "this limit of mastery and of performative conventionality, this limit of performative authority" is exposed. To engage in such an exposure, however—and this is the second aspect of their unique role—the humanities must dedicate themselves to the principle of *unconditional* discussion, *unconditional* freedom of thought ("Condition" 202, 203). For even though we know that in fact this unconditionality does not and has never existed in any pure form, it is the *principle*

We are the humanities.

There is no place we will not go.

of unconditional thought that the humanities guards and upholds for the university. If that unconditional freedom is the raison d'être of the university (versus, say, institutions of technical training and applied knowledge), the humanities are its "originary and privileged place of *presentation*, of manifestation, of safekeeping" ("Condition" 207).

In an engagement of Kant's essay "The Conflict of the Faculties" that occupies stretches of both "Mochlos" and "The University Without Condition," Derrida makes it clear that this unconditionality, this freedom, is also a kind of weakness or (to use a term we explored earlier) a form of radical passivity. "Because it is a stranger to power," he writes, "because it is heterogeneous to the principle of power"—versus "all research institutions that are in the service of economic goals and interests of all sorts"—"the university is also without any power of its own" ("Condition" 206). And the question, for Derrida as for Kant, is how that weakness can be seen as the site of a unique kind of strength. In the context of the humanities so understood, then, deconstruction serves as "a place of irredentist resistance or even, analogically, as a sort of principle of civil disobedience, even of dissidence in the name of a superior law and a justice of thought" ("Condition" 208).

This last passage helps underscore the fact that the implications for the idea of humane advocacy of Derrida's writings on the university and the humanities are bracing but need not be, I think, enervating. (Indeed, we have the example of Derrida's own outspoken stance on the contemporary "holocaust" and "genocide" against our fellow creatures to suggest otherwise.) Rather, his aim is to make us all the more vigilant and self-critical about the assumptions we may unwittingly reproduce when we undertake even the most high-minded and seemingly commonsensical forms of advocacy. As I suggested at the outset, the question of advocacy must always be confronted in context and on site, and in that light we need to understand that what might seem "apolitical" or "uncommitted" to some in Derrida's cautious approach to such questions is, in fact, a product of his taking quite seriously his responsibility to the humanities and the university *as a philosopher* (and not, let's say, as a lawyer, a sociologist, or an ecologist).

In fact, as he points out in "The Principle of Reason," many apparently more "committed" and unabashed forms of advocacy in the contemporary university are quite easily recontained as part of its standard operating machinery of dissensus—a shopping-mall pluralism, if you will, in which "animal studies" might well be viewed as simply the latest flavor du jour in a fundamentally neoliberal project of incorporation.[20] Speaking of "sociology or politology," Derrida writes that

> I would be the last to want to disqualify them. But whatever conceptual apparatus they may have . . . they never touch upon that which, in themselves, continues to be based on the principle of reason and thus on the essential foundation of the modern university. They never question scientific normativity, beginning with the value of objectivity or objectification, which governs and authorizes their discourse. . . . These sociologies of the institution remain in this sense internal to the university, intra-institutional, controlled by the deepseated standards, even the programs, of the space that they claim to analyze. ("Principle" 149)

In this sense, they are "homogeneous with the discourse that dominates the university in the last analysis," and that "explains, to a certain extent, the fact that even when it claims to be revolutionary, this discourse does not always trouble the most conservative forces of the university" ("Principle" 149). This is not to say that such work is not worthwhile; it is simply to say that it is *situated* both conceptually and institutionally. Indeed, when it comes to "the animal question," Derrida himself recognizes that, on the one hand, "for the moment, we ought to limit ourselves to working out the rules of law [*droit*] such as they exist." But, on the other, he insists that "it will eventually be necessary to reconsider the history of this law and to understand that although animals cannot be placed under concepts like citizen, consciousness linked with speech, subject, etc., they are not for all that without a 'right.' It's the very concept of right that will have to be 'rethought'" (*For What* 73–74).

It is a question, in other words, not just of responsibility but of how a generalized kind of responsibility, a generalized ethical calling, articulates with a *specific* site and practice of responsibility—in the university, in the humanities, and (for Derrida) as a philosopher. It is not a question of being right or wrong about a cause; it is a question of much larger hegemonic structures of thought and of subjectivity endemic to humanism that particular forms of advocacy sustain and indeed extend, whatever side of the question one might choose. To put it this way is to give a different valence to the question of "humane advocacy," to ask what more "humane" forms of advocacy might look like. And it also explains why, for Derrida, forms of humane advocacy based upon a certain model of animal rights—while they may be powerful outside the university precisely *because* they mobilize hegemonic juridical and philosophical tenets of liberalism— are problematic *within* the humanities and *to* his specific duties as a philosopher. As he argues in a late interview,

> to confer or to recognize rights for "animals" is a surreptitious or implicit way of confirming a certain interpretation of the human subject, which itself will have been the very lever of the worst violence carried out against nonhuman living beings. . . . It would reproduce the philosophical and juridical machine thanks to which the exploitation of animal material for food, work, experimentation, etc., has been practiced (and tyrannically so, that is, through an abuse of power). (*For What* 65)

In this light, to desire the most "committed" and "progressive" form of advocacy imaginable when it comes to our responsibilities toward nonhuman animals—and who wouldn't want such a thing?— is to address only *half* the question. But the humanities have a specific burden to bear in articulating the *other* half of that question: namely, is humane advocacy "humane" when it reproduces "a certain interpretation of the human subject" that has itself been the "lever" of the worst violence and exploitation toward our fellow creatures for centuries and in the most "developed" nations on earth? Or, to put a somewhat finer point on it, Derrida would remind us that, in the

humanities, we bear a special kind of responsibility in not meeting that "abuse of power," however enraging it may be, with our own "juridico-egological" activism, which is its mirror image, a "being-able" that might well constitute an abuse of our own.

NOTES

1. See Niklas Luhmann, *Social Systems*, trans. John Bednarz Jr. with Dirk Baecker, intro. Eva Knodt (Stanford, Calif.: Stanford University Press, 1995).

2. Lyotard deploys this notion in a number of places, but the best reference for my purposes here is Jean-Francois Lyotard and Jean-Loup Thébaud, *Just Gaming*, trans. Wlad Godzich, afterword by Samuel Weber (Minneapolis: University of Minnesota Press, 1985).

3. As he notes, his interest in the topic, while associated with his later work, had occupied him in a score of texts reaching back to his early career. See Jacques Derrida, *The Animal That Therefore I Am*, ed. Marie-Louise Mallet, trans. David Wills (New York: Fordham University Press, 2008), 37–40. Further references are given in the text.

4. See my essay "Before the Law: Animals in a Biopolitical Context," *Law, Culture, and the Humanities* 6, no. 10 (2010): 8–23.

5. See, for example, my essay "Exposures," in Stanley Cavell, Cora Diamond, John McDowell, Ian Hacking, and Cary Wolfe, *Philosophy and Animal Life* (New York: Columbia University Press, 2008), 1–41.

6. See my discussion of this point in my essay "Exposures," esp. 27ff.

7. Jacques Derrida, "Signature Event Context," in *Limited Inc*, trans. Samuel Weber, ed. Gerald Graff (Evantson, Ill.: Northwestern University Press, 1988), 12. I am using Weber's translation here, rather than Alan Bass's (referenced below), because Weber includes the term *une grille* (usually translated as "grid" or "network") in his translation, which provides a useful point of contact with Derrida's sense of a "fundamental" or "primitive" semiosis at work (my terms, not his) in both human and nonhuman communication.

8. Jacques Derrida, " 'Eating Well'; or, The Calculation of the Subject: An Interview with Jacques Derrida," in *Who Comes After the Subject?*, ed. Eduardo Cadava, Peter Connor, and Jean-Luc Nancy (New York: Routledge, 1991), 116–117. To gain an even sharper sense of how this contention relates to the question of species difference, see Derrida's discussion of Lacan in chapter 3 of *The Animal That Therefore I Am*.

9. Jacques Derrida, "Violence Against Animals," in Jacques Derrida and Elisabeth Roudinesco, *For What Tomorrow . . . A Dialogue*, trans. Jeff Fort (Stanford, Calif.: Stanford University Press, 2004), 63. Further references are given in the text.

10. Jacques Derrida, "Signature Event Context," in *Margins of Philosophy*, trans. Alan Bass (Chicago: University of Chicago Press, 1982), 315–316.

11. Jacques Derrida, *Specters of Marx*, trans. Peggy Kamuf, intro. Bernd Magnus and Stephen Cullenberg (New York: Routledge, 1994), 169. Further references are given in the text.

12. Jacques Derrida, "Force of Law: The Mystical Foundation of Authority," trans. Mary Quaintance, in *Deconstruction and the Possibility of Justice*, ed. Drucilla Cornell et al. (London: Routledge, 1992), 24.

13. Jacques Derrida, "The Principle of Reason: The University in the Eyes of Its Pupils," in *Eyes of the University: Right to Philosophy 2*, trans. Jan Plug et al. (Stanford, Calif.: Stanford University Press, 2004), 145–146. Further references are given in the text. As I have suggested elsewhere, Derrida's observation should be taken with the caveat that the concept of "information" he deploys not just here but generally in his writings corresponds only to the form of information we find in first-order systems theory and cybernetics, whereas "information" in the second-order systems theory of Maturana and Varela, Luhmann, and others emphasizes the very properties of paradox, contingency, recursive self-reference, and the like that are occulted in the first-order concept of information that Derrida rightly critiques. Those properties are, of course, central to Derrida's own enterprise. See chapter 1 of my book *What Is Posthumanism?* (Minneapolis: University of Minnesota Press, 2009).

14. Jacques Derrida, "The University Without Condition," in *Without Alibi*, ed. and trans, Peggy Kamuf (Stanford: Stanford University Press, 2002), 203. Further references are given in the text.

15. The classic example of the performative—the speech act that does not refer to an antecedent state of affairs but, in being enunciated, makes it so—is the wedding vow. For Derrida's discussion, see "Signature Event Context," 321ff.

16. Jacques Derrida, "Mochlos; or, The Conflict of the Faculties," in *Eyes of the University*, 83, emphasis mine. Further references are given in the text.

17. Aristotle, *Metaphysica (Metaphysics)*, in *The Basic Works of Aristotle*, ed. Richard McKeon (New York: Modern Library/Random House, 1941; 2001), 689.

18. Stanley Cavell, *The World Viewed: Reflections on the Ontology of Film*, enlarged ed. (Cambridge, Mass.: Harvard University Press, 1979), 18. I have discussed this relation between sight or visuality and hearing or listening on the terrain of film, photography, gender, disability, and species in much more detail in chapters 5 and 7 of my *What Is Posthumanism?*

19. For a nuanced and original excavation of this question on a much larger canvas—philosophical, ethical, political, and literary—see David Wills, *Dorsality: Thinking Back Through Technology and Politics* (Minneapolis: University of Minnesota Press, 2008).

20. For more detailed engagement of this point on the terrain of disciplinarity specifically, see chapter 4 of my *What Is Posthumanism?*

3

Consequences of Humanism, or, Advocating What?

Paola Cavalieri

THE PROBLEM

Everyone involved in progressive political activism acknowledges the importance of groups building alliances, and most social movements seek to devise and develop political connections that might increase the possibilities of accomplishing their political goals.

Alliances, however, are a type of cooperative behavior, and cooperation theories tell us that collective action is not always easy to achieve. Agreement on common goals and strategies can be hindered by many elements, such as a lack of shared values or an unequal distribution of costs or responsibilities. But in the case of the possible relationship between human and nonhuman advocacy, the problems may cut deeper.

To clarify this point, we can adopt the traditional subdivision of the animal advocacy movement into the two main areas of animal welfare and animal liberation. Animal welfare[1] aims at improving the treatment of animals, but without changing their status as inferior beings. Animal liberation pursues instead the goal of a moral

and legal extension of equality to nonhuman beings. So far, any alliance between human and nonhuman advocacy can only involve the first type of movement. In other words, progressive intellectuals or groups, even when they deal with animal issues, either do it somewhat obliquely or confine themselves to demanding reforms around the edges of the status quo.

Here are just a few examples. In her celebrated attack on large multinationals and their misdeeds, Naomi Klein focuses on the manipulation of consumers, the exploitation of third-world workers, the increase of domestic unemployment, and the erosion of labor rights, and she only casually mentions animal "cruelty."[2] Vandana Shiva, the leader of a mass movement against corporate globalization,[3] complains that "species are being pushed to extinction" only in connection with the depletion of biodiversity as the primary capital of underdeveloped peoples, without showing any real interest in the individual animals. The Italian Green Party's statute gives pride of place to the protection of the environment and to antiwar struggles and only subordinately mentions the defense of animals, pointing to the proposed UNESCO Declaration of the Rights of Animals, which states that "where animals are used in the food industry, they shall be reared, transported, lairaged and killed without the infliction of suffering."[4] And all over the world, the anti-McDonald's saga, which has in the last few years involved activists from the most disparate movements, including animal rights groups, has focused on the issues of health, the environment, and worker rights, taking animals into account only with reference to the problem of the introduction of "monoculture" factory farming.[5]

Why cannot progressive intellectuals and groups interested in changing the world incorporate the goal of animal enfranchisement? Why cannot they cooperate with those who advocate animal liberation? A comprehensive answer to this question is certainly complex, having to do, among other things, with ingrained hierarchical attitudes and with vested interests in individual and collective practices of exploitation. There is, however, a current notion that well subsumes all these aspects—the notion of humanism. Humanism, as I shall show, does not merely foster an attitude of carelessness toward

the need for moral and legal extensionism concerning animals;[6] it actually polices the species boundary whenever any extensionist demand is openly advanced. It is thus worth having a closer look at it.

HUMANISM

Of course, the sense of humanism that interests us here is not the one implied by the concepts historically employed to refer either to some Greek philosophical strands' concentration on a rational investigation of humankind's predicament or to the Renaissance intellectual rediscovery of the classical world; it instead refers to the view that equal moral respect is owed to all and only human beings. Humanism in this sense is commonly defended in English-speaking countries, but not necessarily under this label.[7] In contrast, in France the term *humanisme* is widely used and revered. In particular, if there is an author who has made himself the most outspoken advocate of current humanism, it is certainly Luc Ferry, who has openly and repeatedly launched attacks on the attempts to bring nonhuman beings into the privileged moral sphere that human beings inhabit.[8]

To what does Ferry attribute the credit for what he defines as the "specificity of the human"? In what does he identify what French philosophical jargon likes to denominate *le propre de l'homme* (*sic*)? His answer: freedom. And, avowedly, his guiding lights on the topic are Jean-Jacques Rousseau and Immanuel Kant. From the Swiss author, Ferry borrows a, so to speak, generic notion of freedom, one connected to the idea that, unlike nonhumans, allegedly guided merely by natural instinct, humans can separate (*arracher*) themselves from nature and are thus characterized by a form of perfectibility. From the German philosopher, on the other hand, he borrows the specifically moral construal of freedom as autonomy of the will, allegedly possessed only by rational (surreptitiously translated into human) beings.

In brief, then, on this rather commonplace view humanism can be described as a doctrine of human ontological and moral superiority

based on the allegation that all and only humans are free insofar as they are antinatural and rational beings. We shall not deal in any detail here with the fundamental rejoinder to such allegations. Suffice it to point at two ad hominem arguments. First, it is clear that not all human beings possess the *humanitas* Ferry emphasizes by making reference to freedom from nature's constraints and rationality—very young babies, the senile, and the severely intellectually disabled are devoid of such properties and would be excluded, on Ferry's own terms, from the sphere of equal respect. Second, if Ferry makes a retreat and points, rather than to *humanitas*, to *hominitas*—that is, to the characteristic of belonging to the biological genus *Homo*[9]—his position is inconsistent, because it is flawed by a form of biological discrimination, *speciesism*, that is parallel to those discriminations he, and the humanism he defends, condemn in racism and sexism.[10]

What really interests us in this context, however, is a different aspect of Ferry's stance. For the distancing of animals has for him a double connotation: it is not only normative—it also plays a, so to speak, genealogical role. In fact, though also making a vague reference to the Stoics and to the fifteenth-century thinker Pico della Mirandola, Ferry traces humanism essentially to the Enlightenment period, when theological worldviews wavered. In this perspective, modern thinking allegedly put "man" (*sic*) in place of the cosmos or of the divinity, so that philosophers started to build their theories from the idea of humanity, accordingly turning to "what essentially distinguishes humanity from animality" as the central aspect of their reflection, in order to account for human worth and significance: "What is it that makes the difference between the human and the animal? Such a question is utterly inseparable from the question of modern humanism. . . . All the debate on the animal is in fact a fundamental debate in the seventeenth and eighteenth centuries, a debate where what is at stake is the birth of humanism."[11]

In other words, Ferry's view has the merit of shedding light on what one might call the "disavowed underside" of humanism.[12] Usually, what is emphasized in the doctrine is its benign side—the aspect of being either an overcoming of discriminatory views such as those based on intrahuman hierarchies or a widening of previous,

more parochial views like tribalism or nationalism—a side that is naturally appealed to when moral extensionism is advocated. But what if an essential part of the explanation for the rise of humanism lay, as Ferry suggests, in the deliberate attempt to distance animals? The suggestion that the exclusion of nonhumans from the sphere of justice, rather than being fortuitous, is part and parcel of modern humanism is far from eccentric, and other authors have advanced it, albeit with different nuances. John Rodman, among others,[13] has even backdated the rise of the "modern" view to the seventeenth century, ascribing what he defines as a counterrevolution in thought to the redefinition by Hugo Grotius and others of the *jus naturae*— which the Roman jurists had defined as what nature had taught all animals—"in a totally hominicentric way" in terms of what accorded with *human* nature.

Such a construal of the origins of humanism is not only historically and conceptually plausible, but it is also heuristically enlightening. For, as we shall see, it can help account for the resistance of progressive movements to embrace radical animal goals. It is to this topic that we shall now turn.

DEHUMANIZATION

Humanism, as we have seen, appears as a form of moral extensionism—namely, an extensionism regarding equality (equal worth, equal treatment). Every form of extensionism regarding equality involves some provisional limits. As Mary Midgley wrote, "the notion of equality is a tool for rectifying injustices. . . . As it is often necessary for reform, it works on a limited scale."[14] But, if the previous account of its origins is correct, the problem with humanism is that, in its context, the limits of equality aren't merely provisional; they are abiding. In other words, the inclusive and the exclusive side are not contingently but structurally tied: they are so intertwined that whenever one side is appealed to, the other immediately presents itself.

It is a matter of course that contemporary human oppressed groups, in advancing their claims, appeal to equality. What, then, if the

notion of equality they appeal to were the one embodied in the doctrine of humanism? Plausibly, such equality would automatically bring along inequality in the form of the relative debasement of animals, and, accordingly, the involved groups would limit themselves to rejecting the hierarchical place allotted to them, avoiding any open-ended challenge. It has been previously suggested that this might be generally the case with current human advocacy movements. But how can one put such an assumption to the test? There is, arguably, a specific factor that can provide a clue to the presence of a humanist stance—the notion of dehumanization. Since such a notion usually refers to the loss of "typically human" attributes and status, with the attendant "reduction to animality," almost whenever one meets with the specter of dehumanization, one can surmise that humanism is at work.[15] We shall therefore apply this grid to the attitudes of some of the main intrahuman progressive areas: the movement against ethnic discrimination and genocide, feminism, the disability rights movement, and the leftist galaxy.

I. Seeing the Camp Through the Species Lens

In 1983, responding to an interviewer who asked him whether it is possible to abolish "man's humanity," Primo Levi, author of the famous *If This Is a Man*, replied:

> Unfortunately, yes; and that is really the characteristic of the Nazi lager (camp). . . . Most of all, our sensibility lost sharpness, so that . . . the memory of family had fallen into second place in face of urgent needs, of hunger, of the necessity to protect oneself against cold, beatings, fatigue . . . all of this brought about some reactions which we could call animal-like. . . . It is curious how this animal-like condition would repeat itself in language: in German there are two words for eating. One is *essen* and it refers to people, and the other is *fressen*, referring to animals. . . . In the lager . . . the verb for eating was *fressen*. As if the perception of the animalesque regression was clear to all.[16]

This is an example among many others. The fear of a possible "reduction to animality" features largely in the literature on genocides and ethnic cleansing. Sometimes it appears, as is the case with Levi, in the form of the anguish before the alleged loss of the "human" dignity of the victimized beings. More often, however, it revolves around the revulsion for a treatment that is deemed unacceptable for human beings. Clear instances of the latter case are the common use of the term "slaughterhouse" for atrocious intrahuman events,[17] the widespread horror over the Nazi use of cattle railcars for the transport of human beings, or the shocked reference to the "reduction to beasts of burden" of human beings subjected to the institution of slavery.

The fear of subhumanization does not express a mere gut reaction. A look at the theoretical reflection on ethnic discrimination is enough to show how deep its philosophical connections with humanism are. The treatment of the topic of the "camp" (lager) provides an excellent litmus test.

In a brief article of 1975, Emmanuel Levinas describes his life in a concentration camp for Jewish prisoners of war while at the same time telling the story of Bobby, a stray dog who, for a short time before the sentinels chased him away, wandered in the region of the camp:

> The other men, called free . . . stripped us of our human skin. We were subhuman, a gang of apes. A small inner murmur, the strength and wretchedness of persecuted people, reminded us of our essence as thinking creatures, but we were no longer part of the world. . . . We were beings entrapped in their species, despite all their vocabulary, beings without language. . . . How can we deliver a message about our humanity which, from behind the bars of quotation marks, will come across as anything other than monkey talk? And then . . . for a few short weeks before sentinels chased him away, a wandering dog entered our lives. . . . He would appear at morning assembly and was waiting for us as we returned, jumping up and down and barking with delight. For him, there was no doubt that we were human. . . . The dog was the last Kantian in Nazi Germany, without the brain needed to universalize maxims and drives.[18]

Levinas's humanistic bias could not be clearer. First, his very praise degrades the only nonhuman character: for an animal to be a Kantian implies an acceptance of one's status as a thing, and Levinas's comment somehow transmits the idea that to be a good dog means to acknowledge one's inferiority. Second, he has no interest whatever in the destiny of the chased dog: his preoccupation lies only with the human characters—with their "human skin," their "essence as thinking creatures," their "humanity." And, finally, he reiteratedly evokes the dreaded descent into dehumanization: the prisoners were "subhuman, a gang of apes," they were "entrapped in their species," their language being reduced to nothing other than "monkey talk."

It is well known that Levinas is one of the authors who most resolutely attempted to reformulate humanism. He defined his view as a "humanism of the other man [sic]."[19] It is also known that he openly maintained that animals lack that "pure" face that earns human beings full ethical attention.[20] So perhaps his approach cannot be seen as really exemplary of the concentration camp literature. In the light of this, we can consider a recent example of the reflection on the topic that is part of a line of thought including David Rousset's meditations on the "concentrationary universe" and Hannah Arendt's insights on the demise of the "rights of Man" after World War I.

Giorgio Agamben has devoted himself in the past few years to the attempt to formulate a posthumanist approach to the political. Within the framework of his criticism of "biopolitics"—the growing inclusion of natural life in the mechanisms and calculations of power—he has paid particular attention to the concentration camp. Arguing that the camp is the most absolute biopolitical space ever realized, insofar as it is the realm of what he characterizes as "bare life"—life exposed to death, life that may be killed[21]—he thus describes it:

> The camp is merely the place in which the most absolute *conditio inhumana* that has ever existed on earth was realized. . . . Its inhabitants were stripped of every political status and wholly reduced to bare life. . . . The correct question to pose concerning the horrors committed in the camps is . . . not the hypocritical one of how crimes of such atrocity could be committed against human beings. It would be more

honest and, above all, more useful to investigate carefully the juridical procedures and deployments of power by which human beings could be so completely deprived of their rights and prerogatives that no act committed against them could appear any longer as a crime.[22]

It is apparent that, in this context too, what is seen as really shocking is not so much the treatment in itself but rather the specific recipients of it. Not only is the stress on how such crimes could be committed *against human beings*, but a clear reference is made to the denial to such beings of "their rights and prerogatives"—rights and prerogatives that are the ones that distinguish humans from nonhumans, as the emphasis on the "inhumanity" of the condition realized in the camp epitomizes.

True, as it has been observed, sometimes nonhuman beings do feature in Agamben's work on concentration camps.[23] But in which way do they feature? What is the view of animals that emerges, for example, from the casual mention of the image of "human *guinea pigs*" for the subjects of Nazi experiments or from the parallel between the "Muselmann"—the weakest among the inmates, wandering through the camp—and a "stray dog"? Against a background in which the "inhuman condition" is the dreaded final outcome, animals appear within the landscape of the camp in the most traditional way. No connections are made: it never occurs to Agamben that the notion of "bare life" as life deprived of any rights and prerogatives and exposed to death paradigmatically fits the condition of animals in our societies. Nonhumans in themselves are wiped out, only to reappear as pretexts to decry the condition of humans—the production of "the non-man . . . within the man [*sic*]."[24]

II. Critical, But Up To a Point

All the thinkers we have so far considered are male authors—and, for that matter, are somehow traditional in their approach, given that they commonly use the word "man" to refer to human beings. Is it possible that their difficulties with unraveling knots of oppression or

with overcoming prejudice are in some way connected with a "patri-archal" view? Is it possible that, if one moves to the different intel-lectual shores of feminism, the scene changes?

What first comes to mind is ecofeminism[25] and, in particular, within it, the position of the vegetarian-feminist Carol Adams. For Adams has actually developed a critical tool that can shed light on the just-mentioned process of removal/reinstatement of animals within intrahuman discourse—the notion of the "absent referent."[26] The structure of the absent referent is enacted when the treatment of some beings is appropriated as a metaphor for the treatment of other beings. Within such a structure, animals are first made absent and are then reinstated as metaphors for describing experiences of human beings.

It is evident that the notion can be particularly useful in uncover-ing intertwined dynamics of oppression. Unluckily, however, femi-nist theorists on the whole have not appropriated it. All the more so: feminists themselves resort to the mechanism of the absent referent when they assume, for example, the metaphor of butchering—when they say that pornography depicts woman as a "female piece of meat" or when they refer to overcrowded prostitution hotels as *maisons d'abattage* (literally, "houses of slaughter")—without acknowledging the originating oppression of animals that generates the power of the metaphor.[27]

In fact, all the intellectual history of the women's movement is marked by the dissociation from nonhumans. In that sort of first Enlightenment manifesto of the movement that is *A Vindication of the Rights of Woman*, Mary Wollstonecraft, deploring that the compulsive pressure and desire to marry makes "mere animals" of women, takes it to be absurd that "the dignity of the female soul be as disputable as that of animals."[28] At the dawn of modern feminism and in the wake of the existentialist cult of freedom, Simone de Beauvoir declares that women, who in maternity remain closely bound to nature and to their bodies "like animals," demand "not to subordinate existence to life, the human being to its animality."[29] In the 1960s, the second wave of the movement was opened by *The Feminine Mystique*, a book that, in the effort to describe the psychological condition of suburban house-

wives, directly borrowed the notion of dehumanization from the literature on the concentration camps.[30] More recently, leftist feminists like Alison Jaggar not only invoked dehumanization in a historical-materialistic key to refer to the prevalence of egoism in capitalist societies but also lamented that Western civilization has defined women's work "as non-rational, even animal."[31] Finally, the revulsion for the idea of a "reduction to animality"—of the confinement of women "to the cultural level of animal life," of a demotion to the status of "an animal, body, part of a body"—is shared by positions ranging from global attacks on patriarchy such as those by Kate Millet to more focused stances centering on pornography and sexual objectification.[32]

Thus, apart from some voices in the ecofeminist area, what prevails in feminist theory is a negative attitude toward nonhumans and their status. All this obviously rebounds on the attitude of the political movement. While in the animal advocacy press one can find articles lamenting women's indifference for the plight of animals,[33] a recent piece in the feminist publication *Bitch* summarizing the situations presents a discouraging picture, stressing that campaigns to end nonhuman abuse have not succeeded in forging alliances with mainstream women's organizations and that "none of the major feminist organizations in the United States devotes committee or internet space to or has policies dealing with vegetarianism . . . or animal rights issues."[34]

What can explain such a situation? Once again, the pervasive presence of the notion of dehumanization and of the recourse to animals as negative yardsticks in approaches that—being as diverse as the liberal and the existentialist, the socialist and the radical—have different theoretical cores and take different stances on such basic questions as whether women should insist on equality of treatment or on recognition of difference[35] suggests that humanism does play a role here. And what is particularly disappointing is that these very elements feature prominently just in the contested cultural landscape. This is how Adams epitomizes the situation:

> In constructing stories about violence against women, feminists have drawn on the same set of cultural images as their oppressors. . . .
> Feminist theorists take us to the intersection of the oppression of

women and the oppression of animals, and then do an immediate about-face, seizing the function of the absent referent to forward women's issues, and so imitating and complementing a patriarchal structure.[36]

Indeed, with French candor, Simone de Beauvoir had avowed right from the start the key idea behind this attitude, which often remains unarticulated: "The fact that we are human beings is infinitely more important than all the peculiarities that distinguish human beings from one another."[37] Unluckily, the "importance" of this fact has simply been taken for granted, as most often occurs with the effects of cultural imprinting. But aren't such effects just the main hindrances to discourses of enfranchisement?

III. A Flexible Concept of Dignity

If the discourse on discrimination and the camps has involved well-known intellectuals, and if feminist discussions keep causing heated debates, it seems at first sight that another important form of intrahuman advocacy that emerged in the 1960s, the disability rights movement, has for long remained confined to congresses and declarations. The first reason coming to mind is that, unlike discriminated ethnic groups or women, this minority, and in particular the group composed of mentally impaired individuals, to which we shall particularly refer, are not always able to stand up for their rights. In a sense, this makes such a movement particularly interesting, as this latter difficulty is shared with the animal movement.

The situation has somewhat changed with the rise of the interdisciplinary field of disability studies, which has involved academics from all over the world. If there is an author whose work has provided a foundation for the development of the field and who continues to be influential in it, it is Michel Foucault, with his analysis of the institutionalization of health systems. "Insofar as Foucault challenges us to consider our historical and moral distance from the conceptions and practices of the past"—the disability scholar Licia

Carlson states—"his work is as important to cognitive disability as it is to madness"; moreover, since in his writings references to animality tend to organize knowledge about various categories of otherness, Foucault's reflection on madness "can help viewing the history of 'idiocy' as another variation of the same complex, ever-changing relationship between the human and non-human."[38] How, then, do animals feature in Foucault's writings? Since he sees reason as merely one among various human features, one coexisting with different forces generically covered under the notion of "unreason," one might expect that Foucault devotes some attention to the traditional human/animal divide. Not so. Though nonhumans are frequently referred to as examples, reference points, or explanatory notions, and though, when depicting situations in which the insane are imprisoned or disciplined, their plight is often compared to that of animals,[39] nowhere does Foucault show any interest in the predicament of animals per se. In line with the structure of the absent referent, he merely appropriates the animals' condition as a metaphor for the condition of other—that is, human—beings.

This blindness to nonhuman questions proceeds directly from the commitment to the relevance of sheer membership in the species *Homo sapiens*. It seems that wrongs inflicted on humans are not in themselves wrongs. It is only their infliction on *humans* that is wrong. Foucault is exemplary in this respect, for the exclusive focus on humanity marks advocacy for nonparadigmatic humans—be they mentally ill or cognitively disabled—from its beginning in the French Enlightenment[40] down to recent statements such as the 1975 UN "Declaration on the Rights of Disabled Persons," whose Article 3 claims that disabled persons "have the inherent right to respect for their *human dignity*."[41] Such a connection between *humanitas* and dignity brings us back to a point we have considered while discussing Luc Ferry. Kant clearly links dignity with a philosophical notion of humanity, by associating it via rationality with moral freedom: "Morality is the condition under which a rational being can be an end in itself. . . . Hence morality, and humanity insofar as it is capable of morality, is that which alone has dignity."[42] As we know, however, not all humans possess *humanitas* in this sense. Among the impaired, the intellectually

disabled are the paradigm case of this problem. And, if one accepts a humanist framework, they should prima facie be denied equal respect. One might thus suppose that disability advocates would attack such a framework, arguing that, by linking dignity to rationality, it discriminates against merely conscious individuals—beings whose life can go better or worse just as the life of more intellectual beings can. One might also suppose that, in doing this, they would come to terms with the problem of nonhuman beings. Things are not so simple, though.

Faced with the perfectionist side of humanism and haunted by the historical record of derogation of the intellectually impaired through ideological animalization, disability scholars would in fact follow either of two courses. First, they would minimize the problems of the cognitively impaired, including the most severe cases; second, they would challenge the paradigm by defining it "ableist"—not perfectionist—thus confining their challenge to a definite view of *human* subjectivity rather than of subjectivity per se. In both cases, they would avoid any possible association with nonhumans, not so much by rejecting it as by erasing it in a Foucauldian manner.[43]

On the other hand, the desired inclusive result is safeguarded by the more or less implicit appeal to the common *hominitas,* or humanity in the biological sense. Thus, for example, pursuing the first course, Aart Hendriks states that

> whereas it is a truism that able-bodied and disabled persons are, at least to some extent, different from each other, these differences should be neither over- nor underestimated. In fact there are more individual and group characteristics than (dis)abilities that could be used to distinguish people from each other. Each person is unique, but what we share is that we are all human beings.[44]

And, on the other front, Jenny Morris, for instance, thus states her view: "We need an ethics of care which is based on the principle that to deny the human rights of our fellow human beings is to undermine our own humanity. We need an ethics of care which recognizes that anyone—whatever their level of communication or cognitive impairment—can express preferences."[45]

In more philosophical minds, though, the stress on the irrelevance of some dissimilarities or on the relevance of the ability to express preferences cannot fail to evoke the animal question. So, there are a few authors who address it, Peter Byrne among them. Byrne opens by stating that every human being is a person, "on the ground that every human being shares in the nature of humanity, and having that nature suffices for being a person," whatever one's intellectual impairments, and he concludes that, in the light of the humanity that the cognitively disabled share with us, we must treat them as our moral equals. What, then, about nonhumans? After some discussion, Byrne surmises that speciesism is more properly called humanism and that "we ought to be puzzled as to why anyone ever thought that we might improve the lot of animals by attacking humanism." In case this weren't clear enough, he expresses his strong objection to any "easy . . . slide from how we reason about prejudice and oppression in the human case to how we should reason about our conduct towards animals."[46]

In the face of such disappointing—and hardly philosophical—claims, nothing sounds fairer than the rejoinder by the special education professor Christoph Anstötz to the colleagues who, realizing that the so-called typical human qualities are not present in all humans, suggest a new definition of the *humanum*—"human is every being born from a human being."[47] Anstötz remarks:

> Anyone who interprets the idea of equality so as to find the criterion of equality only in membership of the species *Homo sapiens* can include profoundly mentally disabled people in the community of equals. . . . [But] discipline offends against its own principles if its ethical disputes . . . are settled by the arbitrary exclusion of living beings who are sentient and defenseless, too, and whose only "fault" is not to be a member of the species *Homo sapiens*.[48]

IV. Hegel's Long Shadow

In the *Economic and Philosophical Manuscripts*, Marx writes: "The animal is immediately identical with its life activity. . . . Man . . . has

conscious life activity. . . . Conscious life activity directly distinguishes man from animal life activity. It is just because of this that he is a species-being. Or it is only because he is a species-being that he is a conscious being."[49] If one thinks that the *Manuscripts* are among the most philosophical of Marx's writings, this is not a good start. Marx illustrates the alienation of the worker in capitalist society, and, in his discussion, animals are once again the negative term of comparison. And this is both in general, in order to define "man," and in particular, in order to illustrate the specific consequences of the capitalist estrangement of labor: "As a result . . . man (the worker) no longer feels himself to be freely active in any but the animal functions— eating, drinking, procreating . . . and in his human functions, he no longer feels himself to be anything but an animal."[50]

Where does this strong human/animal dichotomy come from, exactly? It has been stressed that Marx's operative notion of species-being, or *Gattungswesen*, directly derives from Feuerbach's idea that human consciousness differs from animal consciousness in that it includes an awareness of the self as being a member of a species.[51] In Marx's words, "man" is a species-being insofar as "he is a being for himself."[52] Hasn't this a familiar ring to it? Here too, clearly, as in so many of Marx's notions, one can detect G. W. F. Hegel's powerful influence. The version of humanism that will shape most Marxist, and more generally leftist, intellectuals is therefore the dull, metaphysical Hegelian one, marked by a real contempt for all that is classified as "merely natural."

It should thus come as no surprise that the nonhuman question is conspicuous by its absence both in the past and in the present mainstream history of the Left. There are a few exceptions, of course, mainly from non-Marxist thinkers.[53] On the whole, however, the tendency is clear: nonhuman enfranchisement is not part of the general enfranchisement that the movement pursues. Animals, apart from being used, as we have seen, as negative benchmarks in defining humanity, are seen as part of a nature that must be "humanized"— that is, appropriated—as paradigmatically exemplified in Marx's claim that all nature is "man's inorganic body," both as a means of life and as the object and the tool of his life activity.[54] And, as a logical

consequence of this approach, they become mere ingredients in the analysis of political economy, so that we find, for example, Vladimir Ilyich Lenin stressing how profitable forms of farming such as "cattle-fattening for beef" do not ensure the people's well-being and nutriment without his devoting a thought to the animals involved.[55]

But it is not only a disregard for animal enfranchisement that one finds in Leftist movements—it is also a declared aversion. In the political sphere, one exemplary instance is offered by an article that appeared some time ago on a British Trotskyist Web site.[56] To a reader who declares herself an animal rights supporter and who protests against an article that attacked "the misanthropic outlook at the heart of animal rights extremism," a contributor to the site scornfully replies, among other things: that socialists concentrate on the suffering of humans and not of animals; that the ethical outlook emphasizing equality with animals is "the outlook of a disoriented and backward-looking section of the middle class that has lost all confidence in the mass of the human population"; that to pay attention to animals is to divert attention from warmongering and the destruction of welfare measures; and that "when the working class begins to develop its own political standpoint again . . . the backward, non-scientific and—yes—misanthropic nostrums of the animal rights movement will be swept to the political margins where they belongs [sic]."

Analogous examples of hostility can be detected at the theoretical level, and they are so common that they can easily involve philosophers whose very views are anathema to the Trotskyist strand of thought, such as Slavoj Žižek. Considered by some to be the most important theorist on the left today, Žižek has recently tackled the issue of animal rights. And, from a perspective allegedly interested in imbalances of power, he has openly criticized any "leveling [of] the animal/human divide," deliberately debasing the very idea of animal rights by equating it with the idea of a world in which individuals use reason only in order "to assert their individual interests [and] to manipulate others."[57] This, however, does not come unexpected. For, in the context of an attack on those who refer the awareness of one's mortality to the animal dimension of human beings, Žižek unearthed his actual stance regarding animals:

There is nothing "animal" about finitude and mortality—only "conscious" beings are actually finite and mortal, that is, only they relate to their finitude "as such." Awareness of one's own mortality is not one among many aspects of self-awareness, but its very zero-level: in an analogy to Kant's notion that each consciousness of an object involves self-consciousness, each awareness involves an implicit (self-) awareness of one's own mortality and finitude.[58]

Does this perhaps mean that Žižek sees nonhumans as unconscious beings? Be it as it may, what he offers in these few words is a perspective that, by conveying the conventional Kantian strand once again under Hegel's long shadow—witness the refusal of death to animals—well epitomizes the radically humanistic bent of Leftist movements.[59]

CHALLENGING CHARTISM

In view of all this, it seems that, despite the acknowledged importance of building alliances, it is not an easy matter for a movement that does not advocate reform but full animal enfranchisement to find fellow travelers among the existing intrahuman movements. To this conclusion, it might be objected that, though the instances considered here are comprehensive, they are certainly not exhaustive. Aren't we generalizing beyond the data, thus making the mistake highlighted by Karl Popper's famous dictum that no number of white swans can prove that black swans don't exist? Arguably not, and for the reason that, in order to refute the conclusions reached, it is not enough to point out single counterexamples—something that has been done here as well—but it is also necessary to adduce a list of contrary occurrences at least superior to the one presented. This is, indeed, a hopeless enterprise.

There is, moreover, a deeper reply to this objection. What has been attempted here is a preliminary outline of a critical survey aiming at uncovering the basis of the difficulties in question. This means that, beyond any possible list of examples, the attention has

been focused on the underlying, common conceptual structure—a structure whose origin has been traced to the humanist doctrine. It has been argued, that is, that not only is this doctrine clearly recognizable as a unifying factor but also that it can explain a particular feature that wasn't present in the centuries preceding its appearance, in which nonetheless nonhuman beings were commonly killed and exploited. Such a feature, through a closer study of which light could be thrown on problems such as that of the alleged zoophily of elitist, antiegalitarian, and even racist movements, has to do with what we have called the "disavowed underside" of humanism—with the fact that humanism was born, among other things, out of the determination to distance and debase animals. Since this determination is fundamental to the doctrine, to depart from it means to betray the doctrine as seriously as it would happen in case of the demotion of some human beings. In other words, any yielding to the very idea of animal equality is seen as a disavowal of the common ties of humanity. As Stanley Cavell bluntly puts it: "Now I find that, in response to reminders of the company we may keep with nonhuman animals . . . what I would like to say is simply, 'I am human.'"[60] Seen in this light, humanism has all the characteristics of an ideology. For, as it has aptly been epitomized, an ideology is a belief system that legitimates and inspires prejudice and discrimination; it is a set of widely held, socially shared beliefs that results from and supports oppressive social arrangements.[61]

Is there any possibility of overcoming this powerful hindrance not merely to social change but also to alliances in view of social change? As far as the movement advocating a radical alteration of the present ethicopolitical status of animals is concerned, what is needed is the construction of a theory and a practice that may autonomously challenge the humanistic intellectual and social paradigm and the way we conceive of the political in general; only subsequently will alliances become viable or at least conceivable. As for the intrahuman advocacy groups, on the other hand, it is worth reminding them of an argument that Harriet Taylor and John Stuart Mill addressed to those Chartists who claimed universal suffrage as their inherent right while dismissing the women's request for equality: to declare

that something is a general right and demand it only for the part to which the claimants themselves belong is to renounce even the appearance of principle. Taylor and Mill's conclusion is that "the Chartist who denies the suffrage to women is a Chartist only because he is not a lord; he is one of those levelers who would level only down to themselves."[62] A fortiori, this argument holds for the intrahuman movements in question. For not only do they not cooperate in the struggle to liberate those beings who are at the end of the chain of exploitation—they also actually, and constantly, participate in their exploitation.

NOTES

1. The animal welfare movement is often also defined as the "humane movement." I do not use this phrase here to avoid confusion with the meaning(s) of the term "humane" as employed in the title of this book.

2. Naomi Klein, *No Logo: Taking Aim at the Brand Bullies* (New York: Picador, 2000).

3. Vandana Shiva, "Earth Democracy, Living Democracy," *Combat Law* 1, no. 5.1 (December–January 2003).

4. Universal Declaration of the Rights of Animals, http://jainsamaj.org /literature/universal-301002.htm.

5. See Peter Fleming and André Spicer, *Contesting the Corporation: Struggle, Power, and Resistance in Organizations* (Cambridge: Cambridge University Press, 2007), 1–9.

6. The notion of "moral extensionism" has been developed in environmental ethics to refer to the broadening of the class of entities that deserve (full) moral consideration.

7. E.g., in his defense of the species barrier, Robert Nozick clearly champions a version of humanism, just as John Rawls does when he states that, unlike "human beings as moral persons," animals are not owed duties of justice. Recently, however, Roger Scruton defended a form of humanism "devoted to exalting the human person above the human animal"; see Roger Scruton, "The New Humanism," *The American Spectator* (March 2009).

8. See, for a summary, Luc Ferry, "Sur les droits de l'homme," lecture delivered on April 21, 2008, at the Institut français de Prague, www.france.cz/IMG/doc _retranscription-2.doc. Ferry also defends "humanism" with reference to deconstructionist attacks on the "metaphysics of subjectivity" in recent philosophy, but this is quite another matter. See Luc Ferry and Alain Renaut, *French Philosophy of the Sixties: An Essay on Antihumanism* (Amherst: University of Massachusetts Press, 1990).

9. For the distinction between *humanitas* and *hominitas*, see Raymond Corbey, *The Metaphysics of Apes: Negotiating the Animal-Human Boundary* (New York: Cambridge University Press, 2005), 94.

10. See on this Paola Cavalieri, Luc Ferry, Marie-Angèle Hermitte, and Joëlle Proust, "Droits de l'homme, droits du singe, droits de l'animal," *Le débat* 108 (2000): 155–192. For a brilliant posthumanist critique of Ferry's positions, see Cary Wolfe, *Animal Rites: American Culture, the Discourse of Species, and Posthumanist Theory* (Chicago: University of Chicago Press, 2003), 21–45.

11. Luc Ferry, *Apprendre à vivre* (Paris: Plon, 2006), chap. 6, sect. 2.

12. The phrase is Žižekian: see Slavoj Žižek, *Violence* (New York: Picador, 2008), 168.

13. John Rodman, "Animal Justice: The Counter-Revolution in Natural Right and Law," *Inquiry* 22 (1979): 3.

14. Mary Midgley, *Animals and Why They Matter* (Athens: University of Georgia Press, 1983), 67.

15. The provisos "usually" and "almost" are in order because "dehumanization" can also involve denying one mere consciousness—in which case, however, "reification" would be a better definition. See Nick Haslam, "Dehumanization: An Integrative Review," *Personality and Social Psychology Review* 10, no. 3 (2006): 252–264.

16. Primo Levi, "Interview with Daniel Toaff," *Sorgente di Vita*, Radiotelevisione Italiana (April 25, 1983).

17. See, e.g., David Corn, "The Slaughterhouse Province: An American Diplomat's Report on the Armenian Genocide, 1915–1917," *The Nation* (May 28, 1990); or David Rieff, *Slaughterhouse: Bosnia and the Failure of the West* (London: Touchstone, 1996).

18. Emmanuel Levinas, *Difficult Freedom* (Baltimore, Md.: The Johns Hopkins University Press, 1990), 152–153.

19. Emmanuel Levinas, "Humanism of the Other Man," in *Collected Philosophical Papers* (Dordrecht: Martinus Nijhoff, 1987).

20. Emmanuel Levinas, "The Paradox of Morality," in *The Provocation of Levinas: Rethinking the Other*, ed. Robert Bernasconi and David Wood (London: Routledge, 1988), 169, 172.

21. Giorgio Agamben, *Homo Sacer: Sovereign Power and Bare Life* (Stanford, Calif.: Meridian, 1998), 88, 142.

22. Ibid., 166, 171.

23. See Matthew Calarco, "Jamming the Anthropological Machine," in *Giorgio Agamben: Sovereignty and Life*, ed. Matthew Calarco and Steven DeCaroli (Stanford, Calif.: Stanford University Press, 2007), 165.

24. Agamben, *Homo Sacer*, 109, 154, 157; Giorgio Agamben, *Remnants of Auschwitz: The Witness and the Archive* (New York: Zone Books, 2002), 171; and Giorgio

Agamben, *The Open: Man and Animal* (Stanford, Calif.: Stanford University Press, 2004), 37. For radically different perspectives, see Charles Patterson, *Eternal Treblinka: Our Treatment of Animals and the Holocaust* (New York: Lantern Books, 2002); and John M. Coetzee, *The Lives of Animals*, ed. and intro. Amy Gutman (Princeton, N.J.: Princeton University Press, 1999).

25. The strand runs from Andrée Collard's pioneering work to Marti Kheel's recent reflection. See Andrée Collard with Joyce Contrucci, *Rape of the Wild: Man's Violence Against Animals and the Earth* (Bloomington: Indiana University Press, 1989); Marti Kheel, *Nature Ethics: An Ecofeminist Perspective* (Lanham, Md.: Rowman & Littlefield, 2008).

26. Carol J. Adams, *The Sexual Politics of Meat: A Feminist-Vegetarian Critical Theory* (New York: Continuum, 1990), 40–46.

27. Ibid., 57.

28. Mary Wollstonecraft, *A Vindication of the Rights of Woman* (NuVision Publications LLC, 2007), 15, 50.

29. Simone de Beauvoir, *The Second Sex* (New York: Vintage Books, 1989), 64–65.

30. Betty Friedan, *The Feminine Mystique* (New York: W. W. Norton & Company, 2001 [1963]), 103.

31. Alison Jaggar, *Feminist Politics and Human Nature* (Totowa, N.J.: Rowman & Allanheld, 1983), 187, 197.

32. For the reference to the cultural level of animal life, see Kate Millet, *Sexual Politics* (New York: Doubleday, 1970), 119. For the reference to the status of an animal, see Linda LeMoncheck, *Dehumanizing Women: Treating Persons as Sex Objects* (Totowa, N.J.: Rowman & Allanheld, 1985), 29–30.

33. See, e.g., the activist Melinda Fox complaining about the fact that "at every pro-choice event, intelligent, courageous, thoughtful women surrounded [her] consuming and wearing animals"; Melinda Fox, "Speciesist Feminism," *Satya* (January 2005), http://www.satyamag.com/jan05/edit.html.

34. Aimée Dowl, "Raising the Flag for Feminist Vegetarianism," *Bitch* (Winter 2007).

35. On the centrality of this debate, see, e.g., Judith Evans, *Feminist Theory Today* (London: Sage, 1995).

36. Adams, *The Sexual Politics of Meat*, 60.

37. De Beauvoir, *The Second Sex*, 728.

38. Licia Carlson, "The Human as Just an Other Animal: Madness, Disability, and Foucault's Bestiary," in *Phenomenology and the Non-Human Animal*, ed. Corinne Painter and Christian Lotz (Dordrecht: Springer Verlag, 2007), 117–133.

39. See, for example, Michel Foucault, *Madness and Civilization: A History of Insanity*

in the Age of Reason (New York: Vintage Books, 1988), 70, 71, 74, 81, 236, and passim. For a discussion, see Paola Cavalieri, "A Missed Opportunity: Humanism, Antihumanism, and the Animal Question," in *Animal Subjects: An Ethical Reader in a Posthuman World*, ed. Jodey Castricano (Waterloo, Ont.: Wilfrid Laurier University Press, 2008), 98–102.

40. See, e.g., how Doctor Philippe Pinel, who first started a rethinking of the treatment of the "madman," created a connection between their mistreatment and a lack of respect for "the rights of man"; Philippe Pinel M.D., Physician of the Infirmaries, Bicêtre Hospice, Seine Department, "Memoir on Madness: A Contribution to the Natural History of Man" (December 11, 1794), www.pharmore.nl/userFiles /page/Memoir_on_Madness.Ph.Pinel.1794.pdf.

41. "Declaration on the Rights of Disabled Persons," Proclaimed by General Assembly resolution 3447 XXX of December 9, 1975, http://www2.ohchr .org/english/law/res3447.htm.

42. Immanuel Kant, *Groundwork of the Metaphysics of Morals* (Cambridge: Cambridge University Press, 1998), 42–43.

43. With a few exceptions. For example, the disability scholar Nora Groce, in a letter to the *New York Times* written with anthropologist Jonathan Marks, strongly attacks the recent demand to extend human rights to the great apes for seeking "to blur the boundary between apes and people by dehumanizing those for whom human rights are often the most precarious." See Jonathan Marks and Nora Ellen Groce, "Don't Slight Disabled for Animal Rights' Sake," letter to the editor, *New York Times* (February 18, 1997). For a global attack on perfectionism, see Paola Cavalieri, *The Death of the Animal: A Dialogue* (New York: Columbia University Press, 2009), with commentaries by Matthew Calarco, John M. Coetzee, Harlan B. Miller, and Cary Wolfe.

44. Aart Hendriks, "The Significance of Equality and Nondiscrimination for the Protection of the Rights and Dignity of Disabled Persons," in *Human Rights and Disabled Persons*, ed. Theresia Degener and Yolan Koster-Dreese (Dordrecht: Martinus Nijhoff, 1995), 40–62, 43.

45. Jenny Morris, "Impairment and Disability: Constructing an Ethics of Care Which Promotes Human Rights," *Hypatia* 16, no. 4 (Fall 2001): 1–16.

46. Peter Byrne, *Philosophical and Ethical Problems in Mental Handicap* (New York: St. Martin's Press, 2000), 50, 49, 53–54.

47. Curiously enough, in the context of a survey of the moral status of disabled people that unoriginally attacks the intellectual bias only with reference to human beings, Simo Vehmas claims that while disability studies problematize society rather than the individual, the discipline of special education for the disabled, by "viewing disability as a problem instead of an issue," is more conservative in

character. See Simo Vehmas, *Deviance, Difference, and Human Variety: The Moral Significance of Disability in Modern Bioethics* (Publications of the University of Turku, Annales Universitatis Turkuensis, B: 250, Turku 2002), 11.

48. Christoph Anstötz, "Profoundly Intellectually Disabled Humans and the Great Apes: A Comparison," in *The Great Ape Project: Equality Beyond Humanity*, ed. Paola Cavalieri and Peter Singer (New York: St. Martin's Press, 1994), 159–172.

49. Karl Marx, *Economic and Philosophical Manuscripts of 1844 and the Communist Manifesto* (Amherst, N.Y.: Prometheus Books, 1988), 76.

50. Ibid., 74.

51. See, among others, Joseph O'Malley, "Editor's Introduction," in Karl Marx, *Critique of Hegel's "Philosophy of Right"* (New York: Cambridge University Press, 1970).

52. Marx, *Economic and Philosophical Manuscripts*, 155.

53. The most famous one is Horkheimer and Adorno's well-known attack on anthropocentrism in the essay "Man and Animal," in the *Dialectic of Enlightenment*; see Theodor Adorno and Max Horkheimer, *Dialectic of Enlightenment* (London: Verso, 1979), 245–255. Also interesting is the short text in which Rosa Luxembourg, after seeing an abused buffalo, seems to radically overcome the species barrier; see Rosa Luxemburg, "Letter to Sonja Liebknecht" (mid-December 1917), http://www.marxists.org/archive/luxemburg/1917/undated/03.htm.

54. Marx, *Economic and Philosophical Manuscripts*, 76.

55. Vladimir Ilyich Lenin, *The Development of Capitalism in Russia* (La Vergne, Tenn.: University Press of the Pacific, 2004), chap. 4, sect. 3, note 1, http://www.marxists.org/archive/lenin/works/1899/devel/index.htm#Chapter4.

56. http://www.wsws.org/articles/2004/sep2004/corr-s14.shtml.

57. Slavoj Žižek, "The Prospects of Radical Politics Today," *International Journal of Baudrillard Studies* 5, no. 1 (January 2008), http://www.ubishops.ca/baudrillard studies/vol5_1/v5-1-article3-zizek.html. For a reply, see Paola Cavalieri and Peter Singer, "On Žižek and Animals," *International Journal of Baudrillard Studies* 6, no. 1 (January 2009), http://www.ubishops.ca/BaudrillardStudies/vol-6_1/v6-1-Singer-cavalieri.html.

58. Slavoj Žižek, "Da Capo senza Fine," in Judith Butler, Ernesto Laclau, and Slavoj Žižek, *Contingency, Hegemony, Universality: Contemporary Dialogues on the Left* (London: Verso, 2000), 256.

59. Georg Wilhelm Friedrich Hegel, *Aesthetics: Lectures on Fine Art* (Oxford: Clarendon Press, 1975), 1:349. Actually, the presence of the phrase "as such" also reminds one of Heidegger's view—a view that is not considered here because of the controversies surrounding Heidegger's position with respect to humanism; see on this Matthew Calarco, *Zoographies: The Question of the Animal from Heidegger to Derrida* (New York: Columbia University Press, 2008), 15–54.

60. Stanley Cavell, "Companionable Thinking," in *Wittgenstein and the Moral Life*, ed. Alice Crary (Cambridge, Mass: The MIT Press, 2007), 295–296.

61. See David Nibert, *Animal Rights—Human Rights: Entanglements of Oppression and Liberation* (Lanham, Md.: Rowman & Littlefield, 2002), 10, 17.

62. John Stuart Mill, "The Enfranchisement of Women," in *On Liberty and Other Essays* (Oxford: Oxford University Press, 1998).

4

Archaeology of a Humane Society

Animality, Savagery, Blackness

Michael Lundblad

In his conclusion to *The Descent of Man, and Selection in Relation to Sex* (1871), Charles Darwin addresses the idea of descending from "savages." Darwin first acknowledges that his "main conclusion"—"that man is descended from some lowly organized form"—might be "highly distasteful to many."[1] But he argues that all humans, including "savages," as well as nonhuman animals, have descended from a common "lowly origin" that predates the evolution of humanity.[2] According to Darwin, the "rank of manhood" was "attained" before humans "diverged into distinct races, or as they may be more fitly called, subspecies."[3] But he also suggests that contemporary "barbarians" are similar to the primitive ancestors common to all human beings. He proclaims that "there can hardly be a doubt that we are descended from barbarians" and then recalls his "reflection," upon "first seeing a party of Feugians on a wild and broken shore," that "such were our ancestors."[4] In a move apparently designed to appease the racist sensibilities of his audience, though, Darwin suggests that it might be easier to imagine being a descendent of an animal than a "savage": "For my own part, I would as soon be descended from that heroic

little monkey . . . or from that old baboon . . . as from a savage who delights to torture his enemies, offers up bloody sacrifices, practices infanticide without remorse, treats his wives like slaves, knows no decency, and is haunted by the grossest superstitions."[5] Regardless of the "main conclusion" of *The Descent of Man*, this passage suggests a racist conflation of contemporary "savages" with "barbarian" ancestors that would have been common to all human beings.[6]

This kind of move is echoed in the first paragraph of Sigmund Freud's *Totem and Taboo* (1913):

> Prehistoric man . . . in a certain sense . . . is still our contemporary. There are men still living who, as we believe, stand very near to primitive man, far nearer than we do, and whom we therefore regard as his direct heirs and representatives. Such is our view of those whom we describe as savages or half-savages; and their mental life must have a peculiar interest for us if we are right in seeing in it a well-preserved picture of an early stage of our own development.[7]

Between Darwin and Freud, though, after the end of the "peculiar institution" of slavery in the United States, dominant discourses attempted to sidestep this evolutionary narrative, suggesting instead that white men could indeed be linked more closely with "the animal" than "the savage" in terms of both "animal instincts" and common animal ancestors. A related—but less explored—move to distinguish between "civilized" white men and "savage" black men was to focus specifically on the treatment of "real" animals. Rather than delighting in torture, the civilized man could supposedly be identified by the capacity for treating not just humans but also animals "humanely." This new discourse can be seen, for example, in a letter by William James to the *Nation* on June 29, 1876: "Among the many good qualities of our 'Anglo-Saxon' race, its sympathy with the feelings of brute animals deserves an honorable mention."[8] The discourse of humane reform was born at the same moment that constructions of black men were also shifting, and, more specifically, while an explosion of lynchings was being justified by the myth of the black male rapist, which linked an assault on white womanhood with a savage delight

in torture. Humane reform actually became a new and flexible discourse for claiming superiority over various human "races," reinforcing the logic that only the more "civilized" group had evolved enough to treat other groups "humanely."

My purpose in this chapter is to explore this complex and even mutually constitutive relationship between humane reform and U.S. race relations at the end of the nineteenth century. At the same time that black men were hoping to distance themselves from racist constructions of their animality, white men became more interested in getting in touch with their own "animal instincts" and promoting the humane treatment of "real" animals.[9] The myth of the black male rapist is often assumed to be based upon the black man's "animal instinct" for sex, but I will illustrate how the rape of a white woman by a black man was often constructed as more savage than animal in nature. Savagery became a label not only for the behavior of black rapists, though, but also for the behavior of other groups, in cases such as Northerners condemning Southern lynch mobs, men like William James condescending to white men of the lower classes, or even African Americans condemning white lynchers. The discourse of humane reform defined itself against savagery of various kinds, resulting in a "humane society" broadly conceived that was capable of associating whiteness more with animality than savagery and elevating the animal in new and problematic ways.[10]

BIRTH OF A HUMANE SOCIETY

The imperative to treat human beings or animals more "humanely" is actually a relatively recent historical development in the United States. While the word "humane" is older, the logic of humane reform shifted significantly and became more pervasive at the end of the nineteenth century. Previously, the overarching logic tended to be one of Christian duty toward (certain) helpless creatures rather than humane behavior as a way to define the human—as opposed to the animal—in evolutionary terms. The U.S. animal welfare movement grew out of anticruelty statutes that were first enacted in England

toward the beginning of the nineteenth century. In 1822, for example, "An Act to Prevent the Cruel and Improper Treatment of Cattle" was introduced by Col. Richard Martin, an Irish Protestant from Galway, who was nicknamed "Humanity Dick." Once the bill passed Parliament, it became known as "Martin's Act" and led to the founding of the Society for the Prevention of Cruelty to Animals in 1824, which was granted police powers to enforce the law.[11] With Queen Victoria and the Duchess of Kent as lady patronesses, the Society became "Royal" in 1840, and it grew as a club for white noblemen and gentlemen concerned mostly with domestic animals, rather than such species as the fox, which many of them continued to hunt.[12]

The American Society for the Prevention of Cruelty to Animals was founded in 1866, with an emphasis on domestic animals and situated within a Christian framework. According to Henry Bergh, the founder and first president of the ASPCA, for example, "it is a solemn recognition of that greatest attribute of the Almighty Ruler of the Universe, mercy, which if suspended in our own case but for a single instant, would overwhelm and destroy us."[13] In the United States, various SPCAs were established on a state-by-state basis, along with a range of state laws enacted to protect against cruelty to domestic animals. The ASPCA was in effect the SPCA of New York, rather than an umbrella or national organization. The Massachusetts SPCA soon became one of the most prominent early SPCAs, founded by George T. Angell of Boston in 1868. In Angell's view, writing in 1864, the purpose of giving money to "Sabbath schools or other schools" should be "to impress upon the minds of youth their duty towards those domestic animals which God may make dependent upon them."[14] John G. Shortall, as president of the Illinois SPCA, branched off in 1877 to form the American Humane Association, with early attention focused on the transport and slaughter of cattle, but various state organizations directed toward the "humane" treatment of both children and animals were not necessarily affiliated with the AHA.[15] According to Sydney Coleman's 1924 history of the organization, the 1886 AHA convention included a mission statement that sought "to remedy universal cruelties by universal remedies, to foster a national recognition of the duties we owe to

those who are helpless,"[16] and the advocacy of the AHA was directed toward "millions of suffering brutes which cannot speak for themselves."[17] The initiatives were often explicitly Christian, including the creation of what was called "Humane Sunday," in which "thousands of pulpits proclaim the duty of humanity."[18] Other organizations founded in the 1880s included the American Antivivisection Society in 1883 and the first Audubon Society in 1886. I will turn to William James's thoughts about vivisection in particular—as they relate to lynching—toward the end of this chapter.

The first usage of "humanitarian" also indicates Christian roots. In 1819, a "humanitarian" was "one who affirms the humanity (but denies the divinity) of Christ."[19] It could also signify, by 1831, "one who professes the 'Religion of Humanity,' holding that mankind's duty is chiefly or wholly comprised in the advancement of the welfare of the human race."[20] But the connotations outside of theological discourse were usually negative, such as, by 1844, "one who advocates or practises humanity or humane action; one who devotes himself to the welfare of mankind at large; a philanthropist. Nearly always *contemptuous*, connoting one who goes to excess in his humane principles."[21] According to Webster's Dictionary, in 1878, a humanitarian was "one who holds that Christ was merely a man."[22] By 1911, Webster's definition had shifted to include "a philanthropist; an anti-Trinitarian; one who believes that the duty of man consists of acting rightly to others; a perfectionist."[23] The OED does not register the later shift toward more positive connotations of this term, but it does indicate that by 1904 the word "humane" could be "applied to certain weapons or implements which inflict less pain than others of their kind, *spec.* applied to an implement for the painless slaughtering of cattle."[24]

While many humane organizations in the United States were established in the 1860s, it was not until the turn of the century that what might be loosely called the "humane movement" flourished and shifted away from an explicitly Christian logic. In the first three years after the founding of the ASPCA in 1866, for example, only a half-dozen or so state SPCAs were incorporated. But by December 1907, there were 246 societies nationwide, including some organizations advocating for children as well, while the American Humane

Association claimed that 543 associations had been formed.[25] At the turn of the century, intensive pressure was mounted, for example, on behalf of enforcing the "twenty-eight-hour law," which required that transported livestock be given food, water, and rest every twenty-eight hours—a law that had been only sporadically enforced since it took effect in 1873. In addition, anticruelty statutes finally made it on the books in every state of the union by 1907.[26] Organizations under a variety of auspices that responded to a Columbia University study by Roswell C. McCrea furnished enough data to suggest that by 1909, with 348 societies reporting, memberships totaled 64,879, and combined budgets exceeded one million dollars.[27] Much of the roughly $350,000 in contributions was the result of membership dues, while close to $200,000 came from endowments, together suggesting the class (and presumably race) of most members. Subsidies from state and local governments amounted to close to $250,000, and the amount collected from fines was just over $50,000, the result of over 28,000 convictions.[28] According to McCrea, the majority of the SPCAs acted as "private corporations, exercising delegated police powers," with members granted "powers as peace officers" and "special powers of arrest."[29] Most of this work was directed toward abuses of workhorses in urban areas, cruelty and neglect toward domestic pets, and practices of fighting or baiting animals such as cocks and dogs. Exceptions included the "carnivorous appetite, the extension of science, the providing of exercise for an idle class"; thus meat eating, vivisection, and sport hunting, at least for many of the SPCAs, were seen as "weighty enough to justify exceptions in the law of the land."[30] But McCrea noted a general shift in public sentiment by 1910: "conditions have undergone marked change since the earlier days of anti-cruelty work. The grosser forms of cruelty are now exceptional. When they do occur, perpetrators speedily encounter a hostile public attitude."[31]

While a sense of Christian duty persists, what is significant to note is the appropriated logic of evolutionary theory at the turn of the century. Once evolutionary thinking challenges the boundaries between the human and the animal, humane behavior apparently becomes a new way to define what it means to be human: to restrain

one's animal instincts. In a bulletin put out by the State Normal School of San Diego in 1906, the issue of "rights" is qualified by the "law of nature": "The only right anything possesses is the right to be useful. All living beings must subserve some beneficial purpose or finally be eliminated in the process of evolution. In the long run, the weak, the useless, and the harmful must perish. This is the inevitable law of nature."[32] Humans may be at the top of the food chain, as well as God's creation, but there is need for restraint. "To whose benefit is the world of nature finally to contribute? There can be but one answer. Man, standing at the head of the hierarchy of animal species, rightfully claims sovereignty over this great kingdom. . . . The rule of nature is that the lower generally serve the ends of the higher."[33] But distinctions can be difficult, since "a study of biology shows such infinitesimal gaps between species, and even between the higher anthropoids and man, [so] that no one dares positively to declare where the one ends and the other begins."[34] Darwinist constructions of the human led to what Marlon Ross has identified as "a hierarchy of races relatively fixed in their relation to each other, but each moving forward at its own pace toward greater civilization, although 'primitive races' were sometimes seen as static, forever left behind in this quick race toward perfected culture."[35] This "race of races" could be used within a certain racist logic to justify the exploitation and oppression of African Americans by a white race that was supposedly more "fit." But a deeper concern, for some, was the implication that black and white Americans were only infinitesimally different, either in terms of both descending from common animal ancestors or in that "civilized" men were actually looking at earlier, more primitive versions of themselves when they looked at black men.

The relationship between cruelty and evolution could lead to constructions of a new kind of hierarchy: *some* human beings have supposedly evolved enough to be "humane" not only toward animals but also toward other human beings. The door was thus opened for claiming humane behavior as a marker of difference *among* human beings: a marker that soon became crucial in terms of U.S. race relations. A "civilized" society, supposedly, would not delight in the *in*humane treatment of either human or nonhuman animals. The

logic of humane reform could then be extended to a broader societal level, including questions such as how a "civilized" society should treat its criminals and other populations. But it is clear that the evolution of a humane society in the United States does not necessarily result in better treatment of black men, in particular. Instead, it could be used to justify apparent reforms directed toward black prisoners, for example, that frequently ended up treating them worse than before. It is also clear that the "correctional" system of the South—and increasing numbers of black men thus controlled—became a way to police black freedmen and compensate for the loss of slave labor after the Civil War.[36]

Two examples of humane penal reform in the South illustrate how this logic could perpetuate rather than eliminate racist differences in how criminals were treated. First, the opening of state-controlled plantations to function as penitentiaries in Mississippi and Louisiana was justified, according to Mississippi Governor James K. Vardaman, "as both a *humane* and sensible response to Negro crime."[37] As David Oshinsky notes in *"Worse Than Slavery": Parchman Farm and the Ordeal of Jim Crow Justice* (1996), Mississippi's twenty-thousand acre Parchman Farm, which opened as a state penitentiary in 1904, was virtually indistinguishable from a slave plantation. In the first year of its existence, it produced a profit of $185,000 from the sale of cotton, other crops, and livestock.[38] Mississippi was not alone in its construction of a state plantation—Angola in Louisiana functioned similarly—or in its continued use of corporal punishment among convicts. According to Oshinsky, most states outside the South had abolished corporal punishment by 1900, but Arkansas, Texas, Florida, and Louisiana routinely whipped convicts "without serious public opposition. It was part of the regional culture, and most prisoners were black."[39] Mississippi was one of the last states to abolish public executions, and the line between mob lynchings and legal executions was often exceedingly narrow well into the 1930s.[40] While public executions eventually disappeared, plantations such as Parchman and Angola continue to function as working farms up to this day. The point I want to stress here is that working on a plantation-penitentiary was

to resume in the form of police brutality now?

touted as a "humane" alternative to incarceration at the turn of the century: better for the health of the convict, supposedly, than rotting away in jail.

The second example of "humane" penal reform that perpetuates racist cruelties follows similar logic, arguing that convict labor on state-controlled chain gangs provided better alternatives for prisoners. In *Twice the Work of Free Labor: The Political Economy of Convict Labor in the New South* (1995), Alex Lichtenstein reveals how building roads was touted by some as "humanitarian and rehabilitatory" because of the nature of the outdoor work—the virtues of "the strenuous life" valorized by "progressives" like Teddy Roosevelt.[41] Under the previous system of leasing convicts to private companies, daily whippings served as punishment for convicts who failed to complete their assigned "task" for the day. The tasks, which were often deliberately impossible to complete, contributed directly to the profits of private individuals involved in such industries as the extraction of coal or turpentine or the construction of railroads or bricks.[42] Complaints about abuses of privately leased convicts with no state oversight resulted in protests at the turn of the century; one writer in August 1908 objected to "punishments, abuses, and suffering . . . inflicted upon the convicts which were unjustified, unmerciful, cruel and *inhuman*."[43] Yet the protests were directed mostly toward the few white inmates, and the shift from the convict lease system to the state-controlled chain gang simply changed who was doing the whipping of the largely black convict populations. In addition, "even after the transition from the convict lease to the chain gang, investigators and convicts complained about poor food and sanitation, relentless labor, and brutal punishment in the state's isolated road camps."[44] The actual treatment of convicts hardly became more "humane" in the South, in other words, after the shift to state-controlled convict labor on the chain gang at the turn of the century. But the discourse of humane reform could be used in a variety of ways. Southerners might continue to defend chain gangs as more humane than other forms of incarceration, for example, while Northerners could condemn chain gangs as inherently inhumane, thus using humane discourse to claim

superiority over Southerners in relation to the treatment of prisoners generally and black men more specifically.

Excusing the Animal

The birth of a humane society in the United States also raised questions about whether all human beings were similarly driven by "animal instincts" and how those instincts might relate to culpability for various crimes. Concurrent with the rise of the humane movement at the turn of the century was the rise of "heat of passion" defenses in juridical discourses that essentially excused—or at least mitigated—crimes understood as the acting out of one's animal instincts. The racial implications of these new discourses are complex, and there are distinctions to be made between state-sanctioned punishments and extralegal lynchings of black men in particular at the end of the nineteenth century. But it also becomes clear that a black man's animality is not often seen as a mitigating factor for the alleged crime of raping a white woman. From this perspective, we can begin to see how the question of instincts could be used to distinguish between white and black men: a question that could be related to the formulation of "the savage" in Freud, in which "primitive men," who are not quite animals, can supposedly be distinguished from civilized (white) men by the lack of the ability to discipline themselves.

Foucault's *Discipline and Punish: The Birth of the Prison* (1977) is useful for tracing a relevant history of European penal reform that increases attention to the motivations or mental state of the criminal, leading to more self-policing than corporal punishment, in the context of what appears to be more humane methods of incarceration. But it doesn't pay enough attention to the shifting discourses I've traced thus far in the United States, particularly at the end of the nineteenth century, or to differences between white and black criminals. According to Foucault, for white men in France at least, "at the beginning of the nineteenth century . . . the great spectacle of physical punishment disappeared; the tortured body was avoided; the theatrical representation of pain was excluded from punishment."[45] Rather

than a simple shift toward "less cruelty, less pain, more kindness, more respect, more 'humanity,'" though, there was a more significant shift in objective: "The expiation that once rained down upon the body must be replaced by a punishment that acts in depth on the heart, the thoughts, the will, the inclinations."[46] In this way, the power of the state is expanded to judge not just acts but also motivations: "Certainly the 'crimes' and 'offenses' on which judgment is passed are juridical objects defined by the code, but judgment is also passed on the passions, instincts, anomalies, infirmities, maladjustments, effects of environment or heredity."[47] These "shadows lurking behind the case" are "judged indirectly as 'attenuating circumstances.'"[48] What Foucault breezes past, though, is the difference between "passions" or "instincts" at the beginning of the nineteenth century and the signification of these terms once the discourse of animality has shifted toward Darwinist-Freudian formulations at the beginning of the twentieth century.[49]

According to Freud in *Totem and Taboo*, human beings can be distinguished from animals by their ability to repress—or police—their instincts, but "savages" seem to be stuck somewhere between animality and civilization. In Freud's fantasy about the origins of civilization, brothers band together in the primal horde and act upon the oedipal impulses that define humanity; they kill the primal father, eat him, regret it, and subsequently establish a prohibition against killing the father by equating him with a totem animal who can only be killed and mourned ritually. Similarly, the incestuous desire for the mother is renounced and subsequently prohibited as the taboo against incest (SE 13:141–142). Freud's primal horde builds upon Darwin's thinking about ancestral animals, but Freud claims the oedipal impulse (as it leads to totemism and the incest taboo) as the defining characteristic of the human. The implication from Freud, though, is that white civilization developed quickly once the totem and taboo prohibitions were internalized, while contemporary "savages" still have not internalized them, which supposedly explains why similar rituals can still be found among "primitive" people everywhere. Without the achievement of civilized repression, these "savages" supposedly need explicit and external prohibitions against incest, for example,

since "these same incestuous wishes, which are later destined to become unconscious, are still regarded by savage peoples as immediate perils against which the most severe measures of defence must be enforced" (SE 13:17).[50]

In relation to a broader Freudian way of thinking, for white men in the United States at the turn of the twentieth century, the implication could be that white civilization passed through this evolutionary stage quickly, while "savages" are still stuck in the totem-and-taboo stage. In racist formulations, African Americans could be equated with Darwin's construction of that "savage who delights to torture his enemies,"[51] and an argument could be made that black men needed to be policed because they could not police themselves. There is a difference here, though, between a delight in torture and an animal instinct, since animals are assumed to be *amoral* in the acting out of violent instincts. There are several discursive frameworks for explaining the origins of violence or a crime, then, at the turn of the century: an animal instinct for survival, a savage drive to torture, a devilish impulse for wickedness. As E. P. Evans notes in *The Criminal Prosecution and Capital Punishment of Animals* (1906), "the new system of jurisprudence, based upon more enlightened conceptions of human responsibility, is still in an inchoate state and very far from having worked out a satisfactory solution of the intricate problem of the origin and nature of crime and its proper penalty."[52] But there is a new belief at the end of the nineteenth century that a human being's actions are not always his or her own responsibility, that acting "instinctually" or "in the heat of passion" could be seen as a reason to reduce the punishment for a crime.

In twenty-first-century legal practice, most U.S. states distinguish between first-degree murder and voluntary manslaughter by determining whether there was "malice aforethought" as opposed to "circumstances which would 'mitigate' the homicide."[53] The traditional rule would be

> that a killing which would otherwise be murder is mitigated to manslaughter if the defendant acted in a "heat of passion" caused by legally sufficient provocation. The provocation must be conduct of

the victim sufficient to cause a reasonable person in the defendant's situation to lose his customary self-control, and it must actually provoke the defendant into killing before he has time to "cool off."[54]

This "reasonable person" standard has often been invoked in cases involving a husband killing the adulterous lover of his wife "in the heat of passion" or cases of an individual whose "honor" is insulted in the midst of a barroom brawl.[55] The state of "temporary insanity" that such scenarios supposedly provoke can be confirmed by psychiatrists and other medical authorities, but the general logic is to focus more on the motivations and mental state, the *mens rea*, of the criminal than the act itself.[56] At the end of the nineteenth century, this new juridical discourse suggested that violence stemming from one's animal instincts was more "natural," understandable, and excusable. But this logic was not necessarily applied when it came to explaining the motivation of black men supposedly intent upon raping white women, suggesting that this kind of violence might stem from a savage delight in torture rather than an animal instinct.

LYNCHING THE SAVAGE

As the logic of humane reform shifted, it is important to note that various oppositions were established, even if they were sometimes fleeting, overlapping, or even contradictory. The opposite of humane, for example, could actually be seen as savage, rather than inhumane, if the capacity for *either* humane or inhumane behavior is seen as a sign of difference from those savage groups that have not yet evolved this capacity. To describe certain groups as savage is not necessarily the same as calling them animals, or beasts, or brutes, although these terms sometimes seem interchangeable when it comes to the myth of the black male rapist. There are often attempts at distinguishing between the nature and origins of various violent crimes and the people who commit them, leading, for example, to the possibility of associating blackness more with a savage delight in torture than an animalized instinct for sexual reproduction.

As various scholars and activists have pointed out, the myth of the black male rapist existed prior to the end of the nineteenth century, but it exploded as a justification for lynching after Reconstruction. As Martha Hodes notes in *White Women, Black Men: Illicit Sex in the Nineteenth-Century South* (1997), both Ida B. Wells and Frederick Douglass observed how infrequent the allegation of black male rape was before and during the Civil War. According to Hodes,

> Although white people in North America had professed beliefs about the greater sexual ardor of black men ever since the colonial era, and although black men had been accused and convicted of raping white women within the racist legal system of the slave South, Wells and Douglass were nonetheless correct that those ideas and inequities did not include relentless, deadly violence toward black men before the late nineteenth century.[57]

The rape allegation was overblown in two ways: "Not only was there no postwar wave of such sexual assaults, but rape was not in fact the cause white Southerners recorded most frequently when justifying specific lynchings."[58] Nonetheless, "white apologists relentlessly named the rape of white women as the reason for murdering black men, and fully intended the lynching of black men to sustain an atmosphere of terrorism that was in turn intended to maintain the racial hierarchy that emancipation and Reconstruction had begun to destroy."[59] According to Sandra Gunning in *Race, Rape, and Lynching: The Red Record of American Literature, 1890–1912* (1996), "while the figure of blackness as the epitome of animalism and sexual energy has always been an overriding preoccupation for white Americans, the dangerously pervasive stereotype of the black rapist—the black as beast—fully emerged in the post–Civil War era."[60] There is more to explore here, though, in relation to these references to "animalism" and "the black as beast."

One of the difficulties might be that "beast" seems to imply both a devilish impulse and a "real" animal in the jungle. It might also suggest that there is little difference between animality and savagery in the construction of black masculinity, and critics tend to see these

two discourses as interchangeable. Marlon Ross, for example, cites Winthrop Jordan's classic *White Over Black* to argue that

> the discourse connecting the African to a regressive *animality* was in place long before the rise of Jim Crow. Just as upper-class Anglo-Saxon women were seen as needing protection by their fathers, husbands, brothers, and sons due to the natural frailty of their flesh, so African American men were conceptualized as needing to be guarded and pre-empted from the masculine privileges of social, political, and economic rule due to the natural *savagery* of their desires.[61]

But at times, the myth of the black male rapist in particular can be seen as deemphasizing animality in favor of savagery, classifying the alleged criminal as a torturer rather than as an animal whose amoral "heat of passion" could be somewhat excusable. Quincy Ewing's "The Heart of the Race Problem" in the March 1909 issue of the *Atlantic Monthly* illustrates how black people can be aligned more with savagery than animality: "But a little way removed from savagery, [Negroes] are incapable of adopting the white man's moral code, of assimilating the white man's moral sentiments, of striving toward the white man's moral ideals. . . . They are, in brief, an uncivilized, semisavage people, living in a civilization to which they are unequal."[62] The racist logic that follows is outlined by Ida B. Wells in 1895: "Negroes had to be killed to avenge their assaults upon woman. There could be framed no possible excuse more harmful to the Negro and more unanswerable if true in its sufficiency for the white man."[63]

The rape of a white woman by a black man is often constructed as a form of torture—far worse, for some, than any of the atrocities lynchers might commit. Charles H. Smith exemplifies this feeling in a piece for *Forum* in October 1893 titled "Have American Negroes Too Much Liberty?": "The lynching of such a monster . . . is nothing—nothing compared with what he has done. . . . there is no torture that could suffice."[64] George Winston, writing in the *Annals of the American Academy of Political Science* in July 1901, evokes white women shuddering in "nameless horror" at the thought that "the black brute is lurking in the dark . . . a monstrous beast, crazed with lust."[65] In

her infamous speech to the Georgia Agricultural Society on August 11, 1897, Rebecca Latimer Felton proclaimed, "if it needs lynching to protect woman's dearest possession from the ravenous human beasts, then I say lynch a thousand times a week if necessary."[66] According to Felton, "the poor girl would choose any death in preference to such ignominy and outrage and a quick death is mercy to the rapist compared to the suffering of innocence and modesty."[67] Alexander Manly's response to Felton in the *Wilmington Daily Record* on August 18, 1898, dares to suggest that intimacy and attraction between white women and black men is actually common. In Manly's analysis, "every negro lynched is called 'a big, burly, black brute,' when in fact many of those who have thus been dealt with had white men for their fathers, and were not only not 'black' and 'burly' but were sufficiently attractive for white girls of culture and refinement to fall in love with them, as is well known to all."[68] Manly's response was perceived as so outrageous that it led to the Wilmington race "riot" of 1898.[69] The references to "brute" and "beast" here illustrate how the discourses of animality, savagery, and even Christianity can overlap, even if these examples also seem to suggest that the greatest threat to white womanhood is a black man reminiscent of Darwin's "savage who delights to torture his enemies."

While white lynch mobs can also be denounced as savage, often in order for Northerners to claim "humane" superiority over Southerners, the lynchers are sometimes defended as acting out animal instincts "in the heat of passion" or as dispassionate dispensers of justice, much like in the realms of humane vivisection or humane penology, in which supposedly necessary violence is conducted as humanely as possible. According to John Carlisle Kilgo, writing in the *South Atlantic Quarterly* in 1902, "lynchings are the acts of a temporary social insanity"; Southern society is "liable to be outraged suddenly to an uncontrollable point, and thus crazed in its social emotions takes speedy revenge upon the violator of its laws and standards."[70] The response of the lynchers is thus seen as an instinct that is difficult to control. Georgia Governor Hugh Dorsey, for example, writing to the Colored Welfare League of Augusta in May 1918, explains that "personal outrages and violence, especially against helpless women

and children, will not be tolerated by any civilized community, but will provoke prompt retaliation of community vengeance which is difficult, if not impossible, to control." From his perspective, "the surest way to discourage lynching is to convince the lawless element that such provocative outrages will not be tolerated."[71] Alternatively, echoes of humane discourse can be heard in the words of lynching apologists claiming that the violence can be done in a calm and detached way. An anonymous letter to the *New York Times* in 1897, for example, signed by "Georgia," argues that "the negro . . . seems particularly given to this odious crime [of rape]. . . . When it is committed the utmost care is taken to identify the criminal and only when his identity is beyond question is the execution ordered. It is done in a quiet, decided way as a general thing, although in cases of great atrocity sometimes the criminal is shot as well as hanged."[72]

In *A Red Record: Tabulated Statistics and Alleged Causes of Lynchings in the United States, 1892–1893–1894* (1895), Ida B. Wells notes the vast number of lynchings that contradict this description.[73] As Gail Bederman confirms in *Manliness and Civilization: A Cultural History of Gender and Race in the United States, 1880–1917* (1995), lynchings themselves often were not solely about an impatience with the process of justice, which might be solved by a quick and perfunctory execution. Instead, "as lynchings grew in frequency, they also grew in brutality, commonly including burnings alive, castrations, dismemberments, and other deliberate and odious tortures."[74] Wells might be frustrated with the fact that, at times, these "scenes of unusual brutality failed to have any visible effect upon the *humane* sentiments of the people of our land,"[75] but my point is that the logic of humane reform becomes a new and flexible discourse for claiming superiority over those groups one wants to condemn as "savage," even if those people are white. Bederman points out that there was little Northern pressure to stop Southern lynchings at the turn of the century, despite the movement for other "progressive" reforms.[76] She identifies a shift in the tone of the Northern media but not necessarily any sense that lynching could be stopped: "After 1894, most Northern periodicals stopped treating lynching as a colorful Southern folk-way. They dropped their jocular tones and piously condemned lynching as 'barbarous.' It became a

truism that lynching hurt America in the eyes of the 'civilized world.' Nonetheless, journalists still implied one could do little to stop it."[77]

According to Bederman, white antilynching advocates such as William James believed that white lynch mobs were linked with black rapists by common "savage" instincts, such that a lynching became an opportunity "to unleash the savage within them."[78] Bederman cites a letter from James to the *Springfield Daily Republican*, on July 23, 1903, titled "A Strong Note of Warning Regarding the Lynching Epidemic" (subsequently reprinted in the *New York Daily Tribune*). Significantly, James writes about the "carnivore within us," but Bederman can only conclude that "as James saw it, civilization was far weaker than the primal violence of the natural man."[79] From Bederman's perspective, "the natural man was violent and impulsive. He dominated others through physical force. He lacked any self-control or self-restraint. Above all else, he was untouched by civilization. He was the opposite of civilized—he was natural."[80] But Bederman's analysis misses some of the complexities of how "the natural man" could be constructed. Rather than assuming that "savagery" is the common denominator for all human beings, whether white or black, a white man could sometimes equate the "natural" with animality, often in an attempt to distinguish white from black violence or to associate whiteness more with animality than with Darwinist-Freudian savagery.

According to James, the "epidemic" of lynching was spreading all over the country—not just the South—because it unleashed the carnivore within the human being. The instinct for violence is particularly close to the surface, in James's view, for the "young white American of the lower classes" (ECR 171). For those more "civilized," the "blood thirstiness" of the "usual man" seems to be "an exceptional passion, only to be read about in newspapers and romances" (ECR 171). There are other contributing factors as well, since "Negro lynching. . . . appeals to the punitive instinct, to race antipathy and to the white man's pride, as well as to the homicidal frenzy. One shudders to think what roots a custom may strike when *a fierce animal appetite like this* and a perverted ideal emotion combine together to defend it" (ECR 172, my emphasis). The "average man," then, who is "predisposed to the peculiar sort of contagion" common to mob

violence, is led by "one or two real fanatics" who are "actuated by a maniacal sense of punitive justice" (*ECR* 172). But this emphasis on punishment, rather than a delight in torturing black victims, distinguishes what might otherwise be seen as intentional cruelty. The logic, even in James's discussion, seems to be that lynchings can be about animalized violence or a necessary policing of black men who cannot police themselves, rather than the lynching itself being an act of savage torture, despite the tremendous amount of evidence to the contrary.

(IN)HUMANE WHITENESS

James's thinking about lynching can be related to his thinking about vivisection and thus serves as an example of how humane discourse could produce a construction of the white race as the only one capable of avoiding or limiting the inhumane treatment of either animals or black "savages." Like the dispassionate lyncher, the vivisecting scientist can defend himself by the need, supposedly, to fulfill the white man's "painful duty" under certain circumstances. In a letter to the Vivisection Reform Society, reprinted in the *New York Evening Post* on May 22, 1909, James declines the offer of a vice presidency with the organization but agrees to articulate his views on the issue. He acknowledges the merits of the principle against animal cruelty but seems to invoke a residual Christian framework for thinking about humane behavior. He argues that the "rights of the helpless, even though they be brutes, must be protected by those who have superior power" (*ECR* 191). The risk of unnecessary cruelties comes from "the unspeakable possibilities of callousness, wantonness, and meanness of human nature" (*ECR* 191), and therefore "the public demand for regulation rests on a perfectly sound ethical principle, the denial of which by the scientists speaks ill for either their moral sense or their political ability" (*ECR* 192). But he is generally in favor of scientists regulating themselves as a body (or policing themselves), rather than the legislative prohibition of certain acts. James notes the success of the antivivisection movement in bringing about a general shift in

public opinion, even if similar successes cannot be claimed for the antilynching "agitation" at this same moment:

> That less wrong is done now than formerly is, I hope, true. . . . The waste of animal life is very likely lessened, the thought for animal pain less shamefaced in the laboratories than it was. These benefits we certainly owe to the anti-vivisection agitation, which, in the absence of producing actual state-regulation, has gradually induced some sense of public accountability in physiologists, and made them regulate their several individual selves.　　　　　(ECR 191)

As early as 1875, in a letter to the *Nation* on February 25, James sympathizes with the "humane motives" of Henry Bergh, the founding president of the ASPCA, even though, significantly, he sees vivisection as a "painful duty" (ECR 11). He advocates for the restraint of power, avoiding abuse, arguing that "our power over animals should not be used simply at our own convenience, but voluntarily limited and sparingly put forth" in order to avoid "blood shed for trifling ends" (ECR 12). But in his subsequent letter on June 29, he certainly does not want "this virtue" (which is "among the many good qualities of our 'Anglo-Saxon' race") to "run to a maudlin excess" (ECR 18). Indeed, his race pride does not allow him to condemn vivisection performed "in the course of researches begun with no immediately utilitarian aim" (ECR 19). Scientists, as the first letter notes, should not be limited by any outside legislation, since "it is better for many quadrupeds to perish unjustly than for a whole scientific body to be degraded" (ECR 13). The key implication seems to be that scientists should be able to perform the "painful duty" of vivisection when they are involved in the dispassionate pursuit of scientific knowledge.[81] James advises the SPCA to lobby for public opinion rather than for new legislation, arguing that "under this hostile pressure, this constant sense of being challenged—which is very different from the sense of being controlled—the vivisector will feel more responsible, more solemn, less wasteful and indifferent" (ECR 13). The deaths of the animals will be more humane, in other words, but not prohibited.

In his analysis of lynching deaths at the turn of the century, James does not equate the dispassionate duty of the presumably white vivisectionist with the actions of the lower-class lynch mob, even if contemporaries of his might make that analogy. But James is still able to question the animality of the white lynch mob. By July 29, 1903, when he publishes "Epidemic of Lynching" in the *Boston Journal*, James argues that in order to curb the extralegal outrage of lynching that is spreading throughout the country, the single most important thing to do is to have the newspapers stop printing accounts of the violence. In his construction of mob violence, James once again suggests that the primary motive is an impatience with the process of the legal justice system. He even considers mob violence in comparison with "heat of passion" defenses, implying that both embody animal instincts, before ultimately concluding that the animality of the mob cannot be similarly defended: "we by tradition, exempt from punishment the man who shoots the wrecker of his home and happiness in the moment of extreme provocation; but exemption stops before we reach the mob that is actuated solely by an impatient demand for justice—or by the mere thirst for curiosity" (*ECR* 175). James is thus unwilling to excuse lynching on the basis of animal instinct, but the framework for considering white violence in relation to animality remains in place.

Near the end of James Weldon Johnson's *The Autobiography of an Ex-Coloured Man* (1912), the narrator describes a horrific Southern lynching in which a black man is burned alive. The narrator's resulting sense of shame is expressed not only for his country, "the only civilized, if not the only state on earth, where a human being would be burned alive," but also for his race. "Shame at being identified with a people that could with impunity be treated worse than animals. For certainly the law would restrain and punish the malicious burning alive of animals."[82] The narrator wonders why we don't "shudder with horror at the mere idea of such practices being realities in this day of enlightened and humanitarianized thought."[83] By the turn of the century in the United States, the "humanitarianized" or "humane" treatment of at least some animals was increasingly mandated by law, while the torture of black men continued to run rampant. Black

bodies were often literally vivisected in the context of lynchings, without being justified in the name of science.[84] As Darwinist-Freudian constructions of animality and savagery threatened to level the racial playing field, the discourse of humane reform became a productive framework for distinguishing between blackness and whiteness, often in complex and even contradictory ways. An archaeology of this new "humane society," as I hope to have shown here, can reveal how exploring the question of the animal at specific historical and cultural moments can shed new light on U.S. culture.[85]

Humane advocacy in its foundational moment can be seen as a significant—but often overlooked—discourse in relation to contemporaneous constructions of racial difference. This history remains an important background for thinking about humane advocacy today, particularly for those scholars and activists interested in advocating for both human racial and nonhuman animal issues. It is also crucial history for those of us uncomfortable with the prospect of animality being elevated over blackness, in which concern for animals becomes more important than concern for various racial groups, for example. In our own moment of "humanitarianized" thought, advocating for animals is not simply equivalent to advocating for racial others, if animal advocacy itself continues to construct racial distinctions among human beings.

NOTES

I am tremendously grateful to Marlon Ross and Marianne DeKoven for their very helpful insights and suggestions in response to earlier versions of this chapter.

1. Charles Darwin, *The Descent of Man, and Selection in Relation to Sex*, vol. 21 and 22 of *The Works of Charles Darwin*, ed. Paul H. Barrett and R. B. Freeman (New York: New York University Press, 1989), 644.

2. Ibid.

3. Ibid., 633.

4. Ibid., 644.

5. Ibid.

6. Whether or not Darwin himself was a racist is beside the point here, which is to highlight the racist *construction* of contemporary "savages" as somehow simultane-

ously living in the present but also representing the white man's evolutionary past, even if that kind of temporal disconnect seems to contradict Darwin's other conclusions about the evolution of human races or "subspecies." Darwinist constructions of race could certainly be invoked for both racist and antiracist arguments, though, including the idea that all "subspecies" of humans shared most importantly a common humanity that refuted a hierarchy of white over black. For more on Darwin's own thinking about race, including in relation to his British audience, see Gillian Beer, *Darwin's Plots: Evolutionary Narrative in Darwin, George Eliot, and Nineteenth-Century Fiction*, 2nd ed. (Cambridge: Cambridge University Press, 2000). See also Adrian Desmond and James Moore, *Darwin's Sacred Cause: How a Hatred of Slavery Shaped Darwin's Views on Human Evolution* (New York: Houghton Mifflin, 2009).

7. Sigmund Freud, *The Standard Edition of the Complete Psychological Works of Sigmund Freud*, ed. James Strachey, 24 vols. (London: Hogarth Press, 1953–1975), 13:1. Further references are to this edition and will be cited parenthetically in the text as *SE*.

8. William James, *Essays, Comments, and Reviews* (Cambridge: Harvard University Press, 1987), 18. Further references are to this edition and will be cited parenthetically in the text as *ECR*.

9. On white male fantasies of getting in touch with their wild animality, see, for example, Gail Bederman's chapter on G. Stanley Hall in *Manliness and Civilization: A Cultural History of Gender and Race in the United States, 1880–1917* (Chicago: University of Chicago Press, 1995), 77–120.

10. Following Jacques Derrida, I am conscious of the need for specificity when talking about animals, rather than reducing all species to *the* animal: "Confined within this catch-all concept, within this vast encampment of the animal, in this general signifier, within the strict enclosure of this definite article ('the Animal' and not 'animals'), as in a virgin forest, a zoo, a hunting or fishing ground, a paddock or an abattoir, a space of domestication, are all living things that man does not recognize as his fellows, his neighbors, or his brothers." Jacques Derrida, *The Animal That Therefore I Am*, ed. Marie-Louise Mallet, trans. David Wills (New York: Fordham University Press, 2008)], 34. But there is a dominant discourse of animality that I have in mind here that constructs "the animal"—in both human and nonhuman animals—as naturally violent in the name of survival and heterosexual in the name of reproduction. In the case of humane reform, even when directed toward domesticated animals and persistent stereotypes of the loyal plantation Negro as a domesticated pet, there is still a construction of a white man's "animal instincts" that can be either restrained or indulged. I explore this discourse in relation to other aspects of U.S. culture at the turn of the century in a book project titled *Birth of a Jungle: The Evolution of the Beast in U.S. Culture*.

11. Gerald Carson, *Men, Beasts, and Gods: A History of Cruelty and Kindness to Animals* (New York: Scribner's, 1972), 50–54.

12. Ibid., 55–58. For more on the history of animal welfare in England, see Harriet Ritvo, *The Animal Estate: The English and Other Creatures in the Victorian Age* (Cambridge, Mass.: Harvard University Press, 1987).

13. Quoted by Sydney H. Coleman, in *Humane Society Leaders in America, with a Sketch of the Early History of the Humane Movement in England* (Albany, N.Y.: American Humane Association, 1924), 37.

14. Quoted by Roswell C. McCrea in *The Humane Movement: A Descriptive Survey* (1910; repr., College Park, Md.: McGrath, 1969), 12.

15. Carson, *Men, Beasts, and Gods*, 116–118.

16. Coleman, *Humane Society Leaders*, 259.

17. Ibid., 252.

18. Ibid., 264.

19. *Oxford English Dictionary*, 2nd ed. (1989).

20. Ibid.

21. Ibid.

22. Noah Webster, William Greenleaf Webster, and William Adolphus Wheeler, *A Dictionary of the English Language*, academic ed. (New York: Ivison Blakeman Taylor, 1878), 206.

23. Noah Webster, *Webster's New Standard Dictionary . . . Based Upon the Unabridged Dictionary of the English Language of Noah Webster* (New York: Syndicate, 1911).

24. *Oxford English Dictionary*.

25. McCrea, *The Humane Movement*, 12–15.

26. Lawrence Finsen and Susan Finsen, *The Animal Rights Movement in America: From Compassion to Respect* (New York: Twayne, 1994), 52.

27. McCrea, *The Humane Movement*, 15.

28. Ibid.

29. Ibid., 16, 21.

30. Ibid., 35.

31. Ibid., 59.

32. Quoted in ibid., 91–92.

33. Ibid., 92.

34. Ibid.

35. Marlon B. Ross, *Manning the Race: Reforming Black Men in the Jim Crow Era* (New York: New York University Press, 2004), 41.

36. See Edward L. Ayers, *Vengeance and Justice: Crime and Punishment in the Nineteenth-Century American South* (New York: Oxford University Press, 1984); Donald R. Walker, *Penology for Profit: A History of the Texas Prison System, 1867–1912* (College Station: Texas A&M University Press, 1988); and Mark Colvin, *Penitentiaries, Reformatories, and Chain Gangs: Social Theory and the History of Punishment in Nineteenth-Century America* (New York: St. Martin's Press, 1997).

37. Quoted by David M. Oshinsky in *"Worse Than Slavery": Parchman Farm and the Ordeal of Jim Crow Justice* (New York: Free Press, 1996), 110, my emphasis.

38. Ibid., 109.

39. Ibid., 149.

40. Ibid., 209–217.

41. Alex Lichtenstein, *Twice the Work of Free Labor: The Political Economy of Convict Labor in the New South* (London: Verso, 1996), 179.

42. Ibid., 126–151.

43. Quoted in ibid., 159, my emphasis.

44. Ibid., 182.

45. Michel Foucault, *Discipline and Punish: The Birth of the Prison*, trans. Alan Sheridan (New York: Pantheon Books, 1977), 14.

46. Ibid., 16.

47. Ibid., 17.

48. Ibid.

49. Foucault's larger argument, that "man" as a knowing and knowable subject is first constructed at the beginning of the nineteenth century, similarly overlooks the significance of how "man" or "humanity" is changed through the later deployment of "animality." The link between the humane treatment or discipline of criminals and the humane treatment of animals that we see at the turn of the twentieth century in the United States has its roots in the work of Jeremy Bentham at the end of the eighteenth century, although Foucault does not make this connection. Foucault notes that Bentham's Panopticon prison design was likely inspired by Le Vaux's menagerie at Versailles, but Foucault does not mention Bentham's simultaneous advocacy for animals. Often quoted by historians of animal welfare movements, Bentham's famous statement in *Introduction to the Principles of Morals and Legislation* (1780) is: "The question is not, *Can they reason?* nor, *Can they talk?* but, *Can they suffer?*" Quoted by Henry S. Salt in *Animals' Rights: Considered in Relation to Social Progress* (1892; repr., Clarks Summit, Penn.: Society for Animal Rights, 1980), 145–146. Animal welfare historians follow Foucault, in a sense, by not juxtaposing these two sides of Bentham's "humane" (in the earlier Christian sense) impulse for reform. But the two sides continue to be related after humane discourse shifts.

50. For more on Freud's construction of "the primitive," see Marianna Torgovnick, *Gone Primitive: Savage Intellects, Modern Lives* (Chicago: University of Chicago Press, 1990); Anne McClintock, *Imperial Leather: Race, Gender, and Sexuality in the Colonial Conquest* (New York: Routledge, 1995); and Ranjana Khanna, *Dark Continents: Psychoanalysis and Colonialism* (Durham, N.C.: Duke University Press, 2003).

51. Darwin, *The Descent of Man*, 644.

52. E. P. Evans, *The Criminal Prosecution and Capital Punishment of Animals* (London: Faber, 1987), 15–16. Evans provides a fascinating history of "animal trials" in

Europe in which animals seem to be granted agency and therefore responsibility for various "crimes."

53. Phillip E. Johnson, *Criminal Law: Cases, Materials, and Text*, 6th ed. (St. Paul, Minn.: West Group, 2000), 164.

54. Ibid.

55. "Heat of passion" defenses have been used, as Eve Sedgwick points out, even in cases where the concept of "homosexual panic" has been distorted to defend violence against gays and lesbians after alleged "come-ons." See Eve Kosofsky Sedgwick, *Epistemology of the Closet* (Berkeley: University of California Press, 1990), 20–21.

56. On legal definitions of "reasonable" or "unreasonable" emotions in such cases, see Dan M. Kahan and Martha C. Nussbaum, "Two Conceptions of Emotion in Criminal Law," *Columbia Law Review* 96 (1996).

57. Martha Hodes, *White Women, Black Men: Illicit Sex in the Nineteenth-Century South* (New Haven: Yale University Press), 2.

58. Ibid., 176.

59. Ibid.

60. Sandra Gunning, *Race, Rape, and Lynching: The Red Record of American Literature, 1890–1912* (New York: Oxford University Press, 1996), 5.

61. Ross, *Manning the Race*, 10–11, my emphasis. Ross's brilliant study has different priorities than mine in this chapter, such as Ross's desire to "show how struggles to reform the notion of black manhood—in terms of citizenship, patriarchy, patronage, companionship, romance, militance, and male entitlement—have constantly worried, disrupted, and altered the dominant discourse on race and masculinity" (8).

62. Quoted by Gail Bederman in *Manliness and Civilization: A Cultural History of Gender and Race in the United States, 1880–1917* (Chicago: University of Chicago Press, 1995), 49.

63. Ida B. Wells, "The Case Stated," *A Red Record: Tabulated Statistics and Alleged Causes of Lynchings in the United States, 1892–1893–1894* (1895); reprinted in Christopher Waldrep, ed., *Lynching in America: A History in Documents* (New York: New York University Press, 2006)], 6. Waldrep's volume is an invaluable collection of documents and essays illustrating the complexities and differences among many different kinds of lynchings. For important studies of lynching, see Ayers, *Vengeance and Justice*; Gunning, *Race, Rape, and Lynching*; Jacqueline Goldsby, *A Spectacular Secret: Lynching in American Life and Literature* (Chicago: University of Chicago Press, 2006); Adam Gussow, *Seems Like Murder Here: Southern Violence and the Blues Tradition* (Chicago: University of Chicago Press, 2002); Grace Elizabeth Hale, *Making Whiteness: The Culture of Segregation in the South, 1890–1940* (New York: Pantheon Books, 1998); and Mason

Boyd Stokes, *The Color of Sex: Whiteness, Heterosexuality, and the Fictions of White Supremacy* (Durham, N.C.: Duke University Press, 2001).

64. Quoted by Hodes, *White Women, Black Men*, 204.

65. Ibid., 201.

66. Rebecca Latimer Felton, "Needs of the Farmers' Wives and Daughters" (1897); reprinted in *Lynching in America: A History in Documents*, ed. Christopher Waldrep (New York: New York University Press, 2006), 144.

67. Ibid.

68. Alexander Manly, "Mrs. Fellows's Speech" (1898); reprinted in *Lynching in America: A History in Documents*, ed. Christopher Waldrep (New York: New York University Press, 2006), 147.

69. For more on the Wilmington riot, see Hodes, *White Women, Black Men*, 193–197.

70. John Carlisle Kilgo, "An Inquiry Concerning Lynchings," (1902); reprinted in *Lynching in America: A History in Documents*, ed. Christopher Waldrep (New York: New York University Press, 2006), 10.

71. "Hugh Dorsey Answers the Colored Welfare League of Augusta" (1918); reprinted in *Lynching in America: A History in Documents*, ed. Christopher Waldrep (New York: New York University Press, 2006), 199.

72. "Georgia" (1897); reprinted in *Lynching in America: A History in Documents*, ed. Christopher Waldrep (New York: New York University Press, 2006), 7.

73. Wells, "The Case Stated," 4. As Jacqueline Goldsby notes, the term lynching can represent not only hangings but also any form of extralegal murder perpetrated by white people against those identified as black. There are many racial atrocities that aren't typically included when determining the number of lynchings in this period, suggesting that the violence was much more widespread than often acknowledged: "Despite the word's imprecision, and despite the fact that black people were 'lynched' in any number of ways (hanging, shooting, stabbing, burning, dragging, bludgeoning, drowning, and dismembering), similar atrocities that occurred in the course of race riots aren't called 'lynching,' nor are they factored into established inventories of lynching's death toll. Hundreds of murders and assaults occurred under the regimes of convict lease labor and debt peonage too, the accounts of which often describe what we would consider lynchings. Like the rapes of black women by white men, however, those atrocities aren't considered part of lynching's history" (10–11).

74. Bederman, *Manliness and Civilization*, 47.

75. Wells, "The Case Stated," 4, my emphasis.

76. Bederman, *Manliness and Civilization*, 71.

77. Ibid., 70. Other strategies could be seen as successful, though, such as

"raising public consciousness about the violence, funding publication of a vibrant literature of resistance, and mobilizing select sectors of the national public for mass political action," along with the "state-based anti-lynching laws" successfully achieved through the work of Ida B. Wells after 1893–1895. See Goldsby, *A Spectacular Secret*, 317n12.

78. Bederman, *Manliness and Civilization*, 73.

79. Ibid. James does write about an "aboriginal capacity for murderous excitement," but it is at least a stretch to assume that the reference is to an "uncivilized savage" rather than something like an animal instinct.

80. Ibid.

81. For more on the antivivisection movement, see Jennifer Mason, *Civilized Creatures: Urban Animals, Sentimental Culture, and American Literature, 1850–1900* (Baltimore, Md.: The Johns Hopkins University Press, 2005), 164–165.

82. James Weldon Johnson, *The Autobiography of an Ex-Colored Man* (1912; repr., New York: Vintage, 1989), 188, 191.

83. Ibid., 189.

84. For examples of lynching victims—both alive and dead— cut up for souvenirs, see Stewart E. Tolnay and E. M. Beck, *A Festival of Violence: An Analysis of Southern Lynchings, 1882–1930* (Urbana: University of Illinois Press). Black bodies were often vivisected in the context of medical experiments as well, leading up to, perhaps most infamously, the Tuskegee Syphilis Study that began in 1932. See Susan M. Reverby, ed., *Tuskegee's Truths: Rethinking the Tuskegee Syphilis Study* (Chapel Hill: University of North Carolina Press, 2000).

85. I argue for this kind of methodology in "From Animal to Animality Studies," *PMLA* 124, no. 2 (2009): 496–502.

What Came Before *The Sexual Politics of Meat*

The Activist Roots of a Critical Theory

Carol J. Adams

In 1974, walking down a Cambridge, Massachusetts, street, I suddenly realized that a deep and abiding connection existed between feminism and vegetarianism, between violence against women and violence against animals. I wrote my first paper on the subject in 1975. In 1976, I began writing a book about the patriarchal roots of meat eating. Within months, I was all set to see my small manuscript published. But it felt incomplete to me, lacking in a critical theory that organized and interpreted my ideas. I realized neither the "book" nor I was ready for its publication. I shelved the early draft.

I returned to western New York, where I had grown up. I became a grassroots activist. What came before *The Sexual Politics of Meat* was the process by which I became the person who could write the book that finally appeared sixteen years after my first revelation. The activism of those intervening years was a crucible for developing the critical theory missing from my initial 1976 manuscript. But I did not become a rural activist because it would help me with my book. I became an activist because I believe strongly that injustice must be challenged. Indeed, through my activism I continually had to solve a basic issue: who comes first in activism, disenfranchised humans or animals? And

the answer, the answer that transformed my early manuscript into *The Sexual Politics of Meat*, was that this is a false question. Divided loyalty (humans versus animals) is one of the issues that my critical theory tries to overcome by identifying the interlocking, overlapping nature of disempowerment and oppression. Activism showed me how to think my way to the arguments that illuminate that insight.

This essay offers the answers to several questions. How is one an activist? How does one balance activism for those on the other side of the vigilantly guarded species boundary with activism for those humans thrown and propelled toward that boundary by oppressive attitudes and actions? In other words, how does one integrate work for the other animals with work for disenfranchised humans (and vice versa)? And finally, what does one learn from activism?

To answer these questions and as a case study specific to writing *The Sexual Politics of Meat*, I explore a particularly difficult activist experience from the 1980s. It became a laboratory for recognizing intersecting oppressions and for learning how to be an activist. It began as a battle for fair housing and evolved into a fight for fairness in the media. It required that I learn how to research and write about these issues, providing an opportunity to learn how to write clearly and concisely. It took an enormous toll on me personally, and I draw on journal notes and dream summaries from that time to illustrate the process of inner education that activists experience. So profoundly did the experience stay with me that I continued to have dreams about it long after the confrontations and tensions of the times were over. On Christmas night, 1998, my dreaming self took me back to Dunkirk, where we had lived until 1987: "I start to think about Dunkirk—the housing suit. How personal it all was. Bruce [my partner] calls out, 'don't make it sound easy.'" Then I awoke. My dreaming self had that right: it was not easy.[1]

RURAL MINISTRY

In 1978, I was the executive director of the Chautauqua County Rural Ministry, an advocacy not-for-profit agency that worked pre-

dominantly with welfare recipients, farm workers, and resettled farm workers. It was based in Dunkirk, New York, a small steel town experiencing the economic displacement of many of the larger steel cities, such as Lackawanna, New York, and Pittsburgh, Pennsylvania. The Lackawanna steel plants were a shadow of their former selves. The Dunkirk steel plant hung by a thread, and other industries in western New York had shut down. In Dunkirk, the urban renewal program of the 1960s destroyed many beloved areas, but nothing had been built in their place. The sight of the empty lots around town inflamed the deeply conservative community's distrust of government. Yet despite these strong antigovernment feelings, the city accepted federal monies for several years.

A 1975 study recommended that Dunkirk build one hundred units of low-to-moderate-income housing. That year, 811 people were shown to be living in substandard housing in the city of Dunkirk (population 16,000). In 1979, more than 60 percent of the city's rental units were found to have inadequate plumbing, heating, or sewer facilities. Overcrowding in the available apartments was another concern. Since 1975, the Department of Housing and Urban Development gave the city of Dunkirk millions of dollars to upgrade homes, streets, lighting, and sewers in areas of concentrated deterioration, with the understanding that the city would also build the hundred units of needed housing.

But the city kept postponing its commitment to build the housing. Meanwhile, the millions of dollars that HUD gave Dunkirk were not spent in the area with the concentrated deterioration, known as the Core Area. Not surprisingly, the city had neglected the area where the largest number of minorities lived.

A low-to-moderate-income housing project slated to be built in a largely white part of town came before the City Council for approval. The white city government rejected it. I learned that whites had gone door to door in the area where the housing was to be built despicably arousing alarm by asking, "do you want your daughter to be raped by a black man?" And so I found myself immersed in the "rub a dub dub of agitation," as Theodore Tilton called the activism of Susan B. Anthony and Elizabeth Cady Stanton.

A coalition of groups, including the Rural Ministry and the local branch of the NAACP, began to educate people about why low- and moderate-income housing was necessary. Angry confrontations occurred at city meetings. Frightened by the opposition to the housing, the officials continued to reject any proposals for the desperately needed public housing.

Two interns from the local college, the State University of New York at Fredonia, were working with me to research the claims of the opponents. To respond to rumors generated by anti-housing forces, we researched property values near the existing public housing project. We found that, contrary to rumor, the property values of these houses had not been affected by their proximity to a housing project. We researched what had happened to the money that the Department of Housing and Urban Development had provided to the city for neighborhood improvement. Where had it gone, since it had not gone to the Core Area? We compared what Dunkirk had promised to do with the money with what was actually done with it.

We discovered that in 1979, HUD had ranked Dunkirk two out of twenty-nine in terms of need for money from their Small Cities program. However, Dunkirk ranked twenty-eight out of twenty-nine in terms of the feasibility of their program.

We researched the vacancy rate for apartments in Dunkirk. It was 1 percent. This meant that it was a landlord's market—the competition for available apartments was so great that low-income renters had to accept what was available, and what was available was substandard. The city was not enforcing the building code, and many of the apartment owners were absentee landlords. Twelve percent of the population of Dunkirk lived in substandard housing; factoring in race, 75 percent of minorities lived in substandard housing. (At my office, people came to me with stories of their children waking up to find a rat staring at them.) Always earnest, I drafted several versions for what ultimately became a newspaper ad addressing the most frequently invoked anti-housing stances.

Meanwhile, the city council was repeatedly turning down proposals for the building of new public housing units, though this meant a loss of other forms of HUD money. *This* money was finally going to target the substandard housing in the Core Area, but the council's vote against the housing meant that HUD withdrew the money for rehabilitating homes.

A virulent anti-housing group, the Citizen's Action Board, acted as the channel for all the fear that people have about public housing, fanning the fires with racist discussion and taxpayers' rights rhetoric. In 1980, the *Buffalo Courier-Express* carried a front-page article, "Red-Hot Housing Debate Is Costing Dunkirk Millions." The article included interviews with these anti-housing activists. They were motivated by many things—suspicion of the federal government, lingering fury over what urban renewal in the 1960s had done to the city, and the belief, as one person said, that "public housing discriminates against me, the middle class, the working people. We are paying the shot."[2] One angry man exclaimed, "I've taken the flag down in front of my house. And I will take the pole down soon. There is no freedom left in this country—it's making me sick." One of the individuals the reporter interviewed said, "Somebody is shipping minorities here. I have nothing against them—but why us?"

I assumed that the response to ignorance and fear is education. I believed that when two people or groups argued, each side would listen to the other and would and could be open to the ideas of the opposing side. But ignorance and fear do not create receptive listeners.[3]

We attended meetings; we tried to speak. When the Citizen's Action Board complained that the government shouldn't be in the business of housing, I asked them how many had bought their own homes through Veteran's loans, a form of government subsidies. How many went to school on the GI bill? That was the federal government, too.

It was hard to be heard in the midst of the hostile crowd. As the local newspaper reported, "according to Ms. Adams, Dunkirk is in 'violation of the Fair Housing Act.' 'It's just not a matter of turning down HUD,' she said amid heckling and boos."[4] One friend and sister member of the NAACP, Mary Lee Williams (and wife of the

minister of the Open Door of God in Christ Church), stood up and thundered, as only she could thunder, that in God's eyes we were all equal and no matter what happened on earth, in heaven we would be gathered together. She talked about equality before God and that when we go to meet our maker, no matter what kind of inequality there has been on earth, in heaven we will be equal. I watched as afterward so many of the whites, those speaking out the loudest against the housing, rushed forward to talk with her. It was as though they wanted her assurance that they would get to heaven, despite that they weren't changing their views on the housing.

Heckling greeted most of the African Americans and whites who tried to speak in favor of public housing. Jesse Thomas, a former star athlete at Dunkirk High School, said to a crowd of 250 people gathered at one meeting, "You're saying we're not fit to live in Dunkirk." Someone shouted back, "You said it, we didn't."[5]

The pro-housing forces realized that Dunkirk officials would not change without outside pressure, so we filed a class-action suit against the city of Dunkirk. But we also sued the Dunkirk Housing Authority, the Department of Housing and Urban Development, and a group of investors who purchased property planned as the site for the originally proposed but subsequently abandoned hundred units of housing. (They had purchased it to prevent it from being developed for public housing.) The suit was filed on behalf of the Dunkirk-Fredonia branch of the NAACP, of which I was the chair of the Housing Committee, and individually named plaintiffs who represented low-income and minority renters deprived of access to housing, white homeowners deprived of the benefits of living in an integrated neighborhood, and black homeowners who lived in the Core Area who had been deprived of federally funded housing rehabilitation funds.

Former Speaker of the House Tip O'Neill famously said, "All politics is local." So, too, are attacks and hostility prompted by local politics: they affect your relationships with your neighbors and create a feeling of lack of safety. I was shocked by the fury of the anti-housing forces and dismayed by how they personalized their attacks. I was

married to the local Presbyterian minister, Bruce Buchanan, who was also president of the board of the Rural Ministry. (That is how we met.) Eggs were thrown at our house; anonymous letters encouraging the church to fire Bruce were sent to the church leadership. We felt overwhelmed. Neither of us could sleep through the night. Both of us experienced increased nervousness and short tempers. My notes from that time include this: "the feeling of being exposed, being hated—when you feel you are basically a good person."

Dunkirk abuts the more affluent village of Fredonia, the home of a state university college. Many of the upper- and middle-level owners and managers of the Dunkirk steel plant lived in Fredonia or in the town of Dunkirk but not in the city itself. The housing issue, according to the *New York Times*, "became a magnet for blue-collar political discontent."[6] Their anger had many sources. They felt "false promises" had been made to them, but in fact, the community money had gone to their neighborhoods. They felt a sense of loss of control of their environment, signified by the empty lots around town from urban renewal. An increasing threat of foreign steel competing against their local product created job insecurity. They felt that the federal government was dictating to them. And on a very personal level, there was also a sense of betrayal that a white woman had turned against them. I was not only a white woman; I was the daughter of a well-known local judge.

After the inflammatory letter against us had been received by his congregation, Bruce and I talked with my parents, who lived nearby, about the implications of our activism. Recalling that discussion, I wrote:

> The tension between moving the community ahead—being progressive so that the ultimate [court] settlement is as favorable as possible—and being silent so that Bruce's and my safety are protected. I feel I have let my ideals down because I know I could have done and said more. [Activists: Be aware of your perfectionism!] Bruce and my father say you have already done enough—don't endanger yourself; don't hit your head against a brick wall. I accept the

2nd argument but not the 1st—to accept the 1st is to concede the point.

The way I make sense of my world is to read, read, read. Stunned by the virulence of the racism, I read books about the Dred Scott decision, histories of black women, histories of resistance during slavery, fair-housing books, civil rights oral histories, and books that explored the question *why does blackness matter so to whites?* (Toni Morrison's *Playing in the Dark*, not published until 1993, provides the most compelling answer.)[7] I had never shelved the *idea* of the book on feminism and vegetarianism and continued to notice connections as I read my way through those histories, feminist literary criticism, books on attitudes toward animals, and mysteries and spy novels. (I needed some relief after all!) I was trying to figure out how dominance happens and what protects dominance once it has been established. Throughout the 1980s, as my activism led me into hostile situations, I would ask myself: *how does this relate to animals?* I was examining "animalizing" discourses, though I did not use those words then. This approach to multiple oppressions was very much a part of the radical feminist community I had lived in during the early 1970s.

Theoretically, my experiences were very stimulating. But one does not live one's life mainly on a theoretical level. Nothing prepared me for the virulent hatred that had been directed toward me. In October 1980, while on the island of Iona, a very sacred place in Scotland, I dreamt that *I was in City Hall and various anti-housing people threw small things at me—or swore at me. I became alarmed. Went to ask for protection from the police—the policemen left—ostensibly to get others—but never returned and watched from the other room as the crowd picked me up to beat me up. I woke up crying, "Help. Help."*

"WHAT'S YOUR OPINION?"

At the height of the housing confrontations and after one of the emotional meetings at City Hall, someone remarked to me, "You can try to do all the good you can, but it's undone the next day on 'What's

Your Opinion?'" I had never heard of "What's Your Opinion," a call-in radio show on a local radio station. The next day, on my way to work, I tuned into the station and was startled to hear the moderator of the show, Henry Serafin—a small-town Rush Limbaugh—talking about me. He was complaining that "Carol Adams's Rural Ministry" was going to receive thirty thousand dollars in HUD monies if these funds were awarded to the city of Dunkirk. He also said, "we don't need any more minority housing," and pointed out that the funds would "benefit only the Core Area." I was infuriated that he was giving inaccurate information about the housing while also impugning my motives. Arriving at the church, I leapt out of my car, marched up the two flights of stairs to my corner office, and dialed the station's telephone number. I was put on the air. I pointed out that "it's not minority housing; it's low- and moderate-income housing," and I reminded Serafin that since he was the chair of the Dunkirk's Citizen's Advisory committee, he should know better than to claim that any of those funds were coming to my organization. I asked him to correct the misinformation he was spreading. As for the funds for the Rural Ministry (it was three thousand dollars, not thirty thousand), they were earmarked for the Hotline for Battered Women, a resource Bruce and I had created two years earlier.

After I hung up, all hell broke loose on the radio program. People could not stop talking about me. Not about what I said, not any of the points I had made—but, and this floored me, about whether I paid any income tax.

It turned out that "What's Your Opinion" had been providing an ongoing opportunity for the Citizen's Action Board, the anti-housing group, to stir up people's fears about public housing. Serafin, the moderator of the show and the owner of the station, was a member of the Citizen's Action Board, an owner of substandard apartments in Dunkirk, and one of the investors who had bought up the property originally slated as the site for the hundred units of housing.

A year and a half later, the Dunkirk police chief, Edward Mulville, told the *New York Times*: "Serafin eggs people into saying things they wouldn't otherwise. He really is a detriment to the area. If I were driving through here for the first time and heard that show on the car

radio, I'd change my plans to stop, step on the gas and keep right on going."[8] But those of us in Dunkirk had no such choice.

I was invited to be the guest on "What's Your Opinion?" I agreed to appear with the understanding that Serafin would retract his statement that the Rural Ministry was to receive thirty thousand dollars. Once we were on the air, he refused to do so. As I tried to describe the history of the Dunkirk housing controversy and help people understand why the money for home repair was going to go to the Core Area, he told me to "hurry up," to "cut it short." Then he asked, "when are you going to start acting like a lady?"

Each successive program involved Serafin and his cohorts talking against the housing, the Rural Ministry, the mayor, and me: who did I think I was, and so on. When I was introduced to someone in northern Chautauqua County, they would inquire if I was the same Carol Adams who was always being attacked on "What's Your Opinion?"

That June, a new twist in the personalization of the housing battle found its expression on the local airwaves. The *Buffalo Courier-Express* sent a reporter to research the controversy, and the resulting story appeared on the front page of the Sunday paper.[9] Not understanding that I had kept my own name when I married, the reporter referred to me as "Mrs. Adams." The next day, "What's Your Opinion?" focused on the newspaper article and the question of my name: "Miss . . . or Ms. Adams, I don't know why she kept her maiden name. Her husband's name is Buchanan. It sounds like a colored name, but it isn't."

As people learned of our efforts to get WBUZ to discuss the housing issue accurately, someone contacted us with this information: Serafin had accepted the placement of someone from the county's office of employment and training but had refused the placement when the person turned out to be African American. He called the county and asked, "Don't you have any white girls to send me?" He complained that the job applicant "would make charcoal look white." These comments had been recorded; we received copies.

The legal scholar Robert Cover refers to "the violence of the word."[10] WBUZ was broadcasting the violence of the word—racist hate messages, slurs, and disparagements. WBUZ created an envi-

ronment in which it was safe for whites to exhibit their racism, Mari Matsuda shows how racist speech is related to racist acts. "Gutter racism, parlor racism, corporate racism, and government racism work in coordination, reinforcing existing conditions of domination."[11] Racist speech on the radio and in the community tracked and reinforced the city's diversion of funds from the area in the city with the greatest number of substandard buildings and minorities and the city's failure to build needed housing.

MEDIA ADVOCACY AND AN INFORMAL OBJECTION

Through contacts in Washington, I learned about the Media Access Project and arranged to meet Andrew Schwartzman.[12] From what he heard about WBUZ and the actions of its owner, Schwartzman felt that there had been egregious violations. But, he warned us, it is hard to challenge licenses, it takes a long time, and the Fairness Doctrine, which requires that all sides of a controversy of local importance must be presented, was under assault in Congress. (The Fairness Doctrine was soon dismantled, paving the way for television stations like Fox News). We needed to prove other violations, since the Fairness Doctrine violations, though egregious from our perspective, would not be seen as being so in Washington, D.C. So we went to work to compile a case against WBUZ's license renewal. We investigated their license-renewal application and discovered serious misrepresentations to the Federal Communications Commission (FCC) regarding their local programming and public surveys—as well as the apparent instance of racial discrimination.

On April 23, 1981, we filed *An Informal Objection to the License Renewal Application of* WBUZ with the FCC. The objectors were the Chautauqua County Rural Ministry, the Dunkirk-Fredonia League of Women Voters, and the Dunkirk-Fredonia Branch of the NAACP. Andrew Schwartzman of the Media Access Project in Washington, D.C., was our attorney. The *Informal Objection* is divided into two parts: 177 pages of information regarding areas where we believed WBUZ had violated FCC regulations, followed by over two hundred pages

of exhibits, including newspaper articles, information from WBUZ's public file, affidavits, and other material, that backed up our complaint. After we filed our *Informal Objection*, we received several anonymous calls about WBUZ. One person reported that WBUZ had run two on-air contests and then not given away the prizes. We checked into this and found it was true. This information was filed in an amendment to the *Informal Objection*.

That summer, Bruce and I were back in Scotland, where he was serving a Scottish church. One night, I dreamt *one of the leading racists threatens and attempts to rape me.* On the fourth of July, I dreamt *a vague but plaguelike evil is spreading through Dunkirk or, at least, affecting some people in Dunkirk. I have a strange intuitive feeling that the deaths are being caused by men. Men who get possessed and murder their wives.*

We returned from Scotland in August, and Bruce was appointed by the Dunkirk mayor to the Dunkirk Housing Authority and soon became its president. Our housing suits were settled out of court. The consent degree that the Department of Housing and Urban Development signed committed them to fund the building of the housing. Thus, despite that under President Reagan this housing program had been eliminated nationwide, HUD still had to fund the units in Dunkirk because of the consent decree. As president of the Dunkirk Housing Authority, Bruce oversaw the bidding, contracting, and building of the housing. Those ninety-six units were the last units under that program built by HUD anywhere in the United States.

After the *New York Times* described the problems besetting Dunkirk, including the issues with WBUZ, the Justice Department's Community Relations Services offered to mediate between WBUZ and those of us challenging its license. We agreed to their mediating assistance to work with Serafin to solve our disagreements. We also tried to help him find a buyer. He remained intransigent.

An administrative law judge held hearings in Jamestown to consider the information in the *Informal Objection*. He ruled that Serafin should lose his license to operate WBUZ. This decision was appealed to a three-person board, which issued an interim opinion. In 1986, as the FCC was slowly moving through the process of consid-

ering whether to grant WBUZ a renewal of its license, "What's Your Opinion?" was abuzz with fury.

Caller: I don't think you can get a fair hearing from a judge when Daddy is a judge.

(The WBUZ hearing was before an administrative law judge from Washington, not before any local judge.)

Serafin: Nobody ever gave me anything. I worked for everything I have. These people want to take it all away.

Caller: I don't know what these people are doing. I wish they would go south or something.

Serafin: The NAACP, I never had a problem with this group. I understand Carol Adams and her husband Bruce Buchanan were members of it and on the board of directors of the NAACP.

Caller: One of the guys on the NAACP was hired as a guard for Al Tech, and he only came in once a week and was finally fired.

Caller: The Rural Ministry should change its name to "hemorrhoid."

Caller: Carol Adams lives up on Pennsylvania Avenue. She lives in a house owned by the church. I doubt that she pays any local taxes. So she doesn't pay anything, except cause you trouble.

Caller: I don't know what's wrong with her.

Serafin: I have trouble figuring it out myself. . . . I think her father— he's a nice guy—should tell her off. They ruined this city by bringing in the money for those welfare people to come, and she doesn't pay any taxes. All she causes is trouble.

Caller: Her husband, who's supposed to be a minister, which I have doubts of, he owns nothing here. He pays no taxes. He's helping to tear the city apart with his wonderful wife here. I don't know why he gets to be on the housing authority and decide where the houses go. Why don't he stay in the pulpit and preach good will? I think he should go to California with his wife there—get on the first freight train and not get off 'til they get to California.

Caller: I think that Carol Adams should mind her own business and check her own backyard, too. They call themselves a holy family. Let's get a branch of the KKK up here and run them out of town.

They've done nothing for no one here except the colored people. Nobody likes them here, nobody wants them here. Let's get them out of here. They only help minorities.

Caller: Why don't you bring charges of harassment against Ms. Adams and that great minister? But don't take them to Mayville. Now I'm not against Judge Adams, he's a good friend of mine, what do you think?

Serafin: Well, that's a thought.

When fighting racists, one forfeits not only privacy but also privilege and whatever class status one has achieved or inherited. Both Serafin and the caller were anxious to distinguish between my father and me. The caller was a retired policeman; this may be why he remained deferential about my father's position.

Five more years transpired before our objection to the license renewal of WBUZ was upheld: "The flagrant, egregious actions of this licensee demonstrates that there is but one remedy: outright denial of renewal of license."[13] It wasn't because WBUZ had violated the Fairness Doctrine. WBUZ's other acts (specifically, its employment discrimination, fraudulent on-air contests, and its misrepresentations) turned out to be the compelling reasons it was denied its license renewal. If Serafin had only given us a chance to present the pro-housing viewpoint, those egregious violations would never have been discovered.

In 1991, WBUZ went off the air. We had hoped that Serafin would sell before this happened, so that the local station could continue to exist. But he refused. When interviewed by the local paper, Serafin continued to deflect any blame, saying, "I think the mistake I made was I dared to mess with Carol Adams."[14]

Ours was the only community-based challenge to a radio-station license to prevail during the Reagan administration. The Media Access Project's Andrew Schwartzman observed that the importance of the case was not that we established new case law; we did not. Instead, we proved that blatant employment discrimination, conducting fraudulent contests, and misrepresentation under oath

were sufficient bases for losing a license—even during the Reagan administration.

FEMINIST-VEGETARIAN THEORY

In 1987, Bruce and I moved to Dallas. Bruce needed to continue his ministry in another context, the housing had been built, and I was going to finish writing my book on feminism and vegetarianism. During the three-day road trip, I read Margaret Homans's *Bearing the Word*, which introduced me to the concept of "the absent referent."[15] Homans writes: "For the same reason that women are identified with nature and matter in any traditional thematics of gender (as when Milton calls the planet Earth 'great Mother'), women are also identified with the literal, the absent referent in our predominant myth of language . . . literal meaning cannot be present in a text; it is always elsewhere." I stopped reading. *The absent referent* . . . isn't that what animals are too? Politicized, the term defined animals consumed as meat and recognized the tension between presence/absence and living/dead. Without animals, there would be no meat eating, yet they are absent from the act of eating meat because they have been transformed through violence into food. Behind every meal of "meat" is an absence: the death of the animal whose place the "meat" takes. The absent referent is that which separates the flesh eater from the animal and the animal from the end product. The function of the absent referent is to allow for the moral abandonment of a being while also emptying violence from the language. *Hamburger, pork loin, drumstick*—there is no "who" in these words, so how can there be a being who has been harmed?

The next morning, I realized that women, too, were absent referents in a patriarchal, meat-eating culture. By the time we arrived at Dallas, I had the organizing theory for my feminist-vegetarian critical theory: a structure of overlapping but absent referents links violence against women and animals. I got to work writing the book as we unpacked and settled in. The following year, a friend nominated

[margin handwritten note: the literal is present in text. It is elsewhere]

us for a ten-thousand-dollar award for our creative use of law and legal institutions in a rural area where activism through the law had not been tried. We won the award, and with some of the money I bought a computer upon which, in 1989, I finished writing *The Sexual Politics of Meat.*

The Sexual Politics of Meat argues that a process of objectification, fragmentation, and consumption enables the oppression of animals. Animals are rendered beingless through technology, language, and cultural representation. Objectification permits an oppressor to view another being as an object. The oppressor then violates this being through objectlike treatment: e.g., the rape of women, which denies women freedom to say no; or the butchering of animals, which converts them from living, breathing beings into dead objects. This process allows fragmentation or brutal dismemberment and finally consumption. Once fragmented, consumption happens: the consumption of a being and the consumption of the meaning of that being's death, so that the referent point of meat changes. Consumption is the fulfillment of oppression, the annihilation of will, of separate identity. So too with language: a subject first is viewed, or objectified, through metaphor. Through fragmentation, the object is severed from its ontological meaning. Finally, consumed, it exists only through what it represents. The consumption of the referent reiterates its annihilation as a subject of importance in itself.

I found an overlap of cultural images of sexual violence against women and fragmentation and dismemberment of nature and the body in Western culture. I suggested that this cycle of objectification, fragmentation, and consumption linked butchering with both the representation and reality of sexual violence in Western cultures, normalizing sexual consumption. While the occasional man may literally eat women, we all consume visual images of women all the time.

The interlocking oppression of women and animals could also be found in the use of a dominant and domineering language in which the meaning of the violent transformation of living to dead is consumed and negated as it is "lifted" into metaphor and applied to women. This structure of overlapping absent referents also moves in the other direction, in which women's objectification becomes the

basis for cultural constructions about meat animals: women are animalized, and animals are feminized and sexualized. These acts are interrelated and interconnected. In *Neither Man nor Beast: Feminism and the Defense of Animals* and *The Pornography of Meat*, I extended my discussion of interconnected oppressions, arguing that the category of species in our culture carries gender associations. Even male domesticated animals are depicted as females in ads about turkey *breasts*, barbecues that portray pigs as buxom women wanting to be eaten, or "tasty chicks." Without the reproductive abuse of female animals, who are forced to manufacture "meat" for production through their *reproduction*, there would be no animal bodies to consume. Hostile terms for women such as cow, chick, sow, old biddy, and hen derive from female beings who have absolutely no control over their reproductive choices. Their ability to be exploited lowers their standing and gives a powerful, negative charge to the meaning of the slang arising from their exploitation. The category of gender in our culture carries species associations. Women are depicted as animals.

Why is the fate of domesticated animals so potently negative? In *Neither Man nor Beast*, I propose that in our culture, "meat" operates as a mass term defining entire species of nonhumans.[16] Mass terms refer to things like water or colors; no matter how much you have of it or what type of container it is in, it is still water. You can add a bucket of water to a pool of water without changing the water at all. Objects referred to by mass terms have no individuality, no uniqueness, no specificity, no particularity. When humans turn a nonhuman into "meat," someone who has a very particular, situated life, a unique being, is converted into something that has no distinctiveness, no uniqueness, no individuality. When one adds five pounds of meatballs to a plate of meatballs, it is more of the same thing; nothing is changed. But to have a living cow and then kill that cow, butcher that cow, and grind up her flesh, you have not added a mass term to a mass term and ended up with more of the same. You have destroyed an individual.

What is on the table in front of us is not devoid of specificity. It is the dead flesh of what was once a living, feeling being. The crucial point here is that humans make someone who is a unique being and

therefore not the appropriate referent of a mass term into something that is the appropriate referent of a mass term.

How do you make a person less of a human? Two of the most predictable ways are to make a person or a group of people into (false) mass terms and to view them as animals. Acts of violence that include animalizing language create people as false mass terms, since animals already exist in that linguistic no-man's land of lacking a recognizable individuality. Disowning our animal connections is part of dominance. By definition in this dominant culture, the human transcends animality. Western philosophy defined humanness not only as *not animal* but also as *not woman* and not "colored." In Western philosophy, the concept of manhood applied not just to adult men but to the attributes of being human—rationality, autonomy, unemotionality. Women's status is lowered by their being seen as animal-like; men's status is raised by their being seen as the definition of what is human.

REFLECTIONS ON INTERLOCKING OPPRESSIONS

Running the Hotline for Battered Women during the late 1970s and early 1980s introduced me to shocking examples of interconnected oppressions. At one point we were helping a woman who lived on a farm with her husband and her kids. She had called us; we had helped her get out and find a safe place to live. One Sunday, when her husband was returning his kids after his visitation with them, as they were about to get out of his pickup truck, the family dog ran onto the driveway. Her husband plunged the truck forward so that it ran over the dog; then he threw the truck in reverse and backed over the dog. He repeated this forward-backward motion many times. Then he got out of the truck, grabbed his shotgun, and, in front of his devastated family, shot the dog several times. His violence was a form of controlling behavior. Harming or threatening to harm pets is often one of the most effective ways to exert control over another.[17]

The traditional depictions of evolution from "ape" to *Homo sapiens*, in which a lumbering, bent-over creature eventually becomes bipedal, capture a prevailing myth of our culture—the natural progression of

evolution to its zenith, the white human male. Any close examination of these depictions reveals that it is always the white male human body that serves as the prototype. The evolutionary depictions reflect a series of cultural ideas, not only that humans are different from nonhumans but that men are different from women. Katherine Firth closely examined the way in which the traditional depictions of evolution were used in a computer ad. The final figure is not only standing erect but holding a Toshiba computer, the symbol of technology. Firth finds that the ad not only depicts human dominion over animals but also a further example of dominance. The man holding the computer and representing evolutionary triumph is clothed as a white-collar worker. The invisible blue-collar worker is not the culmination of evolution; the suit-wearing, upper-middle-class man is.[18]

With the housing battle, I encountered interlocking oppressions up close and personal. I experienced the animalizing mythos behind the Toshiba ad that celebrated white, upper-middle-class men's successes. It took me many years to think about it, but like many representations, it racializes *and* animalizes gender while engendering *and* animalizing race.

From the moment the anti-housing forces went from house to house asking, "Do you want your daughter to be raped by black a man?" they interwove racism, sexism, and speciesism. The archetypal rape scenario for white racists—the specter of the black male rapist—had been used as an excuse for lynching black businessmen and other independent black men earlier in the century. In 1980, it was called into service to defeat needed low-to-moderate-income housing. It became the organizing but rarely acknowledged mythology of our community.

This scare tactic, of course, did not tell the truths about rapes: the most frequent form of rape is rape by acquaintances—husbands, ex-husbands, lovers, and boyfriends.[19] Women have the most to fear from the men they know, especially their sexual partners. The racist mythology makes black men the scapegoats of the dominant culture's refusal to acknowledge the actual source of women's lack of safety. The real danger in the community was not black men but the men to whom women were married. The force of the mythology of black-

on-white rape in the United States often resulted in the neglect of the material, emotional, and spiritual needs of women of color who were raped. The *fear* of random black-on-white violence triumphs over the *fact* of interracial woman abuse and white-on-black rape as a form of racial terrorism.[20]

> When Black women were raped by white males, they were being raped not as women generally, but as Black women specifically: Their femaleness made them sexually vulnerable to racist domination, while their Blackness effectively denied them any protection. This white male power was reinforced by a judicial system in which the successful conviction of a white man for raping a Black woman was virtually unthinkable.[21]

Rape laws, it is said, were written to protect only white women, not black women, racializing womankind into two hierarchical groups— white property and black whore.

When Susan Estrich was raped in 1974, she was asked by a Boston policeman, "was he a *crow?*" that is, someone who was black, and not only black, but a stranger. In their books, that was *real rape.*[22]

Kate Clark analyzed reports about rape in the *Sun*, the UK tabloid with the largest circulation. The *Sun* uses subhuman terms for men who are strangers to their victims (the "real rapists," in Ehrlich's terms) and if the victim fits their sense of respectable women (property). These attackers are called *fiend, beast, monster, maniac, ripper.*[23]

In the United States, too, the "beast" language can be found. The rape and violent beating of a wealthy, white woman jogger in Central Park in 1989 provided the press with a field day for bestializing African American and Hispanic boys. They were *savage, a roving gang, a wolf pack*; she was their *prey.* (Only it turns out she wasn't. In 2002, DNA testing supposedly confirmed that she had been raped by someone other than these young men.)

Rapists aren't "beasts" or "animals." Generally, they plan their assaults. They target their victims. At the point at which humans are being the most deliberate in their actions, we call them "beasts." The

"lower" animals are not bestial; that is, they are not ruthlessly violent. They are not beings lacking in dignity or altruism.

Paul Hock's *White Hero, Black Beast* asserts that "the threatened assault of the ever erect black buck on the chaste white lady has dominated the mythologies of the American south for more than three centuries."[24] The events unfolding in my town weren't in the American South; they were in a small, industrial city in upstate New York. Predictably, racist, sexist whites responded to my involvement in this antiracist work with venom. I asked an ally to sit in on one of the organizational meetings of whites who were opposed to the public housing. She came back and reported the white men discussing "Carol Adams and her big black bucks."

In 1915, D. W. Griffith's *The Birth of a Nation* created the film stereotype of the "pure Black buck." As the film historian Donald Bogle describes them, "Bucks are always big baadddd niggers, over-sexed and savage, violent and frenzied as they lust for white flesh."[25] Bucks originally were adult male deer, antelopes, or rabbits.

In the "black man rapes white woman scenario," the violation inherent in the alleged rape was against the white male, who had to assert his right to protect his property. "Do you want *your daughter* . . . ?" Historically in the United States, there were times when white men alleged rape to hide the fact that a white woman had *chosen* to have an African American man as her partner. Not just the white woman but the idea of her as pure, virginal, and sexless had to be protected. Like the threat of lynching in its effect on all blacks, the fear of rape helped to keep white women subordinate, anxious, and dependent. It impugned black women by implying that black men preferred white women over them. And the idea of the black rapist also helped deflect attention from white men who, through rape, were sexually and racially terrorizing black women. The African American woman as victim became invisible.

By viewing African Americans as black beasts, European American men created two pornographic scenarios, one about rapacious black men lusting for white women and the other about lascivious black women available to anyone, man or beast. Both concepts

interacted with the notion of white women as pure, virginal, and sexless: "Black womanhood was polarized against white womanhood in the structure of the metaphor system of female sexuality, particularly through the association of black women with overt sexuality and taboo sexual practices."[26] Black men were seen as beasts, sexually threatening white womanhood—a white womanhood defined to aggrandize the sense of white manhood. Black women were seen as sexed and as not able to be violated, because they would enjoy anything—including sex with animals. Kimberlé Crenshaw explains how "rape and other sexual abuses were justified by myths that black women were sexually voracious, that they were sexually indiscriminate, and that they readily copulated with animals, most frequently imagined to be apes and monkeys."[27] The historian Winthrop Jordan observes that "the sexual union of apes and Negroes was *always* conceived as involving *female Negroes* and *male apes!* Apes had intercourse with Negro *women.*"[28] These representations still animate white racism. Crenshaw reports that into the 1990s, men who assaulted "black women were the least likely to receive jail time."[29]

George M. Fredrickson argues that "the only way to meet criticisms of the unspeakably revolting practice of lynching was to contest that many Negroes were literally wild beasts, with unconventional sexual passions and criminal natures stamped by heredity."[30] By animalizing blacks, the dehumanizing and destructive violence of lynching could be justified. And just so today, any racism that bestializes its victims enables its own self-justification.

The debate about why I had kept my maiden name upon marrying also highlighted the intersection of racism and sexism. The speculation that I had kept my maiden name because I was married to a black man illustrates white racists' logic for why a white woman would disavow her husband's name! The dilemma I then faced was this: if I said, "no, I am not married to a black man," this response would be interpreted as perpetuating a form of racism, for it would appear that I was disavowing the idea that I might marry a black man. On the other hand, if I reacted by not dealing with it, by not responding to this salacious interest in my life, this nonresponse would

allow it to remain a secret. As a secret, it would then feed their speculation about my motives. Either way, their concern was "what kind of man is she attached to?" They desired to place me within a male-identified environment while also looking for a way to discredit me.[31]

White racists could only explain my activism by salaciously sexualizing both my black colleagues and me, seemingly confirming Joel Kovel's observation about racism being inherently sexualized. Citing the charges of rape against black men for touching, approaching, looking at, being imagined to have looked at, talking back to, etc., a white woman, Kovel reports, "a mountain of evidence has accumulated to document the basically sexualized nature of racist psychology."[32] Neither the African American men nor I could be granted the notion of acting out of motives other than sexual ones. Because of my antiracist work, I could no longer be positioned as an innocent white girl, like those in the neighborhood who supposedly stood as ready targets for the mythological rapacious black man. I was now not virgin but whore. But still, I, a white person, was given "possession" (through the possessive "her" in the reference to "her big black bucks") of the (now animalized) African American men in these white men's fantasies. I, a white woman, was granted greater individuality than the black men being referred to. Completely erased in these white racists' discourses were black women, who were, in fact, the majority of the plaintiffs in the lawsuit.

A debate began in the community (from hairdressing parlors to factory lunchrooms) about the number of illegitimate children it was believed I had. (It ranged from one to six.) The ongoing interest in my supposed illegitimate children helped to forge a different image of me: not judge's daughter but poor white female trash. This language, too, has an animalizing subtext, having to do with uncontrolled and indiscriminate sexuality. Recently, I have discovered how images of poor white female "trash" are applied to pigs depicted as willing victims of barbeques.

Interlocking oppressions are revealed through the animalizing of humans (through racism, genocide, sexism). The idea of "animal" exists to disempower targeted or vulnerable humans.

After the publication of *The Sexual Politics of Meat*, I attended a meeting of the American Academy of Religion. A scholar who learned that I had written that book asserted that she believed "the most important thing is to help humans. How can we talk about animals when the homeless need us?" This is a very typical—and predictable—response to animal advocates. "Why aren't you doing something important like feeding the homeless?" an angry male student asked me in 2002 at Marist College, when I invited questions from the audience after showing *The Sexual Politics of Meat Slide Show*.

This confrontational response to my work puts me in mind of my mother, who has dementia. When she looks at me, it is hard for her to recognize me as her daughter "Carol," because the "Carol" she remembers is fifteen years old, or thirty, but surely her daughter Carol can't be as old as this woman who appears before her. A few years ago, I took her along to help me pick out a new refrigerator for their house. We figured it would be something enjoyable for her. But she became furious when I told her what it cost. She said, "We've never paid that much for a refrigerator. You must tell them we don't want it." I suggested we talk about it outside, rather than within hearing of the salespeople. Sadly, I suggested this because I knew that when we got outside she would forget that she was angry and what had just made her angry. My mother was angry because the price of the refrigerator was registered in her mind as though it were 1950s or 1960s or 1970s dollars, when, of course, they never would have paid that much for a refrigerator. I have heard this called "retrograde memory." Her memory pulls up information from before Alzheimer's set in. This memory tells her that Carol is thirty and that refrigerators are not that expensive.

When people learn I am a vegan or the author of *The Sexual Politics of Meat*, they react with such vehemence and accuse me of not caring for (1) abused children, (2) the homeless, (3) the hungry, (4) battered women, (5) the environment, and (6) workers, among many other things. I guess I should be pleased that my veganism and/or

authorship of that book galvanizes people to demonstrate their concern for the disempowered; however, I am not sure that their awareness of the suffering of (1) abused children, (2) the homeless, (3) the hungry, (4) battered women, (5) the environment, (6) workers, and those other things lasts much longer than their conversation with me. Sometimes I laughingly claim that my veganism has prompted more people to announce their concerns for human suffering than my activism ever did. I marvel at the desperation of meat eaters to hold onto the idea that they are more humane than I am—or than any vegan is (I am just a very convenient target). Finding out they might be doing more, they accuse vegans of doing less. I believe we need a name for the reactions of people who start accusing animal activists of neglecting some form of human suffering when they learn we are vegan. I propose "retrograde humanism."

Retrograde humanism is a kneejerk reaction prompted by defensiveness. People want to believe that they are good. The structure of the absent referent, in which the animal disappears both literally and conceptually, allows them to believe that they are good people. Until they are among vegans or animal activists, the culture supports them in this belief. We animal activists restore the absent referent by talking about what animals experience. We are saying: You are either harming animals or you are not. There is no neutral position here. Which side are you on? We might not even be saying this verbally; simply the mere presence of a vegan prompts some degree of soul searching in others.

When people say we care more for animals than for human beings, I think they mean: Why aren't you caring for me? Why are you making me uncomfortable? When I experience retrograde humanism, the first thing I notice is its vehemence. It is insistent and often angry. What it reminds me of are those heated moments in the Dunkirk City Hall when the anti-housing group was trying, desperately, to keep control of the debate.

Like me, many vegans and animal activists have worked in homeless shelters or domestic violence shelters; they're social workers, housing advocates, etc. The overwhelming majority of people who

believe it is impossible to be both social activists in the conventional sense and animal activists are meat eaters, because they want to believe in its impossibility. Then they don't have to change.

Retrograde humanists clearly haven't figured out you can be doing both—working for social justice for human beings and for animals. Indeed, we could argue that in working for animals we are doing both, in that animal activists are including animals as a concern of social justice. We could argue this for many reasons, some of which end up reinforcing the human/animal division I would like to see eliminated. Slaughterhouses are deadly for animals, but they are also some of the most dangerous places for humans to work. Often, undocumented workers are employed there and have few protections against an overly rapid line speed. People who live near factory farms often get ill from the effluvia. Concentrated animal farm operations cause water pollution. Eating vegan can lower one's chances of high blood pressure, heart disease, high cholesterol, and diabetes. It reduces the suffering that these illnesses can cause.

Human-centered thinkers want to provide a human-centered critique of a theory or practice that decenters humans. They recenter humans by trying to expose that we have decided to *eliminate* humans from our realm of concern. They uphold the idea that humans must come first, all the while failing to recognize that incorporating animals into the dialogue and activism of social change doesn't eliminate humans from concern; it just reassembles the players by disempowering that human/animal boundary that enforces oppression. It refuses to view the world hierarchically.

People who may never have cared about the homeless before suddenly become possessed with indignation that I appear not to care about the homeless. I want to ask my interrogators, "Why are you so angry?" "Do *you* feed the homeless?" I want to point out that meat eaters tend to mention hungry children around the world when vegetarians/vegans talk about all the suffering animals go through—suffering that people are responsible for, given their choices to eat meat and eggs and drink cow's milk.

I still live in Dallas, where Bruce is the director of a homeless day shelter that provides about 1,400 homeless meals a day. He has over-

seen the feeding of more than two million people since we moved to Dallas. For many years, on a monthly basis, I picked up kung pao "chicken" donated by a vegan Chinese restaurant and delivered it to the Stewpot. So when I told my Dallas friends what happened at Marist College, the question "Why aren't you doing something important like feeding the homeless?" is very funny to them. They ask, "Well, so you told him that that's what Bruce does, right?"

Or they wonder if I answer by describing how in the 1980s I oversaw the first "census" measuring rural homelessness; the resulting report on rural homelessness was the only one of its kind in the country at that time and was utilized by members of Congress in 1988 when drafting and passing the Stewart B. McKinney Homeless Housing Act. I started "the Friendly Kitchen" to provide meals for those who needed free meals (there *is* such a thing as a free lunch). I wrote a grant request for one million dollars to restore an old building, which would have two apartments for those who were currently homeless to get back on their feet. I also advocated for a housing committee within the New York Governor's Commission on Domestic Violence and then chaired it, creating relationships among not-for-profit housing advocates with skills in housing and domestic violence service providers who needed help with creating second-stage housing (housing after one left the shelter, to avoid homelessness).

"You told him all that, didn't you?" my friends ask.

And I say, "No, I did not."

This shocks them. They ask, "Wouldn't that have shown up that student?"

"Only by affirming the legitimacy of his question," I reply. To describe this activism would accept his dismissal of all I had just said as I talked about the ideas of *The Sexual Politics of Meat*. I wasn't going to do this. Which is why I don't answer, "What makes you think I haven't worked for humans?" I am not going to accept his dualistic view of the world (you can be working for animals *or* you can be working for human beings). Why would I accept his analysis that all I had just said was immaterial if I weren't also feeding the homeless?

So, no, I did not say, "I *do* feed the homeless."

How does one answer the question without reinforcing its presumption—that human beings come first? Another possible response was, "Look at the human consequences of meat eating," and then to point out the environmental and health consequences of meat eating.

According to the *New York Times*, the late Dr. Carole C. Noon "was often asked why she spent so much time and energy caring for chimpanzees when children were going hungry. 'I'm always taken aback by the question because I don't view the world in two halves— eating chimps and starving children,' she said. She added, 'Except for a few percent of DNA, they're us.'"[33] Even arguing the connections between the treatment of humans and animals—the argument from interlocking oppressions—carries the message that humans will benefit from animal advocacy. As indeed they will. As long as the category of "animals" exists as way of lowering and demeaning humans, disempowered humans will be victimized by speciesist attitudes.[34]

But maybe the most important thing to say is that including the other animals within my social activism liberates me from calculations about being humane and what that means. I am charged by my critics as being somehow *less* humane because I include animals in my understanding of compassion. In that accusation, retrograde humanists reveal the human-inflected limitations to "humane" that haunt these discussions. Learning to feel compassion for animals enables one to approach the world, all of it, more compassionately. For me, it's not a restriction that closes up the heart and sends it in only one direction. Being alert to how animals experience their lives enriches my life, even when from that alertness I encounter overwhelming grief, sadness, and despair. I have learned that it is okay to feel grief and that grief may be inevitable in thinking about the lives of farmed animals, but that grief does not incapacitate me. It teaches me that we are connected and that my capacity for handling difficult emotions is much greater than I ever knew. (I wonder if, when it comes down to it, retrograde humanists are frightened by the overpowering sense of grief that they recognize they will experience if they engage with the lives of animals.)

The irony isn't that retrograde humanists would approve of my past activism. I don't want to prove my legitimacy according to their

human-centered standards. The irony is that I had to overcome my own humanocentrism to write *The Sexual Politics of Meat*. I know the costs of holding such an all-or-nothing viewpoint: they caused me to postpone writing. After all, the original insight about the connections had come to me back in 1974, but *The Sexual Politics of Meat* only appeared in 1990. The intervening time between idea and completion, between the desire to write and success at writing, was one of conflicted purpose. Why could I pull all-nighters writing grants for services for battered women, requests for the million dollars that funded the building that would help the homeless, or the *Informal Objection to the License Renewal of WBUZ*? Why could I sacrifice for these causes but not write my own book? I knew I had to honor the vision I had in 1974 regarding the connection. Yet there was illiteracy, poverty, discrimination, violence. Writing itself seemed a luxury in the face of urgent human needs. And then there was the topic: feminism *and* vegetarianism. Throughout the 1980s, the topic provided much entertainment for people. Especially painful were my meetings with battered women's advocates from across New York State. How could advocates against violence be eating a diet based on violence? But mine was a minority opinion.

I had to figure out how to be both an advocate and a writer. But more urgently, I had to figure out how to integrate my social justice concerns about illiteracy, poverty, discrimination, injustice, and violence with my fury about what was happening to the other animals. And in figuring this out, I became the person who could write *The Sexual Politics of Meat*.

TELEOLOGICAL FULFILLMENT

On the other side of retrograde humanism is the ardent belief that some animal activists hold that animal rights activism is the teleological fulfillment of human rights activism. I think some of his readers—who then became animal activists after reading *Animal Liberation*—conclude that Peter Singer has made a teleological statement in his preface. To wit: "There's been Black Liberation,

Gay Liberation, Women's Liberation. Now let's talk about Animal Liberation."[35] Reading this, some animal activists conclude, "Well, Black Liberation, Gay Liberation, Women's Liberation—that's been done. I need only to focus on animals." Separating animal liberation from feminism and other social justice issues promotes social injustice. Sexually exploitative vegan and animal activism can be traced from the 1980s to the present, including a short-lived vegan strip club. People for the Ethical Treatment of Animals often relies on different forms of human oppression as it seeks to release animals from oppression. PETA draws on all the pornographic conventions that advertisers draw upon. They exploit the association of women and death ("I'd rather be dead than wear fur"). They project adult male sexuality onto younger women (the Lolita model). They place women in cages, encouraging the human male to experience himself as superior. Not only is this wrong, as it maintains the objectification of women, but, as I argue in *The Pornography of Meat*, it is inappropriate activism, because animals are thereby marked by gender as well as species.

Teleological fulfillment is simply the reverse of retrograde humanism. It results in evangelical-like activism rather than in a movement that seeks to transform social relations among people as well as between people and the other animals. For instance, during the 1990s, animal advocates proposed that child offenders be tried as adults for animal cruelty. But this proposal failed to take into account any understanding of the prison-industrial complex in the United States. As Patrick Kwan points out, "juveniles who are tried as adults are often held and sentenced to prison with adults, which make them prime targets for sexual and physical violence."[36] Such a sentence would appear to be a violation of international human rights law.

Over the years, numerous people have written me to say how *The Sexual Politics of Meat* changed their lives. I think one reason this book prompts such an intense response is because it gave voice to people's intuition that a connection existed between social justice issues and animal issues; that animal issues *are* social justice issues. They don't settle for either side of the retrograde humanism versus teleologi-

cal fulfillment debate because they understand that multiple oppressions are at work. Intersectional oppressions calls for intersectional activism. I know *The Sexual Politics of Meat* gave new justifications for caring about animals. It provided a theory for an activist life committed to change, to challenging objectification, and to challenging a culture built on killing and violence.

One way that I understand my activism is that it is an attempt to restore the absent referent. My writings are attempts to be faithful to the insight that the structure of the absent referent perpetuates violence. It means trying to keep the harm to individuals as a central point. The animals, like the rest of nature, are the raw materials upon which we construct our lives—literally—and upon which we construct our meanings of who we are: *human and not animal*. For retrograde humanism, the issue is not really children starving. The issue is to keep the absent referent from being restored. What evangelical-like animal activist groups fail to acknowledge is that in a culture of oppression, there are multiple absent referents—both human and nonhuman animals. Equality, fairness, justice—these aren't ideas; they are a practice. We practice them when we don't treat other people or other animals as absent referents. We practice it when we ask, "What are you going through?" and understand that we ask the question because it matters to all of us what some are experiencing.

WHAT I LEARNED

Perhaps the greatest mistake I made in 1989 during the prepublication process for *The Sexual Politics of Meat* was to agree to listing myself as an "adjunct professor" at Perkins School of Theology. It was true that I was a visiting lecturer—I had conceived of and taught their first course on "sexual and domestic violence: pastoral and theological issues." But since my graduation from Yale Divinity School in 1976, I had been an activist, not an academic. When *The Sexual Politics of Meat* was published, this biographical information misled many groups of people, most dramatically, right-wing commentators.

During the early 1990s, Rush Limbaugh feasted on *The Sexual Politics of Meat*, seeing it as the most egregious example of academic political correctness. But after my experience with Henry Serafin's comments about my life, Limbaugh seemed laughable.

I felt activists had been given the wrong message by my being listed as a lecturer. I was an adjunct professor; my theory had been honed through my activism, and my activism defined me much more intimately than any temporary academic label. As I explain in the preface to the tenth anniversary edition, *The Sexual Politics of Meat* exists because of activism. It is engaged theory, theory that arises from anger at what is, theory that envisions what is possible. *Engaged theory makes change possible.*

One of my journal notes from the early 1980s says:

> *Being an advocate in the pure sense of the word*
> *is not being a legal technician though trying to line up legal*
> * expertise and guidance*
> *is being willing to risk with people*
> *is living on the raw edge of experience*
> *being forced to be a filter*
> *to let a variety of experiences filter, move through you.*

Along Western New York, one finds reminders of the former strength of steel plants. Just as steel is thrust into furnaces of three hundred to five hundred degrees Fahrenheit and becomes tempered, so too with me. Activism tempered me, strengthening me.

My activism enlarged my understanding of what courage is. I once heard my father telling someone about his World War II experience as a submariner. His captain had said, "Anyone can be brave during a depth charge; there's nothing else you can do but survive it." What is really courageous is to get back into a submarine knowing that at some point you are *going to be* depth charged.

I wasn't courageous in 1978 when I began advocating for fair housing, because I assumed not only that I was right but that I could convince others. I was naïve and did not anticipate the consequences of challenging injustice.

I *was* courageous when I continued acting for what was right despite the consequences. In activism, no guarantee of outcome exists. You take the stance because you know the absent referent is not absent at all but is instead awaiting acts of solidarity that transform the structures creating the absence.

Courage is not so much *an act* as a *commitment to a process.* All I needed in 1978 was the courage to take the next step. First, we tried education. When that failed, we pursued litigation. When there was a backlash, we consolidated. Then we went on the offensive and challenged the radio station. Each step became the self-evident one because of the previous step. We did not have a map for our path. We had conviction. Courage was my commitment to meet whatever happened as I took the next step. My inner self grew to meet the demands the activism required. You only have to have the courage to take the next step.

I learned activism can be very lonely. You do what you do because you believe it is important. Sometimes you are successful, and sometimes you aren't. You can't measure the success of your activism by that outward measurement.

Another of my hastily scribbled notes from the early 1980s reads:

Rules and Lessons of Organizing

Always use the facts—don't exaggerate them, you discredit your case at some later time (statistics re: housing)

Don't allow pettiness to involve you

Don't waste your time anticipating the comments of the opposition (they will always think of something outrageous about you)

That which is most natural about you will be most feared.

Always allow locals to speak.

Never lower yourself to your opponent's level.

Attempt at every chance for conciliation or mediation so that you can say when it's done we tried everything possible to work this out.

Don't waste your time defending yourself. Sometimes silence is the best choice; the art of embracing silence.

Learn to deal with your own anger.

Don't rush. Recognize that change takes time.

I did not know that the distance from the sudden revelation "there's a connection!" between meat eating and male dominance in the fall of 1974 and the publication of the book *The Sexual Politics of Meat* would be fifteen and a half years. In those years, I became the person who could write that book:

Focus/discipline/voice. My activism taught me *how* to write.
Connections/injustice/acknowledging harm/how privilege works. My activism taught me *perspective*—how to notice patterns of interlocking oppression in our culture.
Courage—my activism enlarged my ability to be courageous.

I needed all those to be the author of *The Sexual Politics of Meat*.

NOTES

This essay is dedicated to the memory of my mother, Muriel Kathryn Stang Adams (1914–2009), one of the founders of the Chautauqua County Rural Ministry in 1967, and my father, the Honorable Lee Towne Adams (1922–2010), their legal advisor for many years.

1. This essay is a part of a larger project reflecting on activism and consciousness-changing experiences in my life.

2. Charles Haddad, "Red-Hot Housing Debate Is Costing Dunkirk Millions," *Buffalo Courier-Express* (June 29, 1980): 1, D-13.

3. I draw on this insight in my book *Living Among Meat Eaters*, where I offer advice for talking with meat eaters (New York: Lantern Books, 2008).

4. Ted Lutz, "Council Hears Supporters, Opponents of Public Housing," *Dunkirk Evening Observer* (March 5, 1980): 1, 4.

5. Ted Lutz, "City's Blacks, Whites Exchange Barbs Over Public Housing Issue," *Dunkirk Evening Observer* (March 8, 1980): 1, 4.

6. Richards Lyons, "Mistrust Embroiling 2 Upstate Towns," *New York Times* (December 20, 1981).

7. Toni Morrison, *Playing in the Dark: Whiteness and the Literary Imagination* (New York: Random House, 1993). But see also Joel Olson's thoughtful *The Abolition of White Democracy* (Minneapolis: University of Minnesota Press, 2004).

8. Lyons, "Mistrust Embroiling 2 Upstate Towns," 61.

9. Haddad, "Red-Hot Housing Debate Is Costing Dunkirk Millions."

10. Quoted in Mari J. Matsuda, "Public Response to Racist Speech: Considering the Victim's Story," in *Words That Wound: Critical Race Theory, Assaultive Speech, and the First Amendment* (Boulder, Colo.: Westview Press, 1993), 23.

11. Matsuda, "Public Response," 24.

12. For information on the Media Access Project, go to http://www.mediaaccess.org.

13. *Catoctin Broadcasting Corp.*, 2 FCC Rcd 2126 (Rev. Bd. 1987). See also Douglas Turner, "Official Cites Racial Bias in Lifting Radio License," *Buffalo News* (August 23, 1986): C-4. See Esther B. Fein, "Fredonia Radio Station Is Denied License Renewal; Bias Is Charged," *New York Times* (August 23, 1986): 41.

14. Bill Dill, "Serafin to Appeal FCC Ruling on WBUZ License Renewal," *Dunkirk Observer* (February 24, 1989).

15. Margaret Homans, *Bearing the Word: Language and Female Experience in Nineteenth-Century Women's Writing* (Chicago: University of Chicago Press, 1986), 4.

16. Carol J. Adams, *Neither Man nor Beast: Feminism and the Defense of Animals* (New York: Continuum, 1994), 27–29.

17. See Carol J. Adams, "Woman-Battering and Harm to Animals," in *Animals and Women: Feminist Theoretical Explorations,* ed. Carol J. Adams and Josephine Donovan (Durham, N.C.: Duke University Press, 1995), 55–84.

18. Katherine T. Frith, "Undressing the Ad: Reading Culture in Advertising," in *Undressing the Ad: Reading Culture in Advertising,* ed. Katherine T. Frith (New York: Peter Lang, 1997), 1–14.

19. Diana E. H. Russell, *Rape in Marriage*, exp. and rev. ed. with new intro. (Bloomington: University of Indiana Press, 1990).

20. Angela P. Harris, "Race and Essentialism in Feminist Legal Theory," in *Feminist Legal Theory: Readings in Law and Gender*, ed. Katharine T. Bartlett and Rosanne Kennedy (Boulder, Colo.: Westview Press, 1991).

21. Kimberlé Crenshaw. "Demarginalizing the Intersection of Race and Sex: A Black Feminist Critique of Antidiscrimination Doctrine, Feminist Theory, and Antiracist Politics," in *Feminist Legal Theory: Readings in Law and Gender*, ed. Katharine T. Bartlett and Rosanne Kennedy (Boulder, Colo.: Westview Press, 1991).

22. Susan Estrich, *Real Rape* (Cambridge, Mass.: Harvard University Press, 1987), 1.

23. Kate Clark, "The Linguistics of Blame: Representations of Women in the *Sun's* Reporting of Crimes of Sexual Violence," in *The Feminist Critique of Language* (London: Routledge, 1998), 183–197.

24. Paul Hock, *White Hero, Black Beast: Racism, Sexism, and the Mask of Masculinity* (London: Pluto Press, 1979), 44.

25. Donald Bogle, *Toms, Coons, Mulattoes, Mammies, and Bucks: An Interpretive History of Blacks in American Films* (New York: Continuum, 2001), 13–14.

26. Hazel V. Carby, *Reconstructing Womanhood: The Emergence of the Afro-American Woman Novelist* (New York: Oxford, 1987), 32.

27. Kimberlé Crenshaw, "Whose Story Is It Anyway? Feminist and Antiracist Appropriations of Anita Hill," in *Race-ing Justice, Engendering Power: Essays on Anita Hill, Clarence Thomas, and the Construction of Social Reality*, ed. Toni Morrison (New York: Pantheon Books, 1992), 411.

28. Winthrop D. Jordan, *White Over Black: American Attitudes Toward the Negro, 1550–1812* (Baltimore, Md.: Penguin Books, 1969), 238.

29. Crenshaw, "Whose Story Is It," 413.

30. George M. Fredrickson, *The Black Image in the White Mind: The Debate on Afro-American Character and Destiny, 1817–1914* (New York: Harper & Row, 1971), 276.

31. Discussions with Mary Hunt, Marie Fortune, and Kathleen Carlin helped me to reflect on the implications of this dilemma.

32. Joel Kovel, *White Racism: A Psychohistory* (New York: Vintage Books, 1971), 67.

33. Carole C. Noon obituary, *New York Times* (May 7, 2009), http://www.nytimes.com/2009/05/07/science/07noon.html?_r=2&ref=obituaries.

34. See Carol J. Adams, "The War on Compassion," in *The Feminist Care Tradition in Animal Ethics: A Reader*, ed. Josephine Donovan and Carol J. Adams (New York: Columbia University Press, 2007).

35. Peter Singer, *Animal Liberation* (New York: New York Review Press, 1975).

36. Personal communication, used with permission. May 2009.

6

Compassion

Human and Animal

Martha C. Nussbaum

I think I could turn and live with animals, they are so placid and self-contain'd,
I stand and look at them long and long.
They do not sweat and whine about their condition,
They do not lie awake in the dark and weep for their sins,
They do not make me sick discussing their duty to God,
Not one is dissatisfied, not one is demented with the mania of owning things,
Not one kneels to another, nor to his kind that lived thousands of years ago,
Not one is respectable or unhappy over the whole earth.
So they show their relations to me and I accept them,
They bring me tokens of myself, they evince them
plainly in their possession.
　　　　　　　　　—Walt Whitman, *Song of Myself*

Frau von Briest had meanwhile sent in the coffee and was looking toward the round tower and the flower-bed. "Look, Briest. Rollo is lying in front of the gravestone again. He is more deeply affected than we are. He isn't even eating any more."

"Yes, Luise, animals. That's what I'm always telling you. We aren't as wonderful as we think. We always talk about their 'instinct.' In the end that is, after all, the best."...

[Frau von Briest now raises the question whether they, as Effi's parents, are to blame for the disaster: was she simply too young to be married?]

Rollo, who awoke at these words, wagged his head slowly back and forth, and Briest said softly, "Let it go, Luise, let it go ... that is too wide a field."
　　　　　　　　　—Theodor Fontane, *Effi Briest*

I

Human compassion is diseased, I do not speak primarily of its all-too-familiar failures of extent, the way we work up tremendous sympathy for thirteen people dead in Minnesota but have no emotional response to hundreds of thousands of people dead in Darfur. Those failures are common ground between humans and other animals,[1] and we may plausibly see a tendency to focus on the near at hand as part of our animal heritage, tenacious and difficult to overcome. No, I am speaking about failures of compassion that we would *not* expect to find in any other animal, cases of the most close-up and horrible human suffering that evoke, from its witnesses (and, often, perpetrators) no compassionate response. History, it often seems, is full of little else. Let me, however, confine myself to three closely related examples, cases in which it is plain not only that the emotional and moral failure in question is peculiarly human—an ape or elephant on the scene would do far better, or at least less badly—but also that the failure is at least partly explained by what the primatologist Frans de Waal has called "anthropodenial," the implicit denial (on the part of humans) that we are really animals.[2] It is no accident that all three of my cases concern misogyny, so often a prominent aspect of anthropodenial.[3]

To put my thesis in a nutshell: anthropodenial, a uniquely human tendency, is not simply a pernicious intellectual position; it is a large cause of moral deformity.

My first case is the ending of Theodor Fontane's novel *Effi Briest*.[4] Effi is married by her parents, at the age of sixteen, to a much older man who neglects her. Loneliness and immaturity lead her to have a brief affair, which she then breaks off, deciding that she did the wrong thing. She lives happily with her husband and child, until her husband, by sheer chance, discovers the long-ago indiscretion. At this point, husband, child, and parents all repudiate Effi, and she dies, miserable and alone. Only her dog Rollo feels compassion for her at the end of her life, attending to her supportively and seeming to understand her unhappiness; only he manifests deep sorrow after her death. The parents find themselves emotionally frozen: the

shame at being known as the parents of a fallen woman quite overwhelms their parental feeling. Looking at Rollo's unalloyed sadness, Effi's father concludes that in some ways animals behave better than humans.

My second case is Tolstoy's famous novella, *The Kreutzer Sonata*.[5] Describing the events that led him to murder his wife, the leading character describes a long-lasting pattern: the pressure of sexual desire compels him to have intercourse with her, and afterwards he feels revulsion. He sees her as bestial and himself as dragged unwillingly into the bestial by his bondage to desire. Only when he has finally killed her does she become, for him, an object of compassion: he tells his interlocutor, with evident sympathy for women's social situation, that women will never be treated as full human beings as long as sexual intercourse continues to exist. They will always be "humiliated and depraved slave[s]." The abuse he repeatedly inflicted on his wife by his repeated acts of sexual violence and nonconsensual intercourse caused her great pain, which he sympathetically describes. During her life, however, her pain never aroused compassion, because compassionate response was swamped by disgust at the bodily act to which her presence summoned him. Only when, being dead, she no longer arouses desire can she become an object of compassion. No nonhuman animal is mentioned, but it goes without saying that the twisted emotions of this man are all-too-human. Had the poor wife had a Rollo, he would have shown sadness at her suffering.

My third case is, sadly, reality rather than fiction. It concerns the massacre of two thousand Muslim civilians by Hindu mobs in the state of Gujarat, India, in February 2002.[6] During the pogrom, many women were tortured, raped, and burned: by one estimate, about half of the dead were women. A common device was to rape the woman, then torture her to death by inserting a large metal rod into her, and then torch her body. The horrible suffering of these women, which was later the occasion for a tremendous outpouring of compassion and helping behavior in the nation as a whole (as scholars and activists went to Gujarat to take down the testimony of survivors, help them file police reports, and write a record of the horrors for posterity), occasioned jubilation on the part of the Hindu right-wing

rioters, who produced pornographic hate literature celebrating their conquests. In one pamphlet circulated during the riots, written in verse, the chief minister of the state of Gujarat, Narendra Modi (who masterminded the pogrom) is imagined as raping to death a woman who is simply called "the mother of Muslims"; this iconic woman is imagined as dead because she is penetrated by an uncircumcised penis that becomes, somehow, a fatal weapon (remember those metal rods that were actually used to torture and kill women), yet, in the fantasy, she enjoys it to the last. The "poem" ends with a picture of the land of India completely cleansed of Muslims. Presumably, there can be no more of them, once the "mother of Muslims" is dead.

I don't even need to mention the fact that this orchestration of horror corresponds to nothing in the animal world.

Most discussions of the relationship between humans and animals, where empathy and compassion are concerned, focus on two things: *continuities* between human and animal emotion and *good discontinuities*, meaning discontinuities in which we humans have something morally valuable that animals don't have. Thus, Frans de Waal has consistently emphasized the way in which human sympathy, while in some ways more comprehensive than animal sympathy, is yet continuous with animal sympathy. He uses the image of a Russian doll: the outside doll is bigger, but inside we will find a little doll (the animal origins of the human emotion) that is in most respects isomorphic to the outer. Most of the commentators on de Waal's recent Tanner Lectures[7] grant that these continuities obtain and are important, but they focus on *good discontinuities*, stressing the fact that humans possess a range of desirable traits that nonhuman animals don't appear to possess.[8] These include the ability to choose not to act on some powerful desires, the ability to think about one's goals as a system and to rank and order them, the ability to think about the good of people (and animals) at a great distance from ourselves, and the ability to test the principles of our conduct for impartiality and respectfulness to the claims of others.

In this way, many if not most of the people who write on this topic evoke the image of a *scala naturae*, in which we humans are at the top, the largest Russian doll in the set of dolls, the only one who is capable

of full moral agency. Few mention the other side, the corruptions of sympathy that are so ubiquitous in human experience. Christine Korsgaard does prominently, if very briefly, acknowledge these, writing, in response to de Waal, "that human beings seem psychologically damaged in ways that suggest some deep break with nature."[9] On the whole, though, the recent discussion of the human-animal relationship, where compassion is concerned, neglects this "break," which it is my plan to investigate here. I begin by mapping out an analysis of compassion that I have proposed for standard human cases.[10] I then use this to investigate differences between human and animal compassion. This investigation will give us a set of reference points as we pursue our investigation of the "break." The end result, I hope, will be a picture slightly different from de Waal's, though agreeing with many of his most important claims: a picture in which the Russian doll on the outside is malicious and contorted, in ways that do not correspond to any deformation of the inside dolls.

In short, Walt Whitman's account of the animal kingdom (in my epigraph) is no doubt too rosy and a bit sentimental, but in its most essential aspects it is correct.[11] Animals do bring us "tokens of [ourselves]," and we should "accept them." As Whitman knows and emphasizes, however, acceptance of our animality involves an uphill battle against denial of animality and stigmatization of those whom a dominant group of humans views as quasi-animal (including prominently, in Whitman's universe, both women and African Americans). Animals don't have to fight that battle. They don't need a poem like Whitman's "I Sing the Body Electric"—because they are that poem.

Jonathan Glover's *Humanity* is a major achievement.[12] Like no other book known to me in philosophy, it takes on the challenge of describing the moral horrors of the twentieth century and dissecting them perspicuously, so that we can understand a little better what human failings produced them and how a program of moral education and culture-creation might begin to combat these failings. Richly detailed, informed by deep knowledge of history and psychology, the book goes further than any other I know, in any field, in presenting a rich and variegated understanding of inhumanity and its sources—in part because, being a philosophical book, it is so clear

and compellingly argued, in part because, being a book by a reasonable and open-minded man, it refuses to plump for one of the monocausal explanations of atrocity so common in the literature about the Holocaust, where we find endless and sometimes fruitless debate about whether the Final Solution was caused by family structure, or culture, or ideology, or universal human tendencies to submit to authority and peer pressure. "All of the above," is the obviously reasonable answer, but those who seek fame often eschew complexity in order to create a distinctive identity for themselves in the marketplace of ideas. Glover lacks such vices, and thus his book is delightfully complicated and nonreductive.

Despite its rich texture, however, there are two important silences, and the purpose of this paper is to continue and extend Glover's project by speaking about what he has chosen not to speak about. Much though Glover discusses human compassion,[13] he fails to include any discussion of the relationship between the human emotion and closely related emotions in the lives of nonhuman animals. Since I believe that I myself said too little about this question in *Upheavals of Thought*, this is an occasion to remedy that defect. Glover's second and related silence concerns the human denial of kinship with the animal and the misogyny that is all too often a concomitant of that denial, since women have repeatedly been portrayed as somehow more bodily than men, more viscous, less hard, with their indissoluble links to birth and sexual receptivity. At one point, Glover does broach this topic, when he discusses Klaus Theweleit's *Male Fantasies*, with its analysis of the wish of the German males in question to become men of steel, hard and superhuman.[14] Here Glover appears to endorse Theweleit's view that hatred of mere humanity is an important motive in bad behavior, saying, "Those who think of themselves as men of steel have to subdue anything which threatens to return them to the old type of person with soft flesh and disorganized human feelings."[15] He does not carry this analysis further, however—perhaps because he is skeptical of Theweleit's psychoanalytical orientation.[16]

The two silences are mutually reinforcing: not asking how human emotional experience differs from that of animals, Glover fails

to focus on the fear and hatred of mere animal existence that is so conspicuously absent in nonhuman animals and so ubiquitous in human animals. The failure to pursue this lead, in turn, means a failure to explore the topic of misogyny, such a prominent feature of males' hatred of their animal embodiment. Yet, it seems to me that the evidence for such emotional realities is as clear and compelling as the evidence for most of the other psychological responses that Glover does eloquently discuss. The emotions that I shall discuss have been studied by experimental psychology and by clinically and empirically oriented psychoanalysis, often in productive conversation with one another. Once one grants that emotions such as anger, disgust, and shame have an ideational content, one cannot avoid asking what that content is and how it relates to the peculiar situation of the human being, as a highly intelligent being in a weak and mortal body. Experimental psychologists have not evaded these questions, and the hypotheses I shall advance are as testable as anything in a psychology that eschews narrow behaviorism and insists on interpreting the intentional content of living creatures' responses—which is to say, I believe, the only sort of psychology that could possibly illuminate human emotional life.

I offer this analysis in the spirit of extension, not replacement, since, like Glover, I mistrust all reductive monocausal accounts of human depravity. I do so with the greatest admiration for Glover's philosophical courage and insight, here and elsewhere, and also with deep gratitude to a philosophical friend.

II

In *Upheavals of Thought*, I argue for an analysis of the human emotion standardly called "compassion" that derives from a long Western philosophical tradition of analysis and debate.[17] According to my account (to some extent agreeing with this tradition, to some extent criticizing it), compassion has three thoughts as necessary parts.[18] (I call them "judgments," but I emphasize elsewhere that we need not think of these thoughts as linguistically formulated or formulable,

although they do involve some type of predication or combination. Most animals can see items in their environment as good or bad, and this is all we are ascribing, in ascribing emotions to animals, defined as I define them.) First, there is a judgment of *seriousness:* in experiencing compassion, the person who feels the emotion thinks that someone else is suffering in some way that is important and nontrivial. I argue that this assessment is typically made, and ought to be made, from the point of view of an external "spectator" or evaluator, the person who experiences the emotion. If we think that the suffering person is moaning and groaning over something that is not really bad, we won't have compassion for that person. (For example, we don't feel compassion for rich people who suffer when they pay their taxes, if we think that it is just right that they should pay their taxes.) If we think, on the other hand, that a person is unaware of a predicament that is really bad (e.g., an accident that removes higher mental functioning), then we will have compassion for the person even if the person doesn't think his or her situation bad.

Second is the judgment of *non-fault:* we typically don't feel compassion if we think the person's predicament chosen or self-inflicted. This judgment, as we shall later see, is not a conceptual condition for all forms of compassion, since there are forms present in both the human and the animal cases that do not involve any assessment of responsibility. It is, however, a conceptual element in the most common forms of adult human compassion. In feeling compassion, we express the view that at least a good portion of the predicament was caused in a way for which the person is not to blame. Thus, Aristotle held that compassion for the hero of a tragedy views that hero as *anaitios*, not responsible for his downfall.[19] When we think that a person brought a bad situation on himself, this thought would appear to inhibit formation of the emotion. Thus, as Candace Clark has emphasized in her excellent sociological study of American compassion,[20] many Americans feel no compassion for the poor, because they believe that they bring poverty upon themselves through laziness and lack of effort.[21] Even when we do feel compassion for people whom we also blame, the compassion and the blame typically address different phases or aspects of the person's situation: thus we may blame

a criminal for a criminal act while feeling compassion for him, if we think that the fact that he got to be the sort of person who commits criminal acts is in large part an outgrowth of social forces.

Blame comes in many types, corresponding to different categories of fault: deliberate malice, culpable negligence, and so forth. These will remove compassion to differing degrees. People's responsibility for their predicaments can also be more or less serious, as a causal element in the overall genesis of the event. In many such cases, compassion may still be present, but in a weakened form. To the extent that compassion remains, it would appear that it is directed, at least in part, at the elements of the disaster for which the person was not fully responsible.

The tradition then includes a third allegedly necessary element of compassion, namely, the judgment of *similar possibilities.* The person who has compassion often does think that the suffering person is similar to him- or herself and has possibilities in life that are similar. This thought may do important work, removing barriers to compassion that have been created by artificial social divisions, as Rousseau valuably emphasizes in Book IV of *Emile.* For most humans, the thought of similar vulnerability probably is, as Rousseau argues, an important avenue to compassionate responding. I argue, however, that the thought of similarity is not absolutely necessary as a conceptual condition: we can in principle feel compassion for others without seeing their predicament as like one that we could experience.[22] Our compassion for the sufferings of animals is a fine example: we are indeed similar to animals in many ways, but we don't need that thought in order to see that what they suffer is bad and in order to have compassion for them. For the purposes of the present argument, however, we shall see that the thought of similar possibilities has considerable importance in preventing or undoing anthropodenial; its absence is thus a sign of grave danger.

Finally, there is a further thought that is not mentioned in the tradition, which, according to me, must be mentioned: it is what I call the *eudaimonistic judgment.* This is a judgment or thought that places the suffering person or persons among the important parts of the life of the person who feels the emotion. It says, "They count for me:

they are among my most important goals and projects." In my more general analysis of emotions, I argue that the major human emotions are always eudaimonistic, meaning focused on the agent's most important goals and projects and seeing the world from the point of view of those goals, rather than from some impersonal vantage point. Thus we feel fear about damages that we see as significant for our own well-being and our other goals; we feel grief at the loss of someone who is already invested with a certain importance in our scheme of things.

Eudaimonism is not egoism. I am not claiming that emotions always view events and people as mere means to the agent's own satisfaction or happiness; indeed, I strenuously deny this.[23] But the things that occasion a strong emotion in us are things that correspond to what we have invested with importance in our thoughts, implicit or explicit, about what is important in life. The thought of importance need not always antecede the compassionate response; the very vivid presentation of another person's plight may jumpstart it, moving that person, temporarily, into the center of the things that matter. Thus, when people hear of an earthquake or some other comparable disaster, they often become very focused on the sufferings of the strangers involved, and these strangers really matter to them—for a time. As Adam Smith already observed, however, using the example of an earthquake in China, this focus is unstable, easily deflected back to oneself and one's immediate surroundings, unless more stable structures of concern are built upon it that ensure a continued concern with the people of that distant nation.[24]

What of empathy?[25] I define empathy as the ability to imagine the situation of the other. Empathy is not mere emotional contagion, for it requires entering into the predicament of *another*, and this, in turn, requires some type of distinction between self and other.[26] Empathy is not sufficient for compassion, for a sadist may have considerable empathy with the situation of another person and use it to harm that person.[27] An actor may have consummate empathy with his or her character without any true compassion. (Indeed, an actor might play empathetically the part of a person to whom he or she deliberately refuses compassion, believing, for example, that the person brought

all his suffering on himself or that the person was upset about a predicament that is not really worth being upset about.)

Compassion is sometimes an outgrowth of empathy.[28] But it seems plain that we can have compassion for the suffering of creatures whose experience we cannot imagine well or, perhaps, even at all. Of course we need some way of making sense to ourselves of the idea that they are suffering, that their predicament is really bad. But I believe that we can be convinced that animals of various sorts are suffering in the factory food industry, for example, without making much of an attempt to imagine what it is like to be a chicken or a pig. So I would say that empathy is not necessary for compassion. Often, however, it is extremely helpful. Given the imperfection of the human ability to assess predicaments, we should try as hard as we can to imagine the predicaments of others and then see what we think about what we've imagined. I have also suggested that empathy involves something morally valuable in and of itself: namely, a recognition of the other as a center of experience. The empathetic torturer is very bad, but perhaps there is something worse still in the utter failure to recognize humanity.[29]

III

Now we are in a position to think about the continuities and discontinuities between human and animal compassion. The first thing to be said is that no nonhuman animal, so far as we know, has a robust conception of fault and non-fault; thus, the compassion of animals will potentially include many suffering people and animals to whom humans refuse compassion on grounds of fault. Animals notice suffering, and they notice it very keenly; they do not, however, form the idea, "This person is not a worthy object of compassion, because she brought her suffering upon herself." This difference is at work in my *Effi Briest* example: Effi's parents are blocked in their compassion for her suffering and her early death by the obsessive thought of her transgression against social norms. Although they are strongly inclined to have compassion when they see their child waste away,

they nonetheless cannot in the end experience that emotion, because of the power of the thought that their daughter has done one of the worst things imaginable. Effi's father wonders whether Rollo is not to that extent wiser than they are, because his displacement of feeling toward Effi is not blocked.

We see here a defect of my account in *Upheavals*, which I have already acknowledged in responding to John Deigh's excellent critique of the book: I do not mention that there is a type of human compassion that is in that sense very similar to Rollo's, focusing on suffering without asking the question of fault. Young children typically have that sort of compassion, as Rousseau observes in *Emíle*, saying of the boy's emotion: "Whether it is their fault is not now the question. Does he even know what fault is? Never violate the order of his knowledge . . ."[30] (Later on, *Emíle* does learn about fault, and this is an important ingredient of his social maturity, since compassion must be regulated by the sense of justice.)[31] Even after the notion of fault takes root, humans remain capable of the simpler type of compassion. The idea of fault, however, will often block this simpler type, as it does in the case of Effi's parents.

Further research in this area may show that some animals have a rudimentary idea of fault. To the extent that they have an idea of rule following, and of deviation from rule following, as does seem likely for some species, they may well be able to form the idea that some creatures bring their predicaments upon themselves by violating rules.[32] To the extent that they lack the idea that one can choose to pursue some purposes rather than others, however, they would not be likely to go very far in the direction of distinguishing appropriate from inappropriate choices. To the extent that they lack that conception, the idea of bringing misery on oneself would remain in a rudimentary form.

The comparison between humans and animals, then, must focus on the idea of seriousness, the idea of similar possibilities, and what I have called the eudaimonistic judgment. To move further, let us consider three examples of animal compassion or protocompassion.

Case A: In June 2006, a research team at McGill University[33] gave a painful injection to some mice, which induced squealing and writh-

ing. (It was a weak solution of acetic acid, so it had no long-term harmful effects.) Also in the cage at the time were other mice who were not injected. The experiment had many variants and complexities, but to cut to the chase, if the nonpained mice were paired with mice with whom they had previously lived, they showed signs of being upset. If the nonpained mice had not previously lived with the pained mice, they did not show the same signs of emotional distress. On this basis, the experimenters conclude that the lives of mice involve social complexity: familiarity with particular other mice prepares the way for a type of emotional contagion that is at least the precursor to empathy.

Case B: In Amboseli National Park in Africa, a young female elephant was shot by a poacher. Here is a description by Cynthia Moss of the reaction of other elephants in her group, a reaction typical in all three species of elephants:

> Teresia and Trista became frantic and knelt down and tried to lift her up. They worked their tusks under her back and under her head. At one point they succeeded in lifting her into a sitting position but her body flopped back down. Her family tried everything to rouse her, kicking and tusking her, and Tallulah even went off and collected a trunkful of grass and tried to stuff it into her mouth.

The elephants then sprinkled earth over the corpse, eventually covering it completely before moving off.[34]

Case C: George Pitcher and Ed Cone were watching TV one night in their Princeton home: a documentary about a little boy in England with a congenital heart ailment. After various medical reversals, the boy died. Pitcher, sitting on the floor, found his eyes filled with tears. Instantly their two dogs, Lupa and Remus, rushed to him, almost pushing him over, and licked his eyes and cheeks with plaintive whimpers.[35]

In the first case, we see something that we might call emotional contagion, that is, distress at the sight of another's distress, but we have no reason to ascribe to the mice any complex empathetic exercise of imagination and no reason to ascribe any sophisticated thoughts,

so, um what "genuine" emotion? counts!

such as the thought of seriousness or the thought of similar possibilities. I would therefore not be inclined to call the response a genuine emotion. The experiment is certainly interesting, showing a natural response to the sight of the pain of another that is certainly among the precursors of compassion. (Rousseau made much of this natural response, observing that the sight of pain is more powerful in this respect than the sight of happiness: thus our weakness becomes a source of our connection to others.) The most interesting feature, obviously, is the fact that the mice are moved by the plight of mice they know and not mice they don't know. This suggests a surprising degree of cognitive complexity and something like an ancestor of my eudaimonistic judgment. The mice are not precisely *thinking*, "These are my familiar pals, and their fate matters to me, whereas the fate of strangers doesn't matter"—but they have responses that are at least the basis for forming that very standard human thought. (Moreover, in humans the thought often influences action without being fully formulated, so humans are in that sense not always so far from these mice.) They have a personal point of view on the world that differentiates between some mice and other mice.

The second and third cases are rather similar, though with significant variations. In both, we see a recognition of the seriousness of the other creature's plight. The elephants are obviously aware that something major has happened to their friend: they recognize that her collapsed posture is the sign of some serious problem, and their increasingly frantic attempts to lift her up show their gradual awareness that the problem will not be rectified. Pitcher's dogs know him well; like the elephants, they see that something unusual is going on, something that looks serious. Notice that the thought of seriousness tracks the actual suffering manifested by the other party: there is not the same possibility as in the human case of forming the thought, "This person is moaning and groaning, but the plight is not really serious." Thus, if Pitcher were a rich person for whom the thought of paying a just amount of tax brought tears of suffering to his eyes, Lupa and Remus would behave in just the same way. On the other side, if Pitcher were in a seriously bad way without being aware of

it, and thus without manifesting suffering, the dogs would not have compassion for him.

Notice that, as in the case of Rollo and the Briests, there is a subtle difference between Pitcher's compassion for the little boy in the documentary and the compassion of the dogs for Pitcher, for the former is mediated by the thought of non-fault in a way that the latter is not. Pitcher draws attention to the fact that he was raised by a Christian Scientist mother who thought that children (and others) were always to blame for their illnesses, a very severe upbringing. Having rejected these ideas as an adult, Pitcher is able to see the little boy as a victim of circumstances. I think that his intense reaction to the documentary may have been connected to the thought of himself as a boy, cut off from compassion because of the blame that illness always brought with it: in part, he is having compassion for his own childhood self and the lack of care he experienced. The thesis of Pitcher's book is the Fontane-like thesis that dogs are capable of an unconditional type of love that humans have difficulty achieving: in that sense the often errant judgment of fault, with its ability to disrupt compassion, is very important to his whole analysis.

Pitcher, then, strongly suggests that the judgment of fault is always a defect and that animals are better off morally because they lack it. We should probably not follow him all the way. Dogs' inability to form the judgment of fault at times leads them to remain loyal despite cruel behavior. Women have frequently experienced a similar problem, and their failure to judge their abusers to be at fault can be a very serious failing. While not following Pitcher all the way to a fault-free doctrine of unconditional love, however, we can certainly observe that humans often find fault erroneously, hastily, and on the basis of bad social norms—as indeed Pitcher's mother did, blaming his illnesses on his own guilt. To that extent, looking to animals for guidance would seem to be a wise thing to do.

Turning now to the eudaimonistic judgment, we see that, as with seriousness, there is some reasonable analogue in our second and third animal cases. The elephants think that the well-being of their fellow female matters and their behavior betrays their sense of that

importance. The dogs, as is usual, ascribe immense importance to their narrow circle of humans and react to Pitcher's distress in a way that they would never react to the distress of a stranger.

Given that it has recently been shown that elephants can form a conception of the self, passing the mirror test,[36] we should probably conclude that the elephants' ability to form something like the eudaimonistic judgment is more sophisticated than that of the two dogs: having the ability to distinguish self from other, they are able to form a conception of the self as having a distinctive set of goals and ends, to a greater degree, at any rate, than is possible for animals who do not form a conception of the self.

There is something like the eudaimonistic judgment in our two animals cases, then, but there is no reason to suppose that this thought possesses much flexibility. Elephants care about other elephants and, above all, members of their group. (When they come upon the bones of other elephants, they attend to those bones with great concern, but they do not do this for bones of any other species.) Occasionally this concern is extended, through long experience, to a human who becomes something like a member of the group. Thus when the researcher Joyce Poole returned to Kenya after a long absence, bringing her baby daughter, the elephants who knew her greeted her with the ceremony of trumpeting and defecating that typically greets the birth of a new elephant baby.[37] Dogs are much more standardly symbiotic: indeed, far from showing particular concern for dogs as such, they are far more likely to include in the circle of concern whatever creatures they know and live with, including humans, dogs, and, occasionally, even cats or horses. In neither case, however, is the circle of concern very responsive to argument or education. We cannot expect elephants to learn to care for the survival of other African species, we certainly cannot expect predatory animals to learn compassion for the species they kill, and we cannot expect dogs to attach themselves to a person or dog without prolonged experience. In the human case, we hope, at least, that there is a good deal more flexibility than this: people can learn to care about the sufferings they inflict on animals by killing them for food; they can learn to care about the sufferings of people they have never met.

What about similar possibilities? Humans learn, fairly early, that there are some forms of vulnerability that human life contains for all: bodily frailty and disease, pain, wounds, death. Indeed, Rousseau believed that the inevitability of this learning was morality's great advantage in the war against hierarchy and domination: whenever a privileged group tries to think of itself as above the common human lot, this fragile self-deceptive stratagem is quickly exposed by life itself. Life is constantly teaching the lesson of human equality, in the form of exposure to a wide range of common human predicaments:

> Human beings are not naturally kings, or lords, or courtiers, or rich people. All are born naked and poor; all are subject to the miseries of life; to sorrows, ills, needs, and pains of every kind. Finally, all are condemned to death. This is what truly belongs to the human being. This is what no mortal is exempt from.[38]

So, to what extent do animals in our second and third cases form such ideas, and in what form? It seems likely that elephants do have some conception of death and of various related bad things, as standard events in elephant life. Their standard and almost ritualized responses to death indicate that they have at least a rudimentary conception of a species form of life and of the events that can disrupt it (or, as in the case of the birth of a child, enrich it). The fact that elephants can form a conception of the self is helpful in forming a conception of the elephant kind: for one can hardly recognize oneself as a member of a kind without recognizing oneself as a unit distinct from others. It seems less clear whether dogs have such ideas, though they certainly can remember experiences of hunger and pain, and, to that extent, conceive of such bad events as future possibilities for themselves.

IV

Animal compassion is limited, focused on the near-at-hand and relatively rigid. It is, nonetheless, rather predictable, and the natural

connection to the pain of another species' member remains relatively constant as a source of emotion in more sophisticated animals, despite variations in circumstance. Human compassion, as my opening cases suggest, is profoundly uneven and unreliable, in ways that make animals look, at times, like morally superior beings. Humans can markedly fail to have compassion for the very acute suffering of other humans, even their own children. They can also take a terrible delight in the infliction or the sight of suffering. Events that are paradigmatic occasions for compassionate response can elicit, instead, sadistic glee.

We can already see one way in which human compassion goes astray: through the judgment of fault. Having the generally valuable capacity to see ourselves as beings who can make choices, pursuing some inclinations and inhibiting others, we also develop the capacity to impute defective choice to others, and we inhibit compassion on that account. This capacity to think about fault and choice is generally valuable, a necessary part of moral life. Yet it can go badly astray. Sometimes it goes wrong because people want to insulate themselves from demands made by others. Thus, it is very convenient to blame the poor for their poverty and to refuse compassion on that account. If we think this way, we don't have to do anything about the situation of the poor.[39] Sometimes, defective social traditions play the deforming role: the idea that a woman who has sex outside marriage is for all time irredeemably stained, unworthy of friendship or love, was a prominent cultural attitude in nineteenth-century Germany, and it is this attitude that blocks the Briests from responding to their daughter's misery. Judgments of fault clearly suffer from a variety of distortions, which cannot be traced to a single source.

For the remainder of this chapter, however, I want to focus on just one central cause of distortion, which affects several of the thoughts intrinsic to compassion. This is what I have called "anthropodenial," the tendency of humans to define themselves as above the animal world and its bodily vulnerabilities. No other animal has this problem: no animal hates being an animal, wishes not to be an animal, tries to convince itself that it is not an animal. Anthropodenial has many aspects; let me, however, focus on its role in the generation of

two emotions that are particularly likely to interfere with the formation of appropriate compassion: disgust and primitive shame. (Here I can only briefly state the conclusions of my earlier work on these two emotions, in both *Upheavals of Thought* and *Hiding From Humanity*.)[40]

Human infants are extremely needy, physically helpless for far longer than the young of any other animal species. They are also extremely intelligent, able, for example, to recognize the difference between one human individual and another at a far earlier age than had previously been understood—around the age of two weeks, when infants are able to differentiate the smell of their own mother's milk on a breast pad from the smell of another woman's milk. The ability to distinguish reliably between the whole self and another whole self takes a bit longer, but it arrives early too, and between six months and a year a child becomes aware that it is not part of a symbiotic world of nourishment but a distinct member of a world whose other members sometimes care for its needs and sometimes do not.

The child's world is painful. It sees what it needs, and it cannot move to get it. It is hungry and thirsty, but sometimes it gets fed right away and at other times not. Always, it suffers—from hunger, excretory distress, sleep disturbances, and all the familiar miseries of infant life, most of them not worrying to the parent but profoundly agonizing to the infant. Sometimes, as in the womb, everything is perfect and the child is in a state of bliss, hooked up securely to sources of nourishment and pleasure; at other times, it is on its own and helpless. Unable as yet to form a secure conception of the likely return of comfort and security, it experiences (an inchoate form of) desolation and helplessness. Out of the infant's predicament, formed by the *sui generis* combination of helplessness with high cognitive ability, grow numerous emotions: fear that the needed things will never arrive; anger that they are being withheld; joy and even an incipient form of gratitude when needs are met; and, finally, shame.

Shame, in general, is a painful emotion directed at a perceived shortcoming or inadequacy in the self. What I call "primitive shame" is a shame that takes as its object the shortcoming of not being omnipotent. In a sense, a baby expects to be omnipotent, because its prenatal experience, and many of its postnatal experiences, are

experiences of a blissful completeness. It cannot yet comprehend the fact that the world has not been made for its needs, nor the fact that other human beings have their own entitlements and cannot minister constantly to the baby's needs. Its state, then, is one of what's often called infantile narcissism, so well captured in Freud's phrase "His Majesty the Baby." The flip side of infantile narcissism is primitive shame. "I'm the monarch, and yet, here I am, wet, cold, and hungry."

Shame, given narcissistic self-focusing, is connected to aggression: "I can't stand being this helpless, but it's your fault, since you are not waiting on me hand and foot." (Rousseau puts this very well in *Emile*, describing the way in which natural human weakness leads to a desire to turn others into one's slaves.) As time goes on, the infant's narcissism may to some extent be mitigated by the development of a capacity for genuine concern for others and compassion based upon that concern. Learning to get along on one's own also helps: if one can to some extent supply one's own needs, the need for slaves becomes less urgent—the root of the entire program of education in *Emile*. Nonetheless, no human being likes being helpless, and as the inevitability of death dawns on one more and more, we all realize that we are truly helpless in the most important respect of all.

As people struggle to wrest the world to their purposes and to deny the shameful fact of helplessness, it often proves useful to target a group of humans as the ones who are the shameful ones, the weak ones: we are strong and not helpless at all, because we are able to dominate them. Thus, most societies create subordinate groups of stigmatized individuals, whom ideology depicts as brutish, weak, and incapable of transcendence: we fittingly dominate them, because they are shamefully bestial, and we, of course, have managed to rise above our animality.

Disgust aids this strategy. Around the age of two or three, the infant begins to experience a very strong negative emotion directed at its own bodily waste products. Disgust has been the subject of some extremely good experimental work by Paul Rozin and others, and through a wide range of experiments they conclude that the primary objects of disgust are seen as contaminating to the self because they are reminders of our own animality: our own bodily waste products,

corpses, and animals who have properties that are linked with our own waste products, animality and mortality (ooziness, bad smell, etc.). I do not accept every detail of Rozin's argument, but in its basic lines it is very successful in explaining the occasions for disgust and its ideational content.

What is particularly interesting for our purposes is that people typically don't stop there. It's not enough to turn away from our own animality in revulsion: people seem to need a group of humans to bound themselves off against, who will come to symbolize the disgusting, the merely animal, thus bounding the dominant group off more securely from its own hated and feared traits. The underlying thought appears to be, "If I can successfully distinguish myself from those animalistic humans, I am that much further away from being merely animal myself." In most societies, women function as such disgust-groups; racial and ethnic minorities may also be stigmatized as dirty, smelly, slimy, animal-like. (African Americans and Jews have both been repeatedly stigmatized in this way.)

From this point onward, disgust and primitive shame work in close cooperation. Stigmatized as disgusting, subordinate groups are also branded as shameful: defective, unworthy, sullied, not able to rise to the heights of which transcendent humanity is capable. To the extent that the parties who are strenuously engaged in anthropodenial feel threatened, to that extent their stigmatization of the surrogates for their own animality becomes more aggressive.[41]

<center>V</center>

Now we are ready to understand how human compassion is infected by anthropodenial. Once one has targeted a person or group as emblematic of animal decay and animal weakness, this very segmentation of the moral universe will block the formation of an idea of similar possibilities and vulnerabilities. Instead of thinking, in Rousseauesque fashion, "The lot of these unhappy people could at any moment be my own," one will think, instead, "I am above all that. I could never suffer that." The disgusting bodily weakness of others,

the shameful condition of mere animal humanity, is seen as foreign: as the way *women's bodies* so often are, or the way *African American bodies* often have been. One may even become quite incapable of empathetic participation in the plight of these people: for one may see them as so brutish that they could not possibly have insides like one's own, and they are thus to be seen only as objects, the way humans frequently view animals.

This same deformed conception of the species infects the judgment of seriousness. If certain people are mere brutes, they cannot possibly suffer very much: they are just objects, automata, and the appearance of suffering does not reliably indicate a rich inner world, containing suffering similar to one's own.

Finally, shame and disgust infect the eudaimonistic judgment, the judgment of who belongs in one's circle of concern. Compassion is usually underinclusive, favoring the known over the not-known. That in itself poses a great challenge to moral education. In the cases that interest me, however, compassion also segments the known, judging some very familiar human individuals not truly worthy of concern.

Putting my claim this way, however, does not bring out the full riotousness of anthropodenial, its hysterical aggressiveness, driven by profound fear. As Rousseau noted, the denial of similar possibilities is a lie, a lie concerning important and obvious matters. And of course the disgust-and-shame-driven denial is a version of that lie. You have a body that smells and excretes. I have no such body. You will die. I will not die. You are weak. I am omnipotent. The falsity of these declarations periodically makes itself evident to the declarer— every time he excretes, has sex, gets ill. Then, the denial has to be made in a louder and more aggressive tone of voice, so that it drowns out the voice of truth. Thus a vicious ratcheting process begins, with the voice of anthropodenial more and more aggressive—until it demands the utter extinction of the being whose evident kinship to oneself inconveniently exposes the deception.

This vicious process is abetted by and, to an extent, embodied in stereotypes of masculinity that define the "real man" as one who is sufficient unto himself, in need of nobody, able to rise above the weakness of the mere animal body. In surprisingly many cultures,

males, particularly males who have long endured humiliation of some type, tell themselves that a real man must be able to throw off all weakness, like a very efficient machine, displaying his total lack of connection to female receptivity and weakness. One remarkable and extreme form of this view was the widely influential statement of the late nineteenth-century German sex theorist Otto Weininger that women are the body of the man and that men must repudiate all in themselves that is bodily, ergo female.[42]

Anthropodenial is thus linked with an aggressive and potentially violent misogyny, and it is in relations with women, far more than relations with subordinate ethnic or racial groups, that the anxiety about the unmasking of the lie becomes most prominent. Woman, because of her obvious connection with birth and sexual intercourse, comes to emblematize animal nature. The person who is desperate to deny animal nature must not only deny that he is a woman; he must also deny all commonality between him and the woman, imagining himself as sharing none of the inconvenient traits that make woman an object of disgust and shame. But he cannot avoid contact with women, as he may be able to avoid contact with Jews, or blacks, or Muslims. Indeed, he finds himself strongly desiring such contact and repeatedly engaging in very intimate forms of bodily exchange, involving sweat and semen and other signs of his own true nature.[43] So disgust (as so often) follows this descent into the animal, and the only way out of the disgust is to blame it on the woman, to accuse her of luring the otherwise transcendent being into the animal realm. As he repeatedly enters that realm, the denial of his membership must be made in a louder voice, and his conception of himself must be made more metallic, more invulnerable, until the demand for the total extinction of the female, both in the self and in the world, is the logical outcome. The female must be extinguished in the world because she is in the self. She can only cease to be in the self if she ceases to be in the world. And of course compassion, the affirmation of commonality and personal significance, will have been blocked long since.

Let us now return to my three cases, seeing how it happens that humans fall so far below the kindly dogs and elephants and even

below ferocious tigers and lions, who might kill a woman for prey, out of instinct, but not for self-insulation, out of fantasy and denial of their own nature. The case of Tolstoy's murdering husband is a classic case for my thesis. He clearly feels disgust for the female body and for the sexual act that draws him toward that body. At the same time, he cannot stop feeling himself drawn there, and the very strength of his desire threatens, again and again, to expose his project of rising above the animal. Sexuality and its vulnerabilities are difficult enough for any human being to deal with at any time. All cultures probably contain seeds of violence in connection with sexuality. But a person who has been taught to have a big stake in being above the sexual domain, above the merely animal, cannot bear to be dragged into that domain. Yet, of course, the very denial and repression of the sexual build within a mounting tension. (Tolstoy's diaries describe how the tension mounts and mounts inside him until he has to use his wife, and then he despises her, despises himself, and wants to use force against her to stop the cycle from continuing.) In the end, the husband sees, there is nothing to be done but to kill the woman. And the husband also suggests that there is no way for women to prevent themselves from being killed by men, unless they stop being animal, sexual bodies, forgoing intercourse. Join the project of anthropodenial, conceal your bodily nature, and you might possibly be saved. While his wife lives, he cannot have compassion for her, because he cannot see her as human: she is an animal, a brute, utterly dissimilar and terrifyingly similar. She is forcibly ejected from his circle of concern by the sheer terror that her presence arouses. Dead, she suddenly looks more like a nonanimal: she no longer has the animal magnetism that repels him; she seems like she might even have been a rational being.

Effi's parents fail to have compassion for her, despite her evident suffering—so moving to Fontane's reader, as to Rollo—because of a deformation in their judgment of fault, we said. But where does that deformation come from? As we soon see, studying the novel further, Effi's is a culture (like so many) that divides women into two types: pure angels, who are not animals, and disgusting whores, who are mere animals. There can be no compassion for the latter, because

their base nature brought calamity upon them, and it is just the normal outcome of having a base nature, not really a calamity at all. Thus the judgment of fault is interwoven with a defective judgment of similarity: much though we thought of her as our child, she must all along have had a disgusting nature, more like the nature of an animal. (That is why Frau von Briest's suggestion that Effi's misdeed resulted not from evil but rather from being married too young is so threatening to both of them: go down this track, and the whole balance of their human relations would have to be called into question.) They eject her from their circle of concern through their reasoning about dissimilarity and nature-based fault, and they will not permit truth and reason to threaten the self-protective structure they have built up. Rollo, for his part, thinks nothing of fault and sees only the immensity of Effi's suffering; nor does he segment the world into the pure and the impure. It never occurred to him that there was anything wrong with having a bodily nature.

While depicting the parents' warped judgments of fault, Fontane cultivates in his reader, from the novel's start, a Rollo-like disposition, unjudgmental, focused on actual suffering, and skeptical of social norms about women.[44] Indeed, the reader has for some time understood very well what the von Briests dimly intuit at the end, that Effi, high spirited and far from evil, was simply too young to get married. Guided by the nonmoral Rollo-like compassion that the reader has formed toward Effi from the very start of the novel, the reader forms judgments of fault at the end (blaming the parents, the husband, and the surrounding society) that are far more accurate than those formed by Effi's parents.

Now to Gujarat. Lurking beneath any culturally specific scenario lies the general human longing we have described: to escape from a reality that is found to be too dirty, too mortal, too decaying. For a group powerful enough to subordinate another group, escape may possibly be found (in fantasy) through stigmatization of, and aggression against, the group that exemplifies the properties the dominant group finds shameful and revolting in itself. When this dynamic is enacted toward women, who are at the same time alluring, the combination of desire and revulsion or shame may cause a particularly

unstable relationship to develop, with violence always waiting in the wings. Women of a minority group that has already been stigmatized as shameful become targets of reactive shame in a double, and doubly intense, way.[45] The body of the woman, always a convenient vehicle for such displacement, becomes all the more alluring as a target when it is the body of the discredited and feared "other," in this case the hyperfertile and hyperbodily Muslim woman.[46]

In the cultural and historical circumstances of (many) Gujarati Hindu males—to some extent real, to some extent fantasized—conditions are created to heighten anxiety and remove barriers to its expression. Ideology tells such men that they have for centuries been subordinated, first by Muslims and then by the British, and subordinated on account of a Hindu sexuality that is too playful, too sensuous, too unaggressive. To be as powerful as the Victorian conqueror, the Hindu male must show himself to be both pure and consummately warlike.[47]

At the same time, conditions that would have militated against these tendencies—a public critical culture, a robust development of the sympathetic imagination—were particularly absent in Gujarati schools and civil society. (Here my analysis converges very strongly with Glover's, in identifying a set of factors that might have blocked the turn to violence.) This specific cultural scenario explains why we might expect the members of the Hindu right, and the men to whom they make their political appeal, to exhibit an unusual degree of disgust anxiety, as manifested in a paranoid insistence on the Hindu male's purity and freedom from lust—and, at the same time, his consummate aggressiveness.

The hate literature circulated before the pogrom portrays the Muslim woman as hypersexual, enjoying the penises of many men. That is not by itself unusual; Muslim women have often been portrayed in that denigrating way, as closer to the animal than other women. But it then introduces a new element: the desire that is imputed to these women is to be penetrated by an uncircumcised penis. Thus, the Hindu male creates a pornographic fantasy with himself as its subject. In one way, these images show anxiety about virility, assuaging it by imagining the successful conquest of Muslim women.

But of course, like Tolstoy's husband's fantasies, these are not fantasies of intercourse only. The idea of this intercourse is inseparable from ideas of mutilation and violence. Fucking a Muslim woman just means killing her. The fantasy image of the untying of the penises that were "tied until now" is very reminiscent of the explosions of violence in Tolstoy, only the logic has been carried one small step further: instead of murder following sex, because of sex, the murder just *is* the sex. Women are killed precisely by having large metal objects inserted into their vaginas.

In this way, the image is constructed of a sexuality that is so effective, so closely allied with the desire for domination and purity, that its penis just is a pure metal weapon, not a sticky thing of flesh and blood. The Hindu male does not even need to dirty his penis with the contaminating fluids of the Muslim woman. He can fuck her with the clean nonporous metal weapon that kills her, remaining pure himself and securely above the animal. Sexuality itself carries out the project of annihilating the sexual. Nothing is left to inspire fear.

A useful comparison is the depiction of warlike masculinity in a novel of Ernst Jünger, *Kampf als inneres Erlebnis* (*Battle as Inner Experience*):

> These are the figures of steel whose eagle eyes dart between whirling propellers to pierce the cloud; who dare the hellish crossing through fields of roaring craters, gripped in the chaos of tank engines . . . men relentlessly saturated with the spirit of battle, men whose urgent wanting discharges itself in a single concentrated and determined release of energy.
>
> As I watch them noiselessly slicing alleyways into barbed wire, digging steps to storm outward, synchronizing luminous watches, finding the North by the stars, the recognition flashes: this is the new man. The pioneers of storm, the elect of central Europe. A whole new race, intelligent, strong, men of will . . . supple predators straining with energy. They will be architects building on the ruined foundations of the world.[48]

In this fascinating passage, Jünger combines images of machinery with images of male aggressiveness to express the thought that the

new man must be in some sense both predatory and invulnerable. The one thing he must never be is human. His masculinity is characterized not by animal need and receptivity but by a "concentrated and determined release of energy." He knows no fear, no sadness. Why must the new man have these properties? Because the world's foundations have been ruined. Jünger suggests that the only choices, for males living amid death and destruction, are either to yield to an immense and ineluctable sadness or to throw off the humanity that inconveniently inflicts pain.

Something like this paranoia, this refusal of compromised humanity, infects the rhetoric of the Hindu right and, indeed, may help explain its original founders' fascination with German fascism, as well as manifesting the influence, over time, of that same ideology. The woman functions as a symbol of the site of animal weakness and vulnerability inside any male, who can be drawn into his own mortality through desire. The Muslim woman functions doubly as such a symbol. In this way, a fantasy is created that her annihilation will lead to safety and invulnerability—perhaps, to "India Shining," the Jünger-like Hindu-right campaign slogan that betrays a desire for a crystalline sort of domination.[49]

Only this complex logic explains, I believe, why torture and mutilation are preferred as alternatives to abduction and impregnation—or even simple homicide. Only this logic explains why the fantasy of penetrating the sexual body with a large metal object played such a prominent role in the carnage. Only this explains, as well, the repetitious destruction of the woman's body by fire, as though the world cannot be clean until all vestiges of the female body are obliterated from its face.

Human beings are animals, and we inhabit the animal world. We should learn all we can from continuities between the emotions of humans and those of other animals. The diseases of human life, however, are, for the most part, diseases that are utterly foreign to the world of elephants and bonobos, even the more aggressive chimpanzees, because these diseases—many of them, at any rate—spring from a hatred of embodiment and death, of the condition of being an ani-

mal—and the human is the only animal that hates its own animality. Jonathan Glover's wonderful inquiry into human depravity refers, in its title, to a problem: "humanity" means the condition of being human, which we are stuck with, but it is also used by Glover to mean sympathy, respect, and kindliness, qualities opposed to "inhumanity," which, as he shows, we humans all too often exhibit. I have argued that "humanity," the condition of being (merely, animally) human, and our painful awareness of that nontranscendent condition are major sources of "inhumanity," the ability to withhold compassion and respect from other human beings. My argument suggests that a deeper inquiry into the unique problems humans have in dealing with their mortality, decay, and general animal vulnerability will help us understand inhumanity more fully. Without this further inquiry, indeed, we have little hope of coming up with an adequate account of gendered violence or of the aspects of violence in general that are implicitly gendered, involving a repudiation of the filth, stickiness, and nonhardness that are the lot of all human beings but that are all too often imputed to the female body alone.[50]

NOTES

I'm extremely grateful to the editors [of the volume in which this chapter was first published, N. Ann Davis, Richard Keshen, and Jeff McMahan] for their subtle and helpful comments.

1. Not, of course, that they count as failures in thinking about nonhuman animals.

2. See Frans de Waal, *Primates and Philosophers: How Morality Evolved* (Princeton, N.J.: Princeton University Press, 2006), appendix A, 59–67.

3. Thus "anthropodenial" is a trait that only humans can have: it is the tendency to deny our humanity, or to hide from it. It is conceptually possible for a different sort of animal to have a related flaw, denying that it is the species of animal that it is. In fact, however, this sort of denial appears to be present only in our species.

4. Published in 1894; my own translation from the German.

5. Published 1889; for its close relationship to Tolstoy's diaries concerning his sexual relationship with his wife, see Andrea Dworkin, "Repulsion," in *Intercourse* (New York: The Free Press 1987), 3–20.

6. See Nussbaum, *The Clash Within: Democracy, Religious Violence, and India's Future* (Cambridge, Mass.: Harvard University Press, 2007), particularly chap. 6, which cites the full text of the pamphlet.

7. de Waal, *Primates and Philosophers*.

8. See particularly the responses by Christine Korsgaard ("Morality and the Distinctiveness of Human Action") and Philip Kitcher ("Ethics and Evolution: How to Get Here from There") in de Waal, *Primates and Philosophers*, 98–119, 120–139.

9. Korsgaard, "Morality," 104. See also 118: "The distinctiveness of human action is as much a source of our capacity for evil as of our capacity for good."

10. In Nussbaum, *Upheavals of Thought: The Intelligence of Emotions* (Cambridge: Cambridge University Press, 2001), chap. 6; see also some elaborations in the response to John Deigh in "Responses," to the book and the symposium on that book in *Philosophy and Phenomenological Research* 68 (2004): 473–86 and in "Compassion and Terror," *Daedalus* (Winter 2003): 10–26.

11. This part of my argument will be closely related to chapters 5 and 15 (on Whitman) of Nussbaum, *Upheavals*, and especially to Nussbaum, *Hiding from Humanity: Disgust, Shame, and the Law* (Princeton, N.J.: Princeton University Press, 2004).

12. Jonathan Glover, *Humanity: A Moral History of the Twentieth Century* (London: Jonathan Cape, 1999).

13. He actually uses, throughout, the term "sympathy," but very much in the way that I use the term "compassion," so I hope I shall be forgiven to sticking to the usage I have already established; on the terms, see Nussbaum, *Upheavals*, 301–304. As I note there, Adam Smith uses "compassion" for fellow-feeling with another's pain, "sympathy" for the broader tendency to have fellow feeling with "any passion whatever." This difference is immaterial in the present context, since we are speaking of pain only.

14. Klaus Theweleit, *Male Fantasies*, 2 vols., English ed. (Minneapolis: University of Minnesota Press: 1987, 1989). See Glover, *Humanity*, 343.

15. Glover, *Humanity*, 343.

16. On *Humanity*, 343, Glover writes: "Like many Freudian interpretations, Theweleit's account is suggestive but hard to test." Elsewhere, however, Glover does draw attention to a related matter, the tendency of people to compare subordinate groups to animals: see, for example, 339.

17. Nussbaum, *Upheavals*, chap. 6, 304–335.

18. Again, see Nussbaum, *Upheavals*, 301–304; I avoid the term "pity" because, although used synonymously with "compassion" in translating Greek tragedies and Rousseau's French term *pitié*, in modern English it has acquired connotations of condescension and superiority that it did not have earlier, and I am focusing on an emotion that does not necessarily involve superiority.

19. See Nussbaum, *Upheavals*, chap. 6.

20. Candace Clark, *Misery and Company: Sympathy in Everyday Life* (Chicago: University of Chicago Press, 1997).

21. See my discussion of her findings in Nussbaum, *Upheavals*, 313–314.

22. See ibid., 315–321.

23. See ibid., 31–33.

24. Smith, *The Theory of Moral Sentiments*, ed. D. D. Raphael and A. L. Macfie (Indianapolis: Liberty Classics, 1976), 136: "Let us suppose that the great empire of China, with all its myriads of inhabitants, was suddenly swallowed up by an earthquake, and let us consider how a man of humanity in Europe, who had no sort of connexion with that part of the world, would be affected upon receiving intelligence of this dreadful calamity. He would, I imagine, first of all, express very strongly his sorrow for the misfortune of that unhappy people, he would make many melancholy reflections upon the precariousness of human life, and the vanity of all the labours of man, which could thus be annihilated in a moment. . . . And when all this fine philosophy was over, when all these humane sentiments had been once fairly expressed, he would pursue his business or his pleasure, take his repose or his diversion, with the same ease and tranquility, as if no such accident had happened. The most frivolous disaster which could befall himself would occasion a more real disturbance. If he was to lose his little finger tomorrow, he would not sleep tonight; but, provided he never saw them, he will snore with the more profound security over the ruin of a hundred millions of his brethren, and the destruction of that immense multitude seems plainly an object less interesting to him, than this paltry misfortune of his own."

25. See Nussbaum, *Upheavals*, 327–334.

26. For a similar view, see de Waal, *Primates and Philosophers*, 26–27; Nussbaum, *Upheavals*, 327–328.

27. For a similar argument, see de Waal, *Good Natured: The Origins of Right and Wrong in Humans and Other Animals* (Cambridge, Mass.: Harvard University Press, 1996), 41; Nussbaum, *Upheavals*, 329.

28. Important research on this topic has been done by C. Daniel Batson, whose experiments typically involve one group who are asked to imagine vividly the plight of a person whose story is being read to them and another group who are asked merely to assess the technical qualities of the broadcast. The first group is far more likely to report an experience of compassion and also more likely (indeed, very likely) to do something to help the person, provided that there is a helpful thing that is ready to hand and does not exact too high a cost. See Batson, *The Altruism Question* (Hillsdale, N.J.: Lawrence Erlbaum Associates, 1991).

29. See Nussbaum, *Upheavals*, 333: Here I discuss Heinz Kohut's remarks about the Nazis, and I consider a variety of different types of psychopaths.

30. Rousseau, *Emíle*, trans. Allan Bloom (New York: Basic Books, 1979), 224.

31. Ibid., 253. Rousseau puts the introduction of the idea of fault extremely late in the child's development: Emile is already going through puberty before he even experiences compassion (given Rousseau's belief that he will be turned toward others in the first place only by awakening sexual energy), and the thought of fault comes along considerably later than that. I think, by contrast, that children start to ask questions about fault as early as they are able to feel guilt about their own aggression, probably around the age of five or six, and it is only before that that their compassion is consistently of the simple Rollo variety.

32. See de Waal, *Good Natured*, 89–117; Marc Hauser, *Wild Minds: What Animals Really Think* (New York: Henry Holt, 2000), 249–253, argues for a thinner account of animal understanding of rules, denying any rich connection between rule following and moral agency.

33. Dale J. Langford, Sara E. Crager, Zarrar Shehzad, Shad B. Smith, Susana G. Sotocinal, Jeremy S. Levenstadt, Mona Lisa Chanda, Daniel J. Levitin, Jeffrey S. Mogil, "Social Modulation of Pain as Evidence for Empathy in Mice," *Science* 312 (2006): 1967–1970.

34. Cynthia Moss, *Elephant Memories: Thirteen Years in the Life of an Elephant Family*, 2nd ed. (Chicago: University of Chicago Press, 2000), 73; see also Katy Payne, "Sources of Social Complexity in the Three Elephant Species," in *Animal Social Complexity: Intelligence, Culture, and Individualized Societies*, ed. Frans B. M. de Waal and Peter L. Tyack (Cambridge, Mass.: Harvard University Press, 2000), 57–86.

35. George Pitcher, *The Dogs Who Came to Stay* (New York: Dutton, 1995), discussed in my *Upheavals*, 90, and in "Responses: Response to Deigh."

36. See Joshua Plotnik, Frans de Waal, and Diana Reiss, "Self-Recognition in an Asian Elephant," *Proceedings of the National Academy of Sciences*, published online October 30, 2006.

37. Joyce Poole, *Coming of Age with Elephants* (New York: Hyperion, 1997).

38. Rousseau, *Emíle*, 222 (with a few revisions to the Bloom translation: "Human beings" is substituted for "Men," "rich people" for "rich men," "the human being" for "man.")

39. Clark, *Misery and Company*, finds that this attitude is extremely common in America. Of course, even if we did believe that the poor are poor on account of bad choices, it would not follow that we should have no compassion for their situation: for, as Thomas Paine already observed in *The Rights of Man*, we might conclude that bad choices were themselves an outgrowth of stunting social circumstances, such as lack of adequate education and employment opportunities.

40. I give no references to the psychological literature here, since they are given in great detail in those two books, particularly the latter.

41. Glover draws attention to the many ways in which subordination and vio-

lence rely on stigmatization and disgust: see *Humanity*, especially 338–339, 340–342, 356.

42. Weininger, *Sex and Character*, anonymous translation from the sixth German ed. (London and New York: William Heinemann and G. P. Putnam's Sons, n.d.— the first German edition was published in 1903). This crazy book, written by a self-hating Jew and homosexual, had a huge influence and was considered by Ludwig Wittgenstein to be a work of genius. I discuss some of its wilder claims in *Hiding*.

43. A very good treatment of this question is in William Ian Miller, *The Anatomy of Disgust* (Cambridge, Mass.: Harvard University Press, 1997)—again, discussed in detail in *Hiding*.

44. See my more general study of Fontane's critique of social norms of gender and purity in "A Novel in Which Nothing Happens: Fontane's *Der Stechlin* and Literary Friendship," in *Wittgenstein and the Moral Life: Essays in Honor of Cora Diamond*, ed. Alice Crary (Cambridge, Mass.: The MIT Press, 2007), 327–354.

45. For the stigmatization of minorities as a device to cement a sense of national identity, see Nussbaum, *Clash*, chap. 6, drawing on George L. Mosse's classic, *Nationalism and Sexuality: Middle-Class Morality and Sexual Norms in Modern Europe* (Madison: University of Wisconsin Press, 1985).

46. For the role of a myth of the Muslim woman as hyperfertile—which plays a tremendously prominent role in Gujarati political rhetoric—see Nussbaum, *Clash*, chap. 6. Narendra Modi's campaign slogan, on the way to his landslide (postriot) electoral victory in 2002, was, "We are two and we have two; they are five and they have twenty-five." In other words, Hindus are monogamous and relatively chaste, only two children per couple; Muslims are polygamous, each man having four wives, and each wife, hyperfertile, has 6.25 children! In reality, the rate of polygamy is identical for Hindus and Muslims, around 5 percent (though it is illegal for Hindus and legal for Muslims), and the growth rates of the two populations are just the same and not very high.

47. See the cultural and historical material in Nussbaum, *Clash*, chap. 6, showing the way in which British contempt for the type of sexuality typical in Hindu mythology contributed to this pervasive climate of shame. A very perceptive example occurs in Rabindranath Tagore's novel *The Home and the World* (1916), concerning the rise of the Hindu nationalist movement. His nationalist antihero finds himself unable to rape the woman he desires, and he is ashamed of that failure. He muses to himself that there are two types of music: the Hindu flute and the British military band. He wishes he could hear in his blood the music of the military band rather than that disturbingly nonaggressive flute.

48. See discussion in Theweleit, *Male Fantasies*, 2:160–162; and in Glover, *Humanity*, 343.

49. Interestingly, L. K. Advani, the current leader of the BJP, the political party of the Hindu right, just announced that this slogan was a mistake: they should have said "India Rising." *Times of India* (December 17, 2007), http://timesofindia.india times.com/articleshow/2629479.cms. Advani, though a hardliner, is extremely perceptive, and he understands, it would seem, that the idea of purity and perfection offended rural voters, whose lives were not particularly shining. Perhaps, too, at a deeper level he understands the importance of not pretending to a manhood that is invulnerable and above others. (As I discuss in *Clash*, chap. 5, Advani's decision to make a respectful visit to the tomb of Mohammed Ali Jinnah, the founder of Pakistan, was greeted with hoots of outraged masculinity by many members of his own group, who accused him of "sucking Jinnah's cock" and other things of this sort.)

50. On filth as a Nazi preoccupation, see Glover, *Humanity*, 339, 356.

7

Down with Dualism!

Two Millennia of Debate About Human Goodness

Frans de Waal

We approve and we disapprove because we cannot do otherwise. Can we help feeling pain when the fire burns us? Can we help sympathizing with our friends? Are these phenomena less necessary or less powerful in their consequences, because they fall within the subjective sphere of experience?
—Edward Westermarck (1912)

Edward Westermarck's writings, including those about his journeys to Morocco, kept me busy as I leaned back in a cushy seat on a jet from Tokyo to Helsinki. More comfortable than a camel, I bet! I was on my way to an international conference in honor of the Swedish-Finn, who lived from 1862 until 1939 and who was the first to bring Darwinism to the social sciences.

His books are a curious blend of dry theorizing, detailed anthropology, and secondhand animal stories. He gives the example of a vengeful camel that had been excessively beaten on multiple occasions by a fourteen-year-old "lad" for loitering or turning the wrong way. The camel passively took the punishment but, a few days later, finding itself unladen and alone on the road with the same conductor, "seized the unlucky boy's head in its monstrous mouth, and lifting him up in the air flung him down again on the earth with the upper part of the skull completely torn off, and his brains scattered on the ground."[1]

I don't know much about camels, but stories of delayed revenge abound in the zoo world, especially about apes and elephants. We

now have systematic data on how chimpanzees punish negative actions with other negative actions—a pattern called a "revenge system"—and how if a macaque is attacked by a dominant member of its troop it will turn around to redirect aggression against a vulnerable, younger relative of its attacker.[2] Such behavior falls under what Westermarck called the "retributive emotions," but for him "retributive" went beyond its usual connotation of getting even. It included positive tendencies, such as gratitude and the repayment of services. Depicting the retributive emotions as the cornerstone of human morality, Westermarck weighed in on the question of its origin while antedating modern discussions of evolutionary ethics, which often take the related concept of reciprocal altruism as their starting point.[3]

That Westermarck goes unmentioned in the latest books on evolutionary ethics or serves only as a historic footnote is not because he paid attention to the wrong phenomena or held untenable views about ethics but because his writing conveyed a belief in human goodness. He felt that morality comes naturally to people. Contemporary biologists have managed to banish this view to the scientific fringes under the influence of the Two Terrible Toms—Thomas Hobbes and Thomas Henry Huxley—who both preached that the original state of humankind and of nature in general is one in which selfish goals are pursued without regard for others. Compromise, symbiosis, and mutualism were not terms the Toms considered particularly useful, even though these outcomes are not hard to come by in both nature and human society.

Are we naturally good? And if not, whence does human goodness come? Is it one of our many marvelous inventions, like the wheel and toilet training, or could it be a mere illusion? Perhaps we are naturally bad and just pretend to be good?

Every possible answer to these questions has been seriously advocated by one school of thought or another. I myself have struggled before with the question of human nature, contrasting the views of present-day biologists—from whom an admission of human virtue is about as hard to extract as a rotten tooth—with the belief of many philosophers and scientists, including Charles Darwin, that our species moderates its selfishness with a healthy dose of fellow-feeling

and kindness. Anyone who explores this debate will notice how old it is—including, as it does, explicit Chinese sources, such as Mencius, from before the Western calendar—so that we can justifiably speak of a perennial controversy.

WESTERMARCK BEATS FREUD

In a stately building on a wintry, dark Helsinki day, not far from his childhood home, we discussed Westermarck's brave Darwinism, which was initially applauded but soon opposed by contemporary big-shots such as Sigmund Freud and Claude Lévi-Strauss. Their resistance was so effective that the Finn has been largely forgotten.

His most controversial position concerned incest. Both Freud and many anthropologists were convinced that there would be rampant sex within the human family if it were not for the incest taboo. Freud believed that the earliest sexual excitations and fantasies of children are invariably directed at close family members, while Lévi-Strauss declared the incest taboo the ultimate cultural blow against nature— it was what permitted humanity to make the passage from nature to culture.

These were high-flown notions, which carried the stunning implication that our species was somehow predestined to free itself of its biological shackles. Westermarck didn't share the belief that our ancestors started out with rampant, promiscuous sex over which they gained control only with great difficulty. He instead saw the nuclear family as humanity's age-old reproductive unit and proposed that early association within this unit (such as normally found between parent and offspring and among siblings) kills sexual desire. Hence, the desire isn't there to begin with. On the contrary, individuals who grow up together from an early age develop an actual sexual *aversion* for each other. Westermarck proposed this as an evolved mechanism with an obvious adaptive value: it prevents the deleterious effects of inbreeding.

In the largest-scale study on this issue to date, Arthur Wolf, an anthropologist at Stanford University, spent a lifetime examining the

marital histories of 14,402 Taiwanese women in a "natural experiment" dependent on a peculiar Chinese marriage custom. Families used to adopt and raise little girls as future daughters-in-law. This meant that they grew up since early childhood with the family's son, their intended husband. Wolf compared the resulting marriages with those arranged between men and women who did not meet until their wedding day. Fortunately for science, official household registers were kept during the Japanese occupation of Taiwan. These registers provide detailed information on divorce rates and number of children, which Wolf took as measures of, respectively, marital happiness and sexual activity. His data supported the Westermarck effect: association in the first years of life appears to compromise marital compatibility.[4]

These findings are especially damaging to Freud, because if Westermarck is right, then Oedipal theory is wrong. Freud's thinking was premised on a supposed sexual attraction between members of the same family that needs to be suppressed and sublimated. His theory would predict that unrelated boys and girls who have grown up together will marry in absolute bliss, as there is no taboo standing in the way of their primal sexual desires. In reality, however, the signs are that such marriages often end in misery. Co-reared boys and girls resist being wed, arguing that they are too much like brother and sister. The father of the bride sometimes needs to stand with a stick by the door during the wedding night to prevent the two from escaping the situation. In these marriages, sexual indifference seems to be the rule and adultery a common outlet. As Wolf exclaimed at the conference, Westermarck may have been less flamboyant, less self-assured, and less famous than any of his mighty opponents; the fundamental difference was that he was the only one who was right!

A second victim is Lévi-Strauss, who built his position entirely on the assumption that animals lead disorderly lives in which they do whatever they please, including committing incest. We now believe, however, that monkeys and apes are subject to exactly the same inhibitory mechanism as proposed by Westermarck. Many primates prevent inbreeding through migration of one sex or the other. The migratory sex meets new, unrelated mates, while the resident sex

gains genetic diversity by breeding with immigrants. In addition, close kin who stay together avoid sexual intercourse. This was first observed in the 1950s by Kisaburo Tokuda, in a group of Japanese macaques at the Kyoto Zoo. A young adult male who had risen to the top rank made full use of his sexual privileges, mating frequently with all of the females except for one: his mother.[5] This was not an isolated case; mother-son matings are strongly suppressed in all primates. Even in the sexy bonobos, this is the one partner combination in which intercourse is rare or absent. Observation of thousands of matings in a host of primates, both captive and wild, has demonstrated the suppression of incest.

The Westermarck effect serves as a showcase for Darwinian approaches to human behavior because it so clearly rests on a *combination of nature and nurture*: it has a developmental side (learned sexual aversion), an innate side (the way early familiarity affects sexual preference), a cultural side (some cultures raise unrelated children together and others raise siblings of the opposite sex apart, but most have family arrangements that automatically lead to sexual aversion among relatives), a likely evolutionary reason (suppression of inbreeding), and direct parallels with animal behavior. On top of this comes the cultural *taboo*, which is unique for our species. An unresolved issue is whether the taboo merely serves to formalize and reinforce the Westermarck effect or adds a substantially new dimension.

That Westermarck's integrated view was underappreciated at the time is understandable, as it flew in the face of the Western dualistic tradition. What is less understandable is why these dualisms remain popular today. Westermarck was more Darwinian than some contemporary evolutionary biologists, who are best described as Huxleyan.

BULLDOG BITES MASTER

In 1893, before a large audience in Oxford, England, Huxley publicly tried to reconcile his dim view of the nasty natural world with the kindness occasionally encountered in human society. Huxley realized that the laws of the physical world are unalterable. He felt, however,

that their impact on human existence could be softened and modified if people kept nature under control. Comparing us with the gardener who has a hard time keeping weeds out of his garden, he proposed ethics as humanity's cultural victory over the evolutionary process.[6]

This was an astounding position for two reasons. First, it deliberately curbed the explanatory power of evolution. Since many people consider morality the essence of our species, Huxley was in effect saying that what makes us human is too big for the evolutionary framework. This was a puzzling retreat by someone who had gained a reputation as "Darwin's Bulldog," owing to his fierce advocacy of evolutionary theory. The solution that Huxley proposed was quintessentially Hobbesian in that it stated that people are fit for society only by education, not nature.

Second, Huxley offered no hint whatsoever where humanity could possibly have unearthed the will and strength to go against its own nature. If we are indeed born competitors who don't care one bit about the feelings of others, how in the world did we decide to transform ourselves into model citizens? Can people for generations maintain behavior that is out of character, like a bunch of piranhas who decide to become vegetarians? How deep does such a change go? Are we the proverbial wolves in sheep's clothing: nice on the outside, nasty on the inside? What a contorted scheme!

It was the only time Huxley visibly broke with Darwin. As aptly summarized by Huxley's biographer, Adrian Desmond: "[He] was forcing his ethical Ark against the Darwinian current which had brought him so far."[7] Two decades earlier, in *The Descent of Man*, Darwin had stated the continuity between human nature and morality in no uncertain terms. The reason for Huxley's departure has been sought in his suffering at the cruel hand of nature, which had just taken his beloved daughter's life, and in his need to make the ruthlessness of the Darwinian cosmos palatable to the general public. He could do so, he felt, only by dislodging human ethics, declaring it a cultural innovation.

This dualistic outlook was to get an enormous respectability boost from Freud's writings, which throve on contrasts between the conscious and subconscious, the ego and superego, Eros and Death, and

so on. As with Huxley's gardener and garden, Freud was not just dividing the world in symmetrical halves: he saw struggle everywhere! He explained the incest taboo and other moral restrictions as the result of a violent break with the freewheeling sexual life of the primal horde, culminating in the collective slaughter of an overbearing father by his sons. And he let civilization arise out of a renunciation of instinct, the gaining of control over the forces of nature, and the building of a cultural superego. Not only did he keep animals at a distance; his view also excluded women. It was the men who reached the highest peaks of civilization, carrying out tortuous sublimations "of which women are little capable."[8]

Humanity's heroic combat against forces that try to drag us down remains a dominant theme within biology today. Because of its continuity with the doctrine of original sin, I have characterized this viewpoint as "Calvinist sociobiology."[9] Let me offer some illustrative quotations from today's two most outspoken Huxleyans.

Declaring ethics a radical break with biology and feeling that Huxley had not gone far enough, George Williams has written extensively about the wretchedness of Mother Nature. His stance culminates in the claim that human morality is an inexplicable accident of the evolutionary process: "I account for morality as an *accidental* capability produced, in its boundless *stupidity*, by a biological process that is normally opposed to the expression of such a capability" (my italics). In a similar vein, Richard Dawkins has declared us "nicer than is good for our selfish genes" and warns that "we are never allowed to forget the narrow tightrope on which we balance above the Darwinian abyss." In a recent interview, Dawkins explicitly endorsed Huxley: "What I am saying, along with many other people, among them T. H. Huxley, is that in our political and social life we are entitled to throw out Darwinism, to say we don't want to live in a Darwinian world."[10]

Poor Darwin must be turning in his grave, because the world implied here is totally unlike what he himself envisioned. Again, what is lacking is an indication of how we can possibly negate our genes, which the same authors at other times don't hesitate to depict as all-powerful. Thus, first we are told that our genes know what is best for us, that they control our lives, programming every little wheel in the

human survival machine. But then the same authors let us know that we have the option to rebel, that we are free to act differently. The obvious implication is that the first position should be taken with a grain of salt.

Like Huxley, these authors want to have it both ways: human behavior is an evolutionary product except when it is hard to explain. And like Hobbes and Freud, they think in dichotomies: we are part nature, part culture, rather than a well-integrated whole. Their position has been echoed by popularizers such as Robert Wright and Matt Ridley, who say that virtue is absent from people's hearts and souls and that our species is potentially but not naturally moral.[11] But what about the many people who occasionally experience in themselves and others a degree of sympathy, goodness, and generosity? Wright's answer is that the "moral animal" is a fraud: "The pretense of selflessness is about as much part of human nature as is its frequent absence. We dress ourselves up in tony moral language, denying base motives and stressing our at least minimal consideration for the greater good; and we fiercely and self-righteously decry selfishness in others."[12]

To explain how we manage to live with ourselves despite this travesty, theorists have called upon self-deception and denial. If people think they are at times unselfish, so the argument goes, they must be hiding the selfish motives from themselves. In other words, all of us have two agendas: one hidden in the recesses of our minds and one that we sell to ourselves and others. Or, as the philosopher Michael Ghiselin concludes, "Scratch an 'altruist,' and watch a 'hypocrite' bleed." In the ultimate twist of irony, anyone who doesn't believe that we are fooling ourselves, who feels that we may be genuinely kind, is called a wishful thinker and thus stands accused of fooling himself![13]

This entire double-agenda idea is another obvious Freudian scheme. And like a UFO sighting, it is unverifiable: hidden motives are indistinguishable from absent ones. The quasi-scientific concept of the subconscious conveniently leaves the fundamental selfishness of the human species intact, despite daily experiences to the contrary.[14] I blame much of this intellectual twisting and turning on the unfortunate legacy of Huxley, about whom the evolutionary biologist Ernst Mayr didn't mince any words: "Huxley, who believed in

final causes, rejected natural selection and did not represent genuine Darwinian thought in any way. . . . It is unfortunate, considering how confused Huxley was, that his essay [on evolutionary ethics] is often referred to even today as if it were authoritative."[15]

MORAL EMOTIONS

Westermarck is part of a long lineage, going back to Aristotle and Thomas Aquinas, which firmly anchors morality in the natural inclinations and desires of our species. Compared to Huxley's, his is a view uncompounded by any need for invisible agendas and discrepancies between how we are and how we wish to be: morality has been there from the start. It is part and parcel of human nature.

Emotions occupy a central role in that, as Aristotle said, "Thought by itself moves nothing." Modern cognitive psychologists and neuroscientists confirm that emotions, rather than being the antithesis of rationality, greatly aid thinking. They speak of emotional intelligence. People can reason and deliberate as much as they want, but if there are no emotions attached to the various options in front of them, they will never reach a decision or conviction.[16] This is critical for moral choice, because if anything, morality involves strong convictions. These don't—or rather can't—come about through a cool Kantian rationality; they require caring about others and powerful gut feelings about right and wrong.

Westermarck discusses, one by one, a whole range of what philosophers before him used to call the "moral sentiments." He classifies the retributive emotions into those derived from resentment and anger, which seek revenge and punishment, and those that are more positive and prosocial. Whereas in his time there were few good animal examples of the moral emotions—hence his occasional reliance on Moroccan camel stories—we know now that there are many parallels in primate behavior. Thus, he discusses "forgiveness" and how the turning of the other cheek is a universally appreciated gesture: we now know from our studies that chimpanzees kiss and embrace and that monkeys groom each other after fights.[17] Westermarck sees

protection of others against offenders resulting from "sympathetic resentment"; again, this is a common pattern in monkeys and apes and in many other animals who stick up for their friends, defending them against attackers. Similarly, the retributive kindly emotions ("desire to give pleasure in return for pleasure") have an obvious parallel in what biologists now label reciprocal altruism, such as providing assistance to those who assist in return.[18]

When I watch primates, measuring how they share food in return for grooming, comfort victims of aggression, or wait for the right opportunity to get even with a rival, I see very much the same emotional impulses that Westermarck analyzed. A group of chimpanzees, for example, may whip up an outraged chorus of barks when the dominant male overdoes his punishment of an underling, and in the wild they form cooperative hunting parties that share the spoils of their efforts. Although I shy away from calling chimpanzees "moral beings," their psychology contains many of the ingredients that, if also present in the progenitor of humans and apes, must have allowed our ancestors to develop a moral sense. Instead of seeing morality as a radically new invention, I tend to view it as a natural outgrowth of ancient social tendencies.

Westermarck was far from naïve about how morality is maintained; he knew it required both approval and negative sanctions. For example, reflecting on an issue that today we might relate to developments taking place in South Africa's Truth and Reconciliation Commission, he explains how forgiveness prohibits revenge but not punishment. Punishment is a necessary component of justice, whereas revenge—if let loose—only destroys. Like Adam Smith before him, Westermarck recognized the moderating role of sympathy: "The more the moral consciousness is influenced by sympathy, the more severely it condemns any retributive infliction of pain which it regards as undeserved."[19]

The most insightful part of his writing is perhaps where Westermarck tries to come to grips with what defines a moral emotion as moral. Here he shows that there is much more to these emotions than raw gut feeling. In analyzing these feelings, he introduces the notion of "disinterestedness." Emotions, such as gratitude and re-

sentment, directly concern one's own interests—how one has been treated or how one wishes to be treated—and hence are too egocentric to be moral. Moral emotions, in contrast, are disconnected from one's immediate situation: they deal with good and bad at a more abstract, disinterested level. It is only when we make general judgments of how *anyone* ought to be treated that we can begin to speak of moral approval and disapproval. This is an area in which humans go radically farther than other primates.[20]

Westermarck was ahead of his time, and he went well beyond Darwin's thinking on these matters. In spirit, however, the two were on the same line. Darwin believed that there was plenty of room within his theory to accommodate the origins of morality, and he attached great importance to the capacity for sympathy. He by no means excluded animals from this view: "Many animals certainly sympathize with each other's distress or danger."[21] He has been proven right; laboratory experiments on monkeys and even rats have shown powerful vicarious distress responses. The sight of a conspecific in pain or trouble often calls forth a powerful reaction to ameliorate the situation. These reactions undoubtedly derive from parental care, in which vulnerable individuals are tended with great care, but in many animals they stretch well beyond this situation, including relations among unrelated adults.[22]

Darwin did not see any conflict between the harshness of the evolutionary process and the gentleness of some of its products. As discussed in the previous chapter [of *The Ape and the Sushi Master*] with regard to the distinction between motive and function, all one needs to do is make a distinction between how evolution operates and the actual psychologies it has produced. Darwin knew this better than anyone, expressing his views most clearly when he emphasized continuity with animals even in the moral domain. In *The Descent of Man*, he takes exactly the opposite position of those who, like Huxley, view morality as a violation of evolutionary principles: "Any animal whatever, endowed with well-marked social instincts, the parental and filial affections being here included, would inevitably acquire a moral sense or conscience, as soon as its intellectual powers had become as well developed, or nearly as well developed, as in man."[23]

There is never much new under the sun. Westermarck's emphasis on the retributive emotions, whether friendly or vengeful, reminds one of Confucius's reply to the question whether there is any single word that may serve as a prescription for all of one's life. Confucius proposed "reciprocity" as such a word. Reciprocity is also, of course, the crux of the Golden Rule ("do unto others as you would have them do unto you"), which remains unsurpassed as a summary of human morality.

A follower of the Chinese sage, Mencius, wrote extensively about human goodness during his life, from 372 to 289 B.C.[24] Mencius lost his father when he was only three, and his mother made sure he received the best possible education. The mother is at least as well known as her son and still serves as a maternal model to the Chinese for her absolute devotion.

Called the "second sage" because of his great influence, Mencius had a revolutionary bent in that he stressed the obligation of rulers to provide for the common people. Recorded on bamboo clappers and handed down to his descendants and their students, his writings show that the debate about whether we are naturally moral or not is ancient indeed. In one exchange, Mencius reacts against Kaou Tsze's views, which are strikingly similar to Huxley's gardener and garden metaphor: "Man's nature is like the *ke* willow, and righteousness is like a cup or a bowl. The fashioning of benevolence and righteousness out of man's nature is like the making of cups and bowls from the *ke* willow."[25]

Mencius replied:

> Can you, leaving untouched the nature of the willow, make with it cups and bowls? You must do violence and injury to the willow, before you can make cups and bowls with it. If you must do violence and injury to the willow, before you can make cups and bowls with it, *on your principles* you must in the same way do violence and injury to humanity in order to fashion from it benevolence and righteous-

ness! Your words alas! would certainly lead all men on to reckon benevolence and righteousness to be calamities.

Evidently, the origins of human kindness and ethics were a point of debate in the China of two millennia ago. Mencius believed that humans tend toward the good as naturally as water flows downhill. This is also evident from the following remark, in which he seeks to exclude the possibility of a double agenda on the grounds that the moral emotions, such as sympathy, leave little room for this:

> When I say that all men have a mind which cannot bear to see the suffering of others, my meaning may be illustrated thus: even nowadays, if men suddenly see a child about to fall into a well, they will without exception experience a feeling of alarm and distress. They will feel so, not as a ground on which they may gain the favor of the child's parents, nor as a ground on which they may seek the praise of their neighbors and friends, nor from a dislike to the reputation of having been unmoved by such a thing. From this case we may perceive that the feeling of commiseration is essential to man.

Mencius' example is strikingly similar to both the one by Westermarck ("Can we help but sympathize with our friends?") and Smith's famous definition of sympathy ("How selfish soever man may be supposed to be . . . "). The central idea underlying all three statements is that distress at the sight of another's pain is an impulse over which we exert no control: it grabs us instantaneously, like a reflex, leaving us without time to weigh the pros and cons. Remarkably, all of the alternative motives that Mencius considers occur in the modern literature, usually under the heading of reputation building. The big difference is, of course, that Mencius rejects these explanations as too contrived given the immediacy and force of the sympathetic response. Manipulation of public opinion is entirely possible at other times, he says, but not at the moment a child falls into a well.

I couldn't agree more. Evolution has produced species that follow genuinely cooperative impulses. I don't know whether people are,

deep down, good or evil, but I do know that to believe that each and every move is selfishly calculated overestimates human mental powers, let alone those of other animals.

Interesting additional evidence comes from child research. Freud, B. F. Skinner, and Jean Piaget all believed that the child learns its first moral distinctions through fear of punishment and a desire for praise. Like Huxleyan biologists who see morality as culturally imposed upon a nasty human nature, they conceived morality as coming from the outside, imposed by adults upon a passive, naturally selfish child. Children were thought to adopt parental values to construct a superego, the moral agency of the self. Left to their own devices, like the children in William Golding's *Lord of the Flies*, they would never arrive at anything close to morality.

Already at an early age, however, children know the difference between moral principles ("do not steal") and cultural conventions ("no pajamas at school"). They apparently appreciate that the breaking of certain rules distresses and harms others whereas the breaking of other rules merely violates expectations about what is appropriate. Their attitudes don't seem based purely on reward and punishment. Whereas pediatric handbooks still depict young children as self-centered monsters, we know now that by one year of age they spontaneously comfort people in distress and that soon thereafter they begin to develop a moral perspective through interactions with other members of their species.[26]

Rather than being nicer than is good for our genes, we may be just nice enough. Thus, the child is not going against its own nature by developing a caring, moral attitude, and civil society is not like an out-of-control garden subdued by a sweating gardener. We are merely following evolved tendencies.

How refreshingly simple!

NOTES

1. Westermarck (1912).
2. De Waal and Luttrell (1988) and Aureli et al. (1992).

3. For recent debate about evolutionary ethics, see the *Journal of Consciousness Studies* 7, nos. 1–2, edited by L. D. Katz (2000).

4. Wolf (1995). Others before him studied marriages in Israeli kibbutzim and found that children do not have sexual intercourse, let alone marry unrelated children of the opposite sex with whom they have grown up in the same peer group (reviewed by Wolf 1995).

5. Tokuda (1961–1962).

6. Huxley (1894).

7. Desmond (1994).

8. Freud (1913, 1930).

9. De Waal (1996a). See also Flack and de Waal (2000).

10. Williams, quoted in Roes (1998), Dawkins in *Times Literary Supplement* (November 29, 1996), and Dawkins in another interview by Roes (1997). The profound irony, of course, is that contrary to Dawkins's warning against a Darwinian world, such a world is eminently more livable than a Huxleyan one, which is devoid of natural moral tendencies. Dawkins seems almost a reincarnation of Huxley in terms of both combativeness (e.g., Dawkins 1998) and his departure from Darwinism. Notions such as that we are survival machines, that we are born selfish and need to be taught kindness, and especially that morality and biology are miles apart were alien to Darwin yet typical of Huxley. Darwin never looked at any lifeform as a machine. He had a Lorenz-like rapport with animals and didn't shy away from attributing intentions and emotions to them. Crist (1999) discusses at length Darwin's anthropomorphism, which has irritated some scholars but confirms that those with an integrated view of nature don't necessarily have a problem with it. Given their differences of opinion, Darwin couldn't resist referring, in his final letter to Huxley, to the latter's depiction of all living things (including humans) as machines: "I wish to God there were more automata in the world like you" (Cited in Crist 1999).

11. In view of their cynical positions, the titles of the books by Wright (*The Moral Animal*) and Ridley (*The Origins of Virtue*) don't exactly cover their message (Wright 1994; Ridley 1996).

12. Wright (1994).

13. Sober and Wilson (1998) write about this accusation: "We feel we should address a criticism that is often leveled at advocates of altruism in psychology and group selection in biology. It is frequently said that people endorse such hypotheses because they *want* the world to be a friendly and hospitable place. The defenders of egoism and individualism who advance this criticism thereby pay themselves a compliment; they pat themselves on the back for staring reality squarely in the face. Egoists and individualists are objective, they suggest, whereas proponents of altruism and group selection are trapped by a comforting illusion."

14. Ideas about the subconscious and its evolutionary raison d'être have been around since Badcock (1986) and Alexander (1987). The first explicitly sought to provide Freudian-Darwinian solutions to the "problem" of altruism.

15. Mayr (1997).

16. Damasio (1994).

17. Aureli and de Waal (2000).

18. Westermarck lists moral approval as a kind of retributive kindly emotion, hence as a component of reciprocal altruism. These views antedate discussions about "indirect reciprocity" and reputation building in the modern literature on evolutionary ethics (e.g., Alexander 1987).

19. Smith (1759).

20. These reflections by Westermarck parallel Smith's (1759) idea of an "impartial spectator."

21. Darwin (1871).

22. Reviewed by Preston and de Waal (in press).

23. Darwin (1871).

24. This makes Mencius a contemporary of Aristotle—born 384 B.C. in Greece—the first and foremost Western philosopher to root morality in human biology (Arnhart 1998).

25. All quotes are from Mencius (372–289 B.C.), *The Works of Mencius*.

26. Killen and de Waal (2000).

BIBLIOGRAPHY

Alexander, R. A. 1987. *The Biology of Moral Systems*. New York: Aldine de Gruyter.

Arnhart, L. 1998. *Darwinian Natural Right: The Biological Ethics of Human Nature*. Albany, N.Y.: SUNY Press.

Aureli, F., R. Cozzolino, C. Cordischi, and S. Scucchi. 1992. Kin-oriented redirection among Japanese macaques: An expression of a revenge system? *Animal Behaviour* 44: 283–291.

Aureli, F., and F. B. M. de Waal. 2000. *Natural Conflict Resolution*. Berkeley: University of California Press.

Badcock, C. R. 1986. *The Problem of Altruism: Freudian-Darwinian Solutions*. Oxford: Blackwell.

Crist, E. 1999. *Images of Animals: Anthropomorphism and Animal Mind*. Philadelphia: Temple University Press.

Damasio, A. R. 1994. *Descartes' Error: Emotion, Reason, and the Human Brain*. New York: Putnam.

Darwin, C. 1981 [1871]. *The Descent of Man, and Selection in Relation to Sex*. Princeton, N.J.: Princeton University Press.

Dawkins, R. 1998. *Unweaving the Rainbow: Science, Delusion, and the Appetite for Wonder.* New York: Houghton Mifflin.

Desmond, A. 1994. *Huxley: From Devil's Disciple to Evolution's High Priest.* New York: Perseus.

Flack, J. C., and F. B. M. de Waal. 2000. "Any animal whatever": Darwinian building blocks of morality in monkeys and apes. *Journal of Consciousness Studies* 7, no. 1–2: 1–29.

Freud, S. 1989 [1913]. *Totem and Taboo.* New York: Norton.

Freud, S. 1989 [1930]. *Civilization and Its Discontents.* New York: Norton.

Huxley, T. H. 1989 [1894]. *Evolution and Ethics.* Princeton, N.J.: Princeton University Press.

Killen, M., and F. B. M. de Waal. 2000. The evolution and development of morality. In *Natural Conflict Resolution*, ed. F. Aureli and F. B. M. de Waal, 352–372. Berkeley: University of California Press.

Mayr, E. 1997. *This Is Biology: The Science of the Living World.* Cambridge, Mass.: Belknap.

Mencius (372–289 B.C.). *The Works of Mencius.* Trans. Gu Lu. Shanghai: Shangwu Publishing House.

Preston, S. D., and F. B. M. de Waal. In press. The communication of emotions and the possibility of empathy in animals. In *Altruistic Love: Science, Philosophy, and Religion in Dialogue.* Oxford: Oxford University Press.

Ridley, M. 1996. *The Origins of Virtue.* London: Viking.

Roes, F. 1997. An interview of Richard Dawkins. *Human Ethology Bulletin* 12, no. 1: 1–3.

——. 1998. A conversation with George C. Williams. *Natural History* 5: 10–15.

Smith, A. 1937 [1759]. *A Theory of Moral Sentiments.* New York: Modern Library.

Sober, E., and D. S. Wilson. 1998. *Unto Others: The Evolution and Psychology of Unselfish Behavior.* Cambridge, Mass.: Harvard University Press.

Tokuda, K. 1961–1962. A study of sexual behavior in the Japanese monkey. *Primates* 3, no. 2: 1–40.

de Waal, F. B. M. 1996a. *Good Natured.* Cambridge, Mass.: Harvard University Press.

de Waal, F. B. M., and L. M. Luttrell. 1988. Mechanisms of social reciprocity in three primate species: Symmetrical relationship characteristics or cognition? *Ethology and Sociobiology* 9: 101–118.

Westermarck, E. 1912. *The Origin and Development of the Moral Ideas.* Vol. 1. London: Macmillan.

Wolf, A. P. 1995. *Sexual Attraction and Childhood Association: A Chinese Brief for Edward Westermarck.* Stanford, Calif.: Stanford University Press.

Wright, R. 1994. *The Moral Animal: The New Science of Evolutionary Psychology.* New York: Pantheon.

Addendum to Down with Dualism! Two Millennia of Debate About Human Goodness (2010)

Frans de Waal

Since I first wrote about animal empathy and the continuities with human morality, which was in my book *Good Natured* (1996), the topic has been enriched from many sides by neuroscientists, psychologists, and philosophers speculating about the evolution of the moral sense. Note, for example, the excellent contribution by Jonathan Haidt (2001), who explains the intuitive ways in which humans tackle moral dilemmas. Others have continued to explore how animal behavior throws light on this issue. These endeavors were greatly assisted by a study by my team on the sensitivity of monkeys to unequal pay (Brosnan and de Waal 2003), which has been interpreted as reflecting a sense of fairness.

Capuchin monkeys will happily perform a task for cucumber slices until they see others being rewarded with grapes, which taste so much better. They become agitated, throw down their measly cucumbers, and go on strike. A perfectly fine vegetable has become unpalatable! I have to think of their reaction each time I hear criticism of the bonuses on Wall Street.

As a result of these new developments, the field of moral evolution has become quite large and varied and now holds its own conferences and workshops. These are exciting times, but it is also evident that divisions remain. Some students of animal behavior go so far as to call animals "moral," whereas scholars in the humanities generally draw a sharp line and exclude animals from having moral tendencies. Most recently, in *Primates and Philosophers* (2006), I debated these issues with Robert Wright, Christine Korsgaard, Philip Kitcher, and Peter Singer, all of whom were sympathetic to the idea that human morality has roots in animal behavior, but they also insisted that I elaborate on the differences between the behavior of humans and other animals.

I think the differences are substantial and deserve as much attention as the similarities. But since the differences are typically emphasized over and over, often in the absence of any knowledge about animal behavior, I felt my book needed to stress that morality is not some invention of our species. It is not something we developed from scratch but an outgrowth of the social psychology that we inherited from our primate ancestors. I personally like to emphasize these continuities, as I also do in the chapter "Down with Dualism!" reprinted above.

At the same time, however, I should say that to call a chimpanzee a "moral being" seems incorrect, as there is no evidence that chimpanzees reach a reasoned position about what is right or wrong, nor do we have evidence that chimpanzees can act as disinterested judges of actions by others the way Adam Smith proposed as essential for morality (the "impartial spectator"). I alluded to this distinction between chimpanzees and humans when I wrote above that Westermarck tried to define how the moral emotions are special: "Moral emotions are disconnected from one's immediate situation: they deal with good and bad at a more abstract, disinterested level."

Thus far, this capacity for disinterested judgment (i.e., moral judgment of actions that have no implications for oneself) has not been demonstrated in any nonhuman animal. Although one should of course never say that it will never happen, for the moment my

position is that to call chimpanzees or other animals "moral" is a bit like calling them "linguistic" simply because we see parallels between animal communication and human language. These parallels do exist and are important, and apes can even learn certain elements of human language (such as the use of symbols), but this does not make them linguistic beings the way we are. In the same way, I think it is good to insist on the primate parallels and antecedents to human morality and to reject the Huxleyan view that morality falls outside evolution, yet to recognize that the differences remain enormous. In the end, a satisfactory account of how human morality evolved will need to address those differences as well.

Table 1 summarizes the similarities and differences as I see them. The aspect of social pressure is very important for human morality and is the subject of much ongoing research by economists and anthropologists (Gintis et al. 2005). We often confuse being moral with being nice, but of course morality also requires punishment of transgressors, and in this regard humans seem quite unique. There is also the reasoned aspect of our morality and the consensus building, which seem typically human and are probably linked to our language capacities. None of this takes away the continuities, and for those philosophers and other scholars who wish to insist on the differences between humans and other animals I have only one piece of advice: they will never understand the basis of human morality without paying close attention to our primate psychology and our need, like other primates, to get along within a group.

TABLE I

Level	Description	Humans and apes compared
1. Moral sentiments	Human psychology provides the "building blocks" of morality, such as the capacity for empathy, a tendency for reciprocity, a sense of fairness, and the ability to harmonize relationships.	In all these areas, there exist obvious parallels with other primates.
2. Social pressure	Insisting that everyone behaves in a way that favors a cooperative group life. The tools to this end are reward, punishment, and reputation building.	Community concern and prescriptive social rules do exist in other primates, but social pressure is less systematic and less concerned with the goals of society as a whole.
3. Judgment and reasoning	Internalization of others' needs and goals to the degree that these needs and goals figure in our judgment of behavior, including others' behavior that does not directly touch us. Moral judgment is self-reflective (i.e., governs our own behavior as well) and often logically reasoned.	Others' needs and goals may be internalized to some degree, but this is where the similarities end.

Note: Human morality can be divided into three distinct levels, of which the first one-and-a-half seem to have obvious parallels in other primates. Since the upper levels cannot exist without the lower ones, all of human morality is continuous with primate sociality.

Source: This table is reprinted from Frans de Waal, *Primates and Philosophers: How Morality Evolved*, ed. Stephen Macedo and Josiah Ober (Princeton, N.J.: Princeton University Press, 2006), 168.

Brosnan, S. F., and F. B. M. de Waal. 2003. Monkeys reject unequal pay. *Nature* 425: 297–299.

de Waal, F. B. M. 2006. *Primates and Philosophers: How Morality Evolved*, ed. S. Macedo and J. Ober. Princeton, NJ: Princeton University Press.

——. 1996. *Good Natured: The Origins of Right and Wrong in Humans and Other Animals*. Cambridge, Mass: Harvard University Press.

Gintis, H., S. Bowles, R. Boyd, and E. Fehr. 2005. *Moral Sentiments and Material Interests*. Cambridge, Mass.: The MIT Press.

Haidt, J. 2001. The emotional dog and its rational tail: A social intuitionist approach to moral judgment. *Psychological Review* 108: 814–834.

8

Avoid Being Abstract When Making Policies on the Welfare of Animals

Temple Grandin

In this chapter, I am going to discuss two main issues from the viewpoint of a person who has worked for thirty-five years finding practical ways to improve the treatment of cattle and pigs. I have worked to design better equipment and to teach people behavioral principles for moving and handling livestock.[1] The first issue is the importance of staying in touch with what is actually happening on the ground, in farms and in slaughter plants. This is important for implementing effective reforms. The second half of the chapter will discuss the use of animals for food. Before I delve into the issues, I would like to provide some background about myself.

During the 1970s, the main focus of my career was designing better equipment for handling cattle.[2] Cattle handling practices in the 1970s were rough and absolutely awful, and I worked hard to improve animal treatment. During the 1980s, I learned that I had to shift my focus, because better equipment alone could not completely solve all animal handling problems. Good equipment is essential for calm, careful animal handling, but it is useless unless it has good management to go with it. During the 1980s and early 1990s, I spent many weeks giving lectures and training feedlot and slaughter plant

employees on behavioral principles of cattle handling. I soon learned that training the managers was more important than training the employees. To make change take place, I had to convince the managers that calmer, gentler methods would be an economic benefit, by providing better animal weight gain, bruise reduction, and fewer accidents. Ethical reasons alone were not sufficient to convince the manager to change the practices.

In 1999, I was hired by McDonald's to implement animal welfare audits in slaughter plants. I trained their food safety auditors to use a simple objective scoring system for evaluating stunning and handling.[3] This resulted in some great improvements. When huge customers such as McDonald's, Wendy's, and Burger King started using their vast purchasing power to enforce standards, great improvements took place.[4] During 1999 and 2000, I witnessed more improvements than I had seen previously during a twenty-five-year career. My work on improving animal welfare has been recognized by animal advocacy groups such as PETA and the Humane Society of the United States (HSUS). I received the Joseph Wood Krutch Medal from the HSUS in 2001 and the Proggy Award from PETA in 2004.[5] My work has also been recognized by awards from the American Veterinary Medical Association and the Dodge Foundation.

WELFARE ISSUES STOP BEING ABSTRACT AND START BECOMING REAL

When I first started working with McDonald's, Wendy's, Burger King, and other companies, I took vice president–level executives on their first trips to farms, feedlots, and slaughter plants. When conditions were good, they were pleased, but when conditions were bad, they were shocked and horrified. I remember the day when one of the vice presidents saw a half-dead, emaciated old dairy cow walking up the ramp in a slaughter plant that made their hamburgers. This motivated this vice president to implement animal welfare auditing. In the mind of this executive, animal welfare had now changed from an

abstract issue that was delegated to the public relations department or to the company lawyers to something real that was causing suffering.

Executives in other industries have also had eye-opening experiences. I read an op-ed column in the *New York Times* about an executive who worked for a large health insurance company as the director of communications.[6] His job was to fight against reforms in health care that could hurt the profitability of his company. At the age of fifty-six, he quit his job after he visited a three-day charity health program that was held at the local fairgrounds. The sights of hundreds of desperate poor people receiving free health care from doctors working in the animal stalls changed his views on the need for health care reforms. His conscience started bothering him, and he could no longer help his insurance company employer fight reforms that would help these poor people. Both of these cases clearly illustrate the importance of actually observing the people or the animals that a policy has an effect on. I had the opportunity to watch many executives make the transition from considering changes in the abstract to actually mobilizing their companies to make real reforms.

I AM A VISUAL THINKER

I am a visual thinker, and I do not think purely in words.[7] My work has been hands-on out in the field. Half the cattle in North America are handled with equipment I have designed.[8] My ability to think in pictures has really helped me to understand animal behavior and design better facilities for handling them.[9] To understand anything, I have to have a picture in my imagination. If I have no picture, I have no thought.

Compared to other authors in this book, my approach to animal welfare issues will be much less abstract. To understand a concept, I have to convert it to a series of concrete examples, so I can see them like scenes in a movie. For example, when I think about the statement "cruelty to animals is wrong," I immediately see "video clips" from my memory of really awful things done to animals, and I recall

scenes from either undercover videos or cruel acts I have witnessed. Some examples would be people beating pigs with metal rods, bashing an old dairy cow with a forklift, or poking an animal's eyes out. When I read the statement "Good stockmanship and management greatly improves animal welfare," I recall pictures from my memory of farms I have visited where animals were treated really well. I see the beautiful Singing Valley Ranch in Arizona[10] and an immaculate dairy run by a manager who really cared about his cows. I don't think about either of these statements in an abstract way, using just words.

Words are the terms I type into my own internal "search engine" to bring up pictures from my memory. My mind works a lot like a search for photos on the Internet. During my long career, I have seen both the very best and the worst places. When I train animal welfare auditors and inspectors, I always tell them that travel is a great educator. Traveling to many different places enables a person to gain a more realistic perspective, especially when they view the very best, the mediocre, and the worst places. They need to see a wide range of places. I have talked to many U.S. policy makers who have made policies on both humane slaughter and food safety. Some of these people had never been in a slaughter plant. It is impossible for them to make realistic, practical policy if they have never visited the places they are making policy for. This is a big problem in Washington, D.C. Abstractification clouds the perception of reality on all kinds of issues. "Abstractification" is my term for ideology and policy made by people who have no "on the ground" experiences with the issue that they are making policy about.

Visual Thinking Changes My Approach to Improving Animal Welfare

My approach to ethical thinking is bottom-up instead of being theory driven and top-down. Most people form a theory first and then fill in the details. I form my theories and general principles by looking at many specific details and then fit them together like a puzzle. To form a concept, I take many specific examples that I can visualize

in pictures and put them into different categories, such as "cruelty to animals" or "good stockmanship." My ethical principles on animal treatment are based on visits to hundreds of farms and slaughter plants and my reading of many scientific studies. I used this combination of practical experience and academic science to form my opinions and ethical principles on how animals should be treated. I concluded that I should work to get rid of the practices used in the bad places and promote the practices used in the good places. Later in this chapter, I will discuss in more detail my ethical principles for using animals for food.

When I learn of a new law or policy, I think, "how will this affect the treatment of animals on the farm or in a slaughter plant?" Many policies are so vague that inspectors and auditors in the field do not know how to enforce them. Another problem occurs when some well-intentioned policies have unintended bad consequences.

POLICIES WITH BAD RESULTS IN THE FIELD

There are three kinds of really bad policies: ones that are too vague, ones that have unintended bad consequences and may make animal welfare worse, and ones where policy makers get information from sources on only one side of the issue.

Vague Policies

Many government agencies issue regulations that are so vague that nobody knows how to enforce them. This results in one inspector being extremely strict and another inspector who does no enforcement. An example would be a USDA food safety and inspection directive for the Humane Slaughter Act that requires facilities "to avoid agitation and excitement in animals." One inspector may interpret this directive differently than another. The first inspector may think that hitting pigs and causing them to jump on top of each other and continually squeal was acceptable; another inspector might shut the plant

down if one pig made a tiny squeal. The sensible level of enforcement would be somewhere in between these two extremes.

Some other examples of poor, vaguely written guidelines and policies would be these statements: "provide adequate space in a pen" and "handle the cattle properly." One person's idea of adequate space or proper handling may be totally different than somebody else's. More specific wording would result in more consistent enforcement and make it easier for inspectors to do their jobs. For example, "all the cattle must have sufficient space in the stockyard pen to all lie down at the same time without being on top of each other." "Cattle and pigs should not be forced to move faster than their normal walking speed." I would like to ban the words "properly," "adequate," and "sufficient" from welfare guidelines unless these terms are defined.

Research has shown that the normal human mind tends to drop out details and that the autistic mind like mine tends to retain detail (Nancy Minshew, University of Pittsburgh, personal communication, 2006). This may help explain why some policies are so vague and ambiguous that consistent enforcement is impossible. To help prevent policy makers from becoming too vague, they should keep in close contact with people who actually work in the field. I have observed that the most extreme and abstract ideologies on animal issues come from people who have lost touch with what is actually happening to the animals. In any field, the most radical views, which often fail to translate into making actual reform occur, come from people with little or no practical experience. Ideology can become so generalized and vague that implementation in the field is impossible. Problems with being vague will worsen if the policy makers never visit farms or slaughter plants.

Policies with Unintended Bad Consequences

The closing of all the horse slaughter plants in the United States was attributable to advocacy by the HSUS. The ban on U.S. horse slaughter was well intentioned, but it has resulted in many severe horse

welfare problems. Some old horses suffered a fate worse than ending up at the worst horse slaughter plant. Thousands of horses are now being shipped to Mexico, and many of them go to barbaric slaughterhouses where they are killed by being stabbed in the back of the neck. When the U.S. plants closed, exports to Mexico went up 312 percent.[11] Old horses were also abandoned and left to starve, and most of the horse rescue places are at capacity. Closing the Mexican border to horse transport for slaughter will be impossible. Traders and dealers can obtain fake papers and bring the horses to Mexico disguised as breeding and riding horses, which is still legal. I have crossed the U.S.-Mexican border. Homeland security is a one-way valve. Getting into the United States is a two-hour hassle, but when you leave the United States, the Mexican border guard just waves you through. At a scientific meeting, I had a brief conversation with Andrew Rowen, who works for the HSUS, about these unintended bad consequences of the horse slaughter ban. He replied, "It's a matter of values." His idea is that slaughtering horses for human consumption is wrong. Were I hired to implement that abstract concept—that slaughtering horses for human consumption was wrong—I would have approached the issue in a different way. Instead of suddenly shutting down plants that took surplus horses, I would have implemented a program similar to the programs that have effectively reduced the number of surplus pets that have to be euthanized.

The number of pets that have to be euthanized has been greatly reduced through more constructive approaches to the problem. A sudden shutdown of kill shelters would be a disaster. The need to euthanize surplus cats and dogs was reduced by addressing the *causes* of surplus pets. When the problem was addressed in this manner, kill shelters increasingly became obsolete. This approach should also have been used to make horse slaughter plants obsolete. Dog and cat surpluses have been reduced with effective spay-and-neuter programs, which reduce excessive breeding. To my knowledge, there has been little research on the numbers of backyard horses that are indiscriminately bred. As I ponder this issue, I am going through the picture files in my mind and looking at all the sources of surplus horses.

The Indian reservations are big sources of surplus horses. Sometimes horses are allowed to breed so Native American families have a source of income. Periodically, the wild horses were rounded up and sold for slaughter. I have observed horses from Indian reservations arriving at the horse slaughter plant in Nebraska shortly before it closed. Wild horses on the Indian reservations are not covered under the laws that govern the treatment of mustangs on BLM (Bureau of Land Management) lands.

Horses have another problem. A dog serves its function as a pet up until the day it dies; a horse has many years of life after it is no longer useable as a riding horse. To keep the horse for many more years when he can no longer be ridden is expensive. When I asked a supporter of the slaughter-ban policy about costs to low-income folks, he stated, "low-income people should not have horses." This answer is not going to improve the welfare of neglected surplus horses. The only way to implement reforms on this issue is for field workers to spend days and months researching and finding other solutions to reduce surplus horses. That takes long, hard, sustained work. The work I have done to improve slaughter plants for cattle and pigs required years of sustained work.

Policies That Fail to Look at Both Sides of the Issue

David Fraser, at the University of British Columbia, authored a very thoughtful paper on animal issues.[12] There is a tendency for some people to read literature from only one side of the debate.[13] Both the animal advocates and the agricultural lobbyists have some very biased literature. Animal advocates put up videos that show the worst conditions in the worst slaughter plants, and animal agriculture advocates publish misleading literature that shows that everything is wonderful. From my travels to over five hundred farms and slaughter plants in twenty-six different countries, I have learned that the reality and the truth are somewhere in the middle. Most slaughterhouses and pig farms do not house the atrocious conditions that can be viewed on YouTube or on animal activist Web sites. On the other

hand, conditions on farms are not idyllic like the California "Happy Cow" milk commercials.

There is a need to read literature that is more from the middle of the road. In Washington, D.C., and on the Internet, extremists on the absolute opposite sides of animal issues tend to be the most noticeable and vocal. I tend to ignore the extremists and try to read more thoughtful or more carefully researched information from both sides of the issue. I like to read literature that is more objective and less biased.

Over the years, I have observed that people who actually work hands on with animals will usually have less extreme views. These people can be on either general side of the debate. Constructive dialogue can take place with people who are more moderate. The people who are most extreme often live in the abstract worlds of the courtroom, legislature, university classroom, or corporate upper management. They have lost contact with the animals and the people who work with them. On the other hand, people who work in the "trenches" can become desensitized to suffering.[14] The most effective managers for maintaining high standards of animal welfare are involved enough to care but not so involved that they become desensitized to suffering. For example, in designing a slaughter plan, the quality-assurance department will usually do a better job of enforcing animal welfare than will the slaughter floor manager.

I want to have dialogues with people who may disagree with me, but I want those dialogues to help make practical change in the real world, on the ground. It is impossible to have a dialogue with an extremist who thinks I am evil because I believe that using animals for food is ethical. I had one of these extremists attack me at a book signing. I told him that "we have to agree to disagree on the issue of eating meat," but he just wanted to keep attacking and have no dialogue. When I talk to people who are more reasonable, we can agree to disagree on eating meat but discuss other related issues where we do agree. I discuss many issues with animal advocates in areas where we can agree. For example, housing pregnant sows in stalls where they are not able to turn around needs to be changed to placing those sows in group housing. We can both agree that this needs to be changed.

Over my thirty-five-year career, I have observed that economic forces, exposés by activists, and government regulations in response to something bad happening are the major factors that drive changes. Undercover videos of really atrocious practices on a farm or slaughter plant have been drivers of change. A top official for the USDA called the Westland Hallmark video a "policy-changing event." This motivated the USDA to increase Humane Slaughter Act enforcement. People became outraged, and that can create a period of time where improvements can be easily implemented. I have observed that the forces that can bring about societal change are like heat from a welding torch that is used to soften steel so it can be bent into pretty grillwork. When undercover videos create a lot of "heat," it provides an opportunity for reformers like me to make improvements, while the "steel" is soft and workable. The "steel" must be quickly worked and bent before it cools and hardens after the "heat" is removed.

STOP BASHING THE LIVESTOCK INDUSTRY

My old friend Henry Spira was a very effective activist. He knew when to put the pressure on and when to take it off. When he pressured Revlon to stop animal testing of cosmetics, he stopped bashing them when they made improvements. He had figured out that greater reforms would take place if he stopped pressuring Revlon after they had made most, but not all, of the reforms he wanted. I have come to similar conclusions. I would rather achieve 80 percent of what I want and actually achieve it than always try to get 100 percent of what I want and never get any of it.

There is a point where the continuous bashing of the livestock industry by animal activists will retard making reform. Since the late 1990s, the industry has made reforms, but the activists never give it any credit. The audits that McDonald's, Wendy's, and Burger King started in 1999 have brought about large reforms in over fifty plants.[15] The vast majority of meat plants have improved, but unfor-

tunately the activists found one plant that had faked looking good during audits and another atrocious plant that was not on any restaurant company's approved supplier list. Undercover videos from these two plants, Westland Hallmark and Agri-Processors, were shown to the public.[16] Many people think all the other plants are this bad. This is simply not true.

It is very frustrating for me as a reformer to make many improvements on the ground and then have some activists tell the public that nothing has improved. They keep showing videos of the few places that are atrocious.

ACTIVIST PRESSURE MAY START RETARDING PROGRESS

In the late 1990s, activist pressure "softened the steel," and the industry responded by making reforms. Ten years later, some people in the livestock industry are becoming frustrated, because they are still getting bashed even after they made some improvements. I fear that this may result in reform slowing down, and time and money will be wasted on lawyers and security systems instead of on improving conditions for animals. Another trend I am observing in the late 2000s is that some activists who want to abolish the use of animals for food file lawsuits to cause hardship and expense for the livestock industry instead of pressuring for specific reforms. This problem is going to get worse as more and more people get involved with animal law, unless the people studying animal law start a dialogue with "hands-on" people in animal agriculture. Otherwise, abstractification will increase, and these new lawyers will have less and less connection with what is actually happening on the ground. As I wrote earlier in this chapter, "abstractification" is my term for when thinking about policy becomes so abstract that there is no longer any connection with the people and places that the policy will affect. Instead of pressuring the livestock industry to make real reforms, activist pressure may just cause legal gridlock where nothing constructive will happen. They do this because their goal is to abolish the livestock industry instead of reforming it. Unfortunately, all that this will do

is waste everybody's time and money instead of working to reduce animal suffering.

USE OF ANIMALS FOR FOOD

My position is that using animals for food can be done in an ethical manner. My metabolism needs meat and eggs. If I do not eat animal protein, I get lightheaded and have difficulty thinking. My mother has the same metabolism. To prevent horrible yeast infections, I have to eat a lot of animal protein. I have tried eating a vegan diet, and I cannot function on it. I also cannot eat soy because I cannot tolerate all the female hormones that it naturally contains. I have Mennier's disease, which is now in remission. To keep it in remission, I must avoid substances both natural and synthetic that have high levels of female hormones. They could reactivate the autoimmune responses that were destroying my hearing. I tried some soy calcium supplements, but my postmenopausal breasts became very sore. The soreness went away when I stopped taking the supplements. Different people have different genetics and metabolisms. Some people will function well on a vegan diet. I am one of the people who do not.

My concepts are very simple, and they are discussed in detail in *Animals Make Us Human*.[17] Most important, if we are going to use animals for food, the animals must be given a decent life. There are many things in animal agriculture that need to be corrected, but I have also visited places where animals are treated well and their behavior needs are met. Below is a passage from my afterword in *Animals Make Us Human*.[18]

> Over the years I have done lots of thinking and have come to the conclusion that our relationship with the animals we use for food must be symbiotic. Symbiosis is a mutually beneficial relationship between two different living things. We provide the farm animals with food and housing and in return, most of the offspring from the breeding cows on the ranches are used for food. I vividly remember the day after I had installed the first center-track conveyor restrainer

in a plant in Nebraska, when I stood on an overhead catwalk, overlooking vast herds of cattle in the stockyard below me. All these animals were going to their death in a system that I had designed. I started to cry and then a flash of insight came into my mind. None of the cattle that were at this slaughter plant would have been born if people had not bred and raised them. They would never have lived at all. People forget that nature can be very harsh, and death in the wild is often more painful and stressful than death in a modern plant. Out on a western ranch, I saw a calf that had its hide ripped completely off on one side by coyotes. It was still alive and the rancher had to shoot it to put it out of its misery. If I had a choice, going to a well-run modern slaughter plant would be preferable to being ripped apart alive.

My views on animal issues are similar to those of Michael Pollan. He writes in the *New York Times* that "what's wrong with animal agriculture—with eating animals—is the practice not the principle." He is referring to problems in industrialized agriculture. Pollan then adds: "What this suggests to me is that people who care should be working not for animal rights, but animal welfare."[19] My views are very similar and I want to reform animal agriculture not try to eliminate it. For further information, see Pollan's *The Omnivore Dilemma* (the animal rights chapter)[20] and *Animals Make Us Human*.[21]

Making Practical, Real Reform

Here are some things that have made me effective on improving animal agriculture:

1. Farmers and meat plant managers know that I have no hidden agenda. I am not working to eliminate animal agriculture. This helps to make them more cooperative.
2. In my work, I use both scientific research knowledge and practical experience to implement practical improvements.
3. My persistence over a long period of time to bring about changes is more effective than short bursts of activity.

4. Over the years, I have learned how <u>the right economic incentives will bring about reforms</u>. The audits done by McDonald's, Wendy's, and other companies brought about large reforms because meat plant managers now had an economic incentive to improve their plants so they could remain on the approved supplier list.

ATTACKED BY ANIMAL RIGHTS ABOLITIONISTS

I am a reformer who wants to improve the livestock industry. I disagree with the advocates who want to abolish the use of animals for food. Since the publication of *Animals in Translation*,[22] I have received some hateful attacks from individuals who believe that killing animals for food is the same as killing people in Nazi Germany. They have called me an evil Nazi, sent hate mail, and made Web postings that were so nasty and vulgar that they cannot be repeated here. One person said he wanted to apply an electric cattle prod to my anatomy, describing it in the filthiest language imaginable. These extreme individuals who advocate for animals advocated in their e-mails and Web postings things they wanted to do to me that were very cruel— things that they would never do to any animal. I have thought long, hard, and carefully on how to respond to people who think I am a Nazi. In the next section, I provide my response, in which I have used information from my knowledge of animal behavior, neuroscience, biology, farm animal welfare research, sustainable agriculture, and travel to twenty-six countries on five continents.

MY CORE PRINCIPLES FOR USE OF ANIMALS FOR FOOD

There are four core principles of my belief that animals can be used for food in an ethical manner. They are:

1. <u>Prevent suffering</u>—this applies to all animals neurologically capable of suffering.

2. Improve sustainability of agriculture, conserve the environment, and prevent loss of biodiversity.

3. Animals with greater intelligence and social-emotional complexity such as apes, dolphins, elephants, and parrots should not be used for human food. They have higher moral value, but all animals that are capable of suffering have higher moral value than inanimate objects such as houses or cars.

4. Most animal species will avoid eating their own kind as their regular food. This is a natural principle of animal behavior.

Ethical issues concerning companion animals, animals used in sports, and research animals would require additional discussion that is beyond the scope of this paper. Below is further clarification of my four principles concerning my ethical principles for food animals.

1. *Prevent suffering*—In his book *Animal Liberation*, Peter Singer states that preventing suffering is central for the ethical treatment of animals.[23] Scientific research clearly shows that mammals and birds not only feel pain but also suffer from it. This has been proven by self-medication experiments. In these experiments, rats and chickens will consume bitter-tasting analgesic (painkiller) medication when they have an injured joint.[24] When the joint heals, they will stop consuming the bitter drug. Research also clearly shows that the fear circuits in a person and in an animal's brain are similar.[25] I have also reviewed research on animal fear circuits.[26]

In animals that are going to be used for food, steps should be taken to prevent fear and pain during both slaughter and surgical procedures. According to my belief system, this applies to all mammals and birds. Research is now showing that this may also need to be applied to fish.[27] To confirm this finding, the self-medication experiment will need to be done on fish to determine if the fish can actually suffer. Some fish farm managers have responded to these concerns by installing stunning equipment to render fish insensible before slaughter. I am not concerned about oyster suffering. They do not have a developed enough nervous system to suffer.

The work I have done during the last thirty-five years on improving livestock handling and slaughter methods has reduced both fear and pain. It is my opinion that animals must also be housed in a manner that provides them with a decent life that is worth living. Grazing animals that are given well-managed pasture have excellent living conditions. In an earlier part of this chapter, I discussed symbiosis. In a good animal husbandry system, it is possible to have a truly symbiotic relationship. Symbiosis is a common principle in biology.

Conditions for animals housed in intensive systems need improvements. Both intensive and extensive systems can be part of sustainable systems in the future. Animals should be housed in a manner that enables them to engage in positive experiences, such as seeking novel and interesting stimulation, socializing with their own kind, and having opportunities to express highly motivated species-typical behaviors. For a further discussion, see Grandin and Johnson, Fraser, and Webster.[28] I am also an advocate of good stockmanship and animal husbandry. A good stockperson understands animal behavior and treats animals with kindness. Some excellent readings on stockmanship and the need for good husbandry are in Hemsworth and Coleman[29] and Rollin.[30]

When animal issues are being discussed, people often forget that nature can be harsh. Predators kill other animals, and they may die a painful, lingering death. Storms and droughts can cause many wild animals to die. Much suffering occurs in the natural world.

2. *Improve the sustainability of agriculture, conserve the environment, and prevent the loss of biodiversity*—There is great concern about losing local plant and animal breeds in the developing world. Replacement of local plant and animal species with high-producing ones could cause the loss of valuable, diverse animal genetics. At the 2009 American Society of Animal Science meetings, two seminars presented evidence that local varieties of plants and animals must be conserved. If these genetic resources are lost, humans could run out of food if diseases destroyed high-producing genetic lines of plants and animals. Local genetic lines may have genes for disease resistance, and it is essential to prevent their loss. I also believe that conservation of the environment is essen-

tial to keep beautiful places. Natural places have great beauty, and that has moral value.

There is a place for livestock in a future world where both plant and animal agriculture will be forced to be more sustainable. There are vast regions of land where crops cannot be raised because there is not enough ground water for irrigation. I have visited these lands. Some of them are in Wyoming, others in the outback of Australia. The Australian outback is over half of the size of the United States. I used to think Texas was vast until I flew over the eastern part of the outback and visited an excellent cattle station. The only way that food can be raised on these lands is with grazing animals. Rollin[31] is concerned that the outback is so vast that the animals might be neglected. There have been some problems with this, but they can be corrected with good management. The managers must believe in the ethic that they should prevent suffering. Grazing animals can be used in a totally sustainable manner. Animal manure for fertilizing the ground is an integral part of organic agriculture. When grazing is done correctly, it can improve arid land and prevent it from reverting to desert.[32]

Work with large corporations—I have been asked, "why do you work with big corporations when you believe that some of their practices may be either unsustainable or unethical?" I work with them to prevent pain and suffering. Another thing I have learned is that economic factors can become so powerful that they motivate people to engage in practices that will not be sustainable in the future. Two examples are using up deep aquifer water or feeding grain in huge quantities to millions of cattle. Grain is fed to cattle for only one reason. It is cheap. When it gets too expensive, grain feeding will be phased out.

I work to change things where it is possible to make improvements. I do not bang my head against solid cold, hard steel—places where attempting to implement improvements is impossible. There are two kinds of people who make changes—advocates who pioneer radical new ideas and implementers, like me, who make the actual changes on the ground. All my professional life, I have been an implementer. Early in my career, I designed cattle handling equipment, and later in my career, I implemented animal welfare auditing systems. Advocates facilitate the implementers by "softening the steel" so that the

implementers can bend it and work it. There is a need for both the advocates and the implementers.

3. *Animals with greater intelligence and social-emotional complexity have higher moral value*—I believe that the apes, dolphins, whales, parrots, crows, elephants, and other animals with high intelligence and more complex emotional and social behavior have higher moral value. Crows can figure out how to get food out of a tube by using three different lengths of sticks to drag the food out.[33] Compared to other birds such as chickens, the region of the brain that integrates information is larger. I am against killing these cognitively complex animals for human food. However, all species that are capable of suffering should be housed and slaughtered in a manner that prevents suffering. My core principle of preventing suffering applies to all species that are capable of suffering, but my core principle of higher moral value applies only to the more intelligent animals. Therefore, the more intelligent animals should not be bred or raised for the purpose of feeding people. However, all animals that have sufficient neurological complexity to suffer have higher moral values than objects such as houses or cars.

As scientists learn more and more about animal behavior, the list of animal species that should be placed in the intelligent group may expand. Maybe pigs and cattle need to become part of that group. These two species have similar intelligence, but grazing animals often appear to be stupid given their strong flocking instincts. A pig and a dog probably have similar abilities. To avoid eating the more intelligent animals, I would have to eat eggs, chickens, and fish. That would still satisfy my dietary needs. However, that would take the grazing animals off my list of morally acceptable foods, given core principle 3. Even if cattle were now on my list of animals of high intelligence, they are still less intelligent than apes or dolphins. To use vast rangelands in a sustainable manner, grazing animals are required. Therefore, I would keep the grazing or browsing animals such as cattle, bison, sheep, antelopes, deer, and goats on my list of animals acceptable to eat. In the animal kingdom, there are three types of animals, prey species such as the grazing animals; predators such as dogs, wolves, lions, and tigers; and omnivores such as pigs, bears, and people. The prey species are all

vegetarian herbivores. Predators eat mainly meat, and omnivores eat both meat and plant materials. Eating meat is a normal part of an omnivore diet. Chimpanzees, who share 99 percent of their genes with humans, are also omnivores who will kill other animals for meat.[34] Animals eating other animals is part of the natural world. People are also omnivores, so eating meat is a natural thing to do. Most prehistoric people ate meat.[35]

4. *Most animal species do not eat their own kind as their regular food*—After much long and hard thought, I have come to the conclusion that advocates for animal rights will call me a speciesist because I value the human species more than other animals. Some animal rights advocates will say this is the same as racism. However, it is not the same, because racism occurs within our own species. Joel Salatin, a well-known innovator of small-scale sustainable animal agriculture, also makes a moral distinction between other animals and people.[36] He provides a religious reason, but I am going to give a biological reason. There is a principle in animal behavior that each species of animal does not eat its own kind as its regular food. If an animal species dined on its own kind for the majority of its calories, it would become extinct. There are exceptions, such as infanticide (cub killing) by male lions and cannibalism in confined pigs. However, lions do not dine on lions as their main dietary item. Grazing animals such as antelopes are a major component of a lion's diet. A raven will not eat a dead crow, because it looks like a raven. However, a raven will eat a dead chicken.[37] In the animal world, animals treat their own kind differently than they do other animals.

I had to come to the above conclusion to avoid a moral dilemma that is more serious than killing animals for food. If I only believed in my first three core principles, I would morally be able to justify killing humans with severe neurological disabilities to prevent suffering. Some of these individuals have so much brain damage that a dog or a mouse would probably have more intelligence. When I was a child, I had all the symptoms of severe autism. Fifty percent of children with severe autism never become verbal, and about 10 percent of them are so severely autistic that they suffer during their adult lives. Their

nerves are so dysfunctional that they may bite themselves and cannot tolerate loud noises in a supermarket. If my principle number 1 was followed to prevent suffering, then euthanizing handicapped people may be justified. This is similar to Peter Singer's view.[38] My response is that human life must be preserved because human life is precious. It has higher moral value because it is our own species.

If I had been born in Nazi Germany shortly before World War II, Hitler would have had me euthanized as a mental defective. When I was three and had no speech, Hitler's doctors would have decided that I should not live. There would be the possibility that Hitler would have valued a dog's life more than my life when he was making decisions on mass killing. This hits a very sensitive nerve in me. This is a major reason why I cannot place the moral value of other animal species equal to my own species. The people who do this may run the risk of becoming Nazis themselves. I have been accused by animal rights abolitionists of being a Nazi because I am involved in killing animals for food. If a person believes that animals are equal to people, they might have fewer moral qualms about killing other people, to comply with core principles 1 and 2. To prevent people from morally justifying mass euthanasia of the neurologically handicapped, they have to be speciesists and value humans more than other animals.

CONCLUSION

Any animal that has the capacity to suffer when raised for human food deserves to live in an environment that prevents suffering and provides it with a life where it has opportunities to experience positive emotions. When animals are bred and raised for human food, they should be housed and handled in a manner that prevents their suffering. Human beings have the mental capacity to know that they should prevent suffering in animals. Nature has no morals; the natural conditions just exist. Animals eat other animals and sometimes kill them in a painful manner, or draught causes starvation. That's what happens in nature. Nature cannot be moral or evil because it

has no intent. People have the intellect to become good stewards of both the land and the animals, because they are aware that their actions can cause either suffering or destroy the environment.

NOTES

1. Temple Grandin, "Observations of Cattle Behavior Applied to the Design of Handling Facilities," *Applied Animal Ethnology* 6 (1980a): 9; Temple Grandin, "Livestock Behavior Related to Handling Facility Design," *International Journal for the Study of Animal Problems* no. 1 (1980b): 122–137; Temple Grandin, *Livestock Handling and Transport*, 3rd ed. (Wallingford: CABI International, 2007).

2. Grandin, "Observations of Cattle Behavior," 9; Grandin, "Livestock Behavior," 122–137.

3. Temple Grandin, "Objective Scoring of Animal Handling and Stunning Practices in Slaughter Plants," *Journal of American Veterinary Medical Association* 212 (1998): 36–39.

4. Temple Grandin, "Maintenance of Good Animal Welfare Standards in Beef Slaughter Plants by Use of Auditing Programs," *Journal of American Veterinary Medical Association* 226 (2005): 370–373; Temple Grandin, "Effect of Animal Welfare Audits of Slaughter Plants by a Major Fast Food Company on Cattle Handing and Stunning Practices," *Journal of American Veterinary Medical Association* 6 (2000): 848–851.

5. PETA, "Visionary Winner Dr. Temple Grandin," www.peta.org/feat /proggy/2004/winners.html#visionary (2004).

6. Nicholas D. Kristof, "Health Care Fit for Animals," *New York Times* (August 27, 2009).

7. Temple Grandin, *Thinking in Pictures* (New York: Vintage Press, 1995).

8. Grandin, *Livestock Handling and Transport*.

9. Temple Grandin and Catherine Johnson, *Animals in Translation* (New York: Scribner, 2005).

10. Temple Grandin and Catherine Johnson, *Animals Make Us Human* (New York: Houghton Mifflin-Harcourt, 2009).

11. R. Scott Nolan, "U.S. Horse Slaughter Exports to Mexico Increase 312%," JAVMA News, American Veterinary Medical Association, www.avma.org/online news/javma/Jan08/080115a.asp (January 15, 2008).

12. David Fraser, "The 'New Perception' of Animal Agriculture: Legless Cows, Featherless Chickens, and a Need for Genuine Analysis," *Journal of Animal Science* 79, no. 3 (2001): 634–641.

13. Ibid.

14. Temple Grandin, "Behavior of Slaughter Plant and Auction Employees." *Anthrozoos* I (1988): 205–213.

15. Grandin, "Maintenance of Good Animal Welfare Standards," 370–373.

16. Joe Nocera, "A Case of Abuse, Heightened," *New York Times* (March 8, 2009); Nate Herpick, "Kosher Meat Plant Accused of Abuses," *Washington Post* (July 15, 2006).

17. Grandin and Johnson, *Animals Make Us Human*.

18. Ibid.

19. Michael Pollan, "An Animal's Place," *New York Times Magazine* (November 10, 2002), www.michaelpollan.com/article.php?id=55.

20. Michael Pollan, *The Omnivore's Dilemma: A Natural History of Four Meals* (New York: Penguin, 2007).

21. Grandin and Johnson, *Animals Make Us Human*.

22. Grandin and Johnson, *Animals in Translation*.

23. Peter Singer, *Animal Liberation* (New York: Harper Perennial, 2001).

24. F. C. Colpaert, J. P. Taryrer, M. Alliaga, and W. Kock, "Opiate Self Administration as a Measure of Chronic Nocieptive Pain in Arthritic Rats," *Pain* 91 (2001): 33–34.

25. J. E. LeDoux, "Emotion, Memory, and the Brain," *Scientific American* 271 (1994): 50; M. T. Rogan and J. E. LeDoux, "Emotion: Systems, Cells, and Synaptic Plasticity," *Cell* 85 (1996): 369.

26. Temple Grandin, "Assessment of Stress During Handling and Transport," *Journal of Animal Science* 75 (1997): 249–257.

27. L. U. Sneddon, V. A. Braithwaite, and M. J. Gentle, "Do Fish Have Nociceptors: Evidence for the Evolution of Vertebrate Sensory System," *Proceedings Royal Society of London*, B 270 (2003): 1115–1122.

28. Grandin and Johnson, *Animals Make Us Human*; David Fraser, *Understanding Animal Welfare* (Oxford: Blackwell Publishing, 2008); John Webster, *Animal Welfare: Limping Towards Eden* (Oxford: Blackwell Publishing, 2005).

29. Paul H. Hemsworth, and G. J. Coleman, *Human Livestock Interactions* (Wallingford, UK: CABI International, 1994).

30. Bernard Rollin, "The Ethnical Imperative to Control Pain and Suffering in Farm Animals," in *The Well-Being of Farm Animals*, ed. Bernard Rollin and G. J. Benson (Ames, Iowa: Blackwell, 2004), 3–19.

31. Ibid.

32. Allan Savory, "The Savory Grazing Method of Holistic Resource Management," *Rangelands* 5, no. 4 (1983): 155–159.

33. Bruce Bower, "Crows Use Sticks, Stones to Show Skills at Manipulating Tools in the Lab," *Science News* (August 29, 2009): 5–6.

34. Mary Roach, "Almost Human," *National Geographic* (April 2008): 126–144; J. D. Pruetz and P. Bertolani, "Savanna Chimpanzees (*Pan troglodytes versus*) Hunt with Tools," *Current Biology* 17 no. 4 (2007): 412–417.

35. M. P. Richards, "A Brief Review of the Archeological Evidence for Paleolithic and Neolithic Subsistence," *European Journal of Clinical Nutrition* 56 (2002): 1262–1278.

36. Pollan, "An Animal's Place."

37. Bernd Heinrich, *Mind of the Raven* (New York: Harper Collins, 1999).

38. Peter Singer, *Practical Ethics*, 2nd ed. (Cambridge: Cambridge University Press, 1993).

CONTRIBUTORS

CAROL J. ADAMS is an independent scholar whose focus is on interrelated oppressions. Her books include *The Sexual Politics of Meat: A Feminist-Vegetarian Critical Theory*; *Prayers for Animals*; and *The Inner Art of Vegetarianism*. With Josephine Donovan she has edited two anthologies, *Women and Animals: Feminist Theoretical Explorations* and *The Feminist Care Tradition in Animal Ethics: A Reader*.

PAOLA CAVALIERI lives in Milan and is the editor of the international philosophy journal *Etica and Animali*. She is the author of *The Animal Question: Why Nonhuman Animals Deserve Human Rights* and, with Peter Singer, edited the award-winning book *The Great Ape Project: Equality Beyond Humanity*.

MARIANNE DEKOVEN is professor of English at Rutgers University. She is the author of *Utopia Limited: The Sixties and the Emergence of the Postmodern*; *Rich and Strange: Gender, History, Modernism*; and *A Different Language: Gertrude Stein's Experimental Writing*. She is also the editor of the Norton Critical Edition of Gertrude Stein's *Three Lives* and of *Feminist Locations: Global and Local, Theory and Practice*.

FRANS DE WAAL is the C. H. Candler Professor of Primate Behavior in the department of psychology at Emory University and director of living links at the Yerkes National Primate Research Center. His many books include *The Ape and the Sushi Master: Cultural Reflections by a Primatologist*; *Primates and Philosophers: How Morality Evolved*; and, most recently, *The Age of Empathy: Nature's Lessons for a Kinder Society*.

TEMPLE GRANDIN is professor of animal science at Colorado State University. She is the author of numerous books and textbooks, including *Thinking in Pictures: And Other Reports from My Life with Autism; Animals in Translation: Using the Mysteries of Autism to Decode Animal Behavior*; and, most recently, *Animals Make Us Human: Creating the Best Life for Animals*.

DONNA HARAWAY is professor of the history of consciousness and feminist studies at the University of California, Santa Cruz. Her many books include *Primate Visions: Gender, Race, and Nature in the World of Modern Science; Simians, Cyborgs, and Women: The Reinvention of Nature*; and, most recently, *When Species Meet*.

MICHAEL LUNDBLAD is assistant professor of English and director of animality studies at Colorado State University. His work on animality studies has been published in *American Literature, PMLA*, and *American Quarterly*. He is currently completing a book manuscript titled *Birth of a Jungle: The Evolution of the Beast in U.S. Culture*.

MARTHA C. NUSSBAUM is the Ernst Freund Distinguished Service Professor of Law and Ethics at the University of Chicago, appointed in the philosophy department, law school, and divinity school. She is the author or editor of dozens of books, including, most recently, *Frontiers of Justice: Disability, Nationality, Species Membership*; and *Liberty of Conscience: In Defense of America's Tradition of Religious Equality*.

CARY WOLFE is the Bruce and Elizabeth Dunlevie Professor of English at Rice University. His books include *Animal Rites: American Culture, the Discourse of Species, and Posthumanist Theory; What Is Posthumanism?*; and the edited collection *Zoontologies: The Question of the Animal*. He is the founding editor of the series *Posthumanities* at the University of Minnesota Press.

INDEX

absent referent, 7; activism restoring, 133; applied to animals, 117; dehumanization and, 57, 59–60

abstractification, 12; activism increasing, 205–6; defined, 198

academic freedom, 38–39

activism: absent referent restoration via, 133; abstractification increased by, 205–6; Chartism and, 66–68; cooperation and, 49–51, 66–68; corporations and, 211; courage and, 134–36; as engaged theory, 134; evangelical-like, 132; fair housing, 106–10; intersectional, 133; lessons learned from, 133–36; livestock industry bashing and, 204–5; practical, 207–8; retarding progress, 205–6; rules and lessons of organizing, 135; sexually exploitative, 132; *The Sexual Politics of Meat* origins and, 103–4; of vegans, 127–28. *See also* advocacy; humane advocacy

Adams, Carol J., 2, 14n3; dehumanization and, 57, 59–60; as ecofeminist animal rights activist, 10; feminism and, 10, 57, 59–60. *See also Neither Man nor Beast: Feminism and the Defense of Animals; Pornography of Meat, The; Sexual Politics of Meat, The*

Adorno, Theodor, 72n53

advocacy: cultural studies and, 1–8; definitions of, 12–13; Derrida and, 44–47; devil's, 23–24; etymology, 23;

humanism and, 51, 68n8; humanities and, 44–47; implementation compared with, 211–12; media, 113–17; oxymorons, 22–25; passion and, 24–25; university and, 44–47. *See also* activism; humane advocacy; humane reform

Agamben, Giorgio, 56–57

Agri-Processors, 205

AHA. *See* American Humane Association

Ahuja, Neel, 3–4

Amboseli National Park. *See* elephant case study

American Antivivisection Society, 79

American Humane Association (AHA), 78–80

American Society for the Prevention of Cruelty to Animals (ASPCA), 78, 79

Angell, George T., 78

Angola plantation, 82

animal, nonhuman: absent referent and, 117; *fressen* and, 54; human relation to, 40–41, 45–46; intelligence, 209, 212–13; moral values and, 212–13; question, 1–8, 13n1, 45–46; social-emotional complexity of, 209, 212–13; social justice and, 128; specificity vs. "the" animal, 97n10; suffering, 29–31, 208, 209–10; trials, 99n52; welfare auditing, 196–97. *See also* food, animals used for; liberation, animal; People for the Ethical Treatment of Animals; policies, animal handling; Society for

animal, nonhuman (*continued*)
the Prevention of Cruelty to Animals;
welfare, animal; *specific subject*
animality: cultural studies and, 2–6;
debates surrounding, 1–8; discourse of,
3, 4–5, 85, 88–90, 97n10, 110;
lynching and, 88–89, 124; studies, 3,
13, 14n7, 102n85
Animal Liberation (Singer), 131–32, 209
animal rights: abolitionism vs. welfare,
208; Adams and, 10; Calarco and, 2;
priorities surrounding, 2, 14n5;
UNESCO and, 50
*Animal Rites: American Culture, the Discourse of
Species, and Posthumanism Theory* (Wolfe),
5, 15n18
Animals Make Us Human (Grandin), 206–7
animal studies, 2–6, 9, 13n1, 14n7, 45, 181,
190
Animal That Therefore I Am, The (Derrida),
29–32, 33–34
Anstötz, Christoph, 63
Anthony, Susan B., 105
anthropodenial: *Battle as Inner Experience*
and, 165–66; compassion and, 140,
167n3; de Waal and, 140; disgust and,
158–59; *Effi Briest* expressing, 162–63;
eudaimonistic judgment and, 160; *The
Kreutzer Sonata* expressing, 141, 162;
misogyny and, 161–65, 166; primitive
shame and, 157–60; real man and,
160–61
anticruelty statutes, 77–78, 80
apes, 124, 191–92, *193*
Aristotle, 41, 42, 146, 181, 188n24
ASPCA. *See* American Society for the
Prevention of Cruelty to Animals
Audubon Society, 79
Australian outback, 211
autism, 213–14
Autobiography of an Ex-Colored Man, The
(Johnson), 95

Batson, C. Daniel, 169n28
Battle as Inner Experience (Jünger), 165–66
Bearing the Word (Homans), 117
becoming with, 8, 17–19

Bederman, Gail, 91–92
Benston, Kimberly W., 14n7
Bentham, Jeremy, 99n49
Bergh, Henry, 78, 94
Birth of a Nation, The (film), 123
black and white womanhood, 123–24
black bucks, 123
black male rapist myth, 87–88
blame, 146–47
blue-collar discontent, 109
Bogle, Donald, 123
Braidotti, Rosi, 14n7
Buchanan, Bruce, 109, 114, 115, 117,
128–29
bulldog bites master, 177–81, 187n10
Byrne, Peter, 63

Calarco, Matthew, 2
cannibalism, 209, 213–14
capuchin monkeys, 190
Carlson, Licia, 60–61
Castricano, Jodey, 14n2
cattle-handling practices: animal welfare
auditing and, 196–97; improvements
in, 195–96; symbiosis and, 206–7
cattle railcars, 54
Cavalieri, Paola, 9–10
Cavell, Stanley, 42, 67
chain gang, 83
Chartism, 66–68
Christian roots, of humane reform,
77–80
Clark, Candace, 146
Clark, Kate, 122
companion species, 8, 18, 26n3
compassion: anthropodenial and, 140,
167n3; blame and, 146–47; continu-
ities and good discontinuities and, 142;
empathy and, 148–49, 169n28; failures
regarding, 140–42, 167n1; fault and,
149–50, 153, 156, 170n31; judgments
and, 145–48, 153–54; non-fault and,
146–47, 149–50, 153; Nussbaum and,
10–11; pity and, 168n18; poor and, 156,
170n39; seriousness and, 146, 152–53;
similar possibilities and, 147, 155;
sympathy and, 168n13

concentration camp: Agamben and, 56–57; dehumanization and, 54–57; Levi and, 54; Levinas and, 55–56; as slaughterhouse, 55

"Conflict of the Faculties, The" (Kant), 44

Confucius, 184

consumption, 118

cooperative behavior, 49–51, 66–68

courage, 134–36

Cover, Robert, 112

Crenshaw, Kimberlé, 124

Criminal Prosecution and Capital Punishment of Animals, The (Evans), 86, 99n52

critters, 8

cruelty, 7. *See also* anticruelty statutes; Society for the Prevention of Cruelty to Animals

cultural studies: advocacy and, 1–8; animality and, 2–6; Castricano on, 14n2; cultural politics and, 3–4; debates surrounding and within, 1–8; intersectional analysis and, 3, 5–6; literature and, 2–3; posthumanism and, 4–5; species and, 1

Darwin, Charles, 85–86; Huxley and, 177–81, 187n10; morality and, 183; racism and, 75–76, 96n6

Dawkins, Richard, 179, 187n10

De Anima (Aristotle), 42

de Beauvoir, Simone, 58, 60

Declaration of the Rights of Animals (UNESCO), 50

"Declaration on the Rights of Disabled Persons" (UN), 61

dehumanization: Adams and, 57, 59–60; Agamben and, 56–57; Anstötz and, 63; Byrne and, 63; Chartism and, 66–68; concentration camp and, 54–57; de Beauvoir and, 58, 60; defining, 54, 69n15; disability rights movement and, 60–63; feminism and, 57–60; Foucault and, 60–61; Groce and Marks and, 71n43; Hegel and, 64; Hendriks and, 62; Jaggar and, 59; Kant and, 61; Leftist thinkers and, 63–66; Lenin and, 65; Levi on, 54; Marx and,

63–64; Miller and, 59; Morris and, 62; political women's movements and, 59, 70n33; slaughterhouse and, 54; Wollstonecraft and, 58; Žižek and, 65–66

DeKoven, Marianne, 2–3

Department of Housing and Urban Development (HUD), 105, 106, 107, 111, 114

Derrida, Jacques, 9, 13, 13n1; advocacy and, 44–47; animal question and, 13n1; 45–46; animal specificity and, 97n10; animal suffering and, 29–31; decision and, 36–37; freedom and, 38–39; *une grille* and, 32, 47n7; human and animal relation and, 40–41, 45–46; humanities and university and, 37–47; humanities role, 43–44; information concept of, 37, 48n13; inheritance and, 36; knowledge and learning and, 41–43; language technicity and exteriority and, 31–33; listening and, 42–43; not-being-able and, 30–31; performative declaration and, 38–39, 48n15; reason and truth and, 37–38; representational man and, 43; respond and react and, 33–34; responsibility and, 39–40, 46–47; sociology or politology and, 45; spectralizing force and, 34–36; thinking and, 38

Descent of Man, The, and Selection in Relation to Sex (Darwin), 75–76, 183

devil's advocate, 23–24

de Waal, Frans: anthropodenial and, 140; continuities and good discontinuities and, 142; dualism and commonality and, 11–12; moral behavior and, 7–8

dignity, 61–62

disability rights movement, 60–63, 71n40, 71n47

Discipline and Punish: The Birth of the Prison (Foucault), 84–85

disgust: anthropodenial thinking and, 159–60; denial and, 160; Glover and, 170n41; group subordination and, 159, 170n41; infants and, 158–59

disinterested judgment, 191

"Force of Law" (Derrida), 36
forgiveness, 181
Foucault, Michel: dehumanization and, 60–61; European penal reform and, 84–85, 99n49
Fox, Melinda, 70n33
fragmentation, 118
Fraser, David, 202
Fredrickson, George, 124
freedom: academic, 38–39; humanism and, 51–52
fressen (eating [referring to animal]), 54
Freud, Sigmund, 186; double agenda and, 180; dualism and, 178–79; racism and, 76; *Totem and Taboo* and, 76, 85, 86; Westermarck and, 175–76
Friedan, Betty, 58–59

Ghiselin, Michael, 180
Glover, Jonathan: disgust and, 170n41; humanity and, 143–44, 167; *Humanity* and, 143–44; silences of, 144–45; sympathy and compassion and, 168n13; on Theweleit, 168n16
goodness, human: controversy surrounding, 174–75; Huxley and, 177–81; Mencius and, 184–85; moral emotions and, 181–83, 188n18; moral evolution and, 190–92, *193*; summary remarks on, 185–86; Westermarck and, 175–77, 181–83, 188n18
Grandin, Temple, 12, 206–7, 208
Green Party, Italian, 50
Griffith, D. W., 123
grille, une (grid or network), 32, 47n7
Groce, Nora, 71n43
group subordination: disgust and, 159, 170n41; primitive shame and, 158
Gujarat: anthropodenial in, 163–65; British influence in, 164, 171n47; campaign slogan and, 166, 172n49; extremists, 11; massacre, 141–42; misogyny in, 163–65, 166, 171n46; Muslim woman and, 164, 171n46; pornographic fantasies and, 164–65

guman (Proto-Indo-European earthlings), 21
Gunning, Sandra, 88

Haidt, Jonathan, 190
Haraway, Donna, 5–6; terminology and, 7, 8
"Have American Negroes Too Much Liberty?" (Smith, Charles H.), 89
Heart of the Race Problem, The (Ewing), 89
heat of passion defense: juridical discourses and, 84–87; murder vs. manslaughter and, 86–87, 100n55
Hegel, G. W. F., 64
Heidegger, 72n59
Hendriks, Aart, 62
Hindu extremists. *See* Gujarat
Hobbes, Thomas, 174, 180
Hock, Paul, 123
Hodes, Martha, 88
Homans, Margaret, 117
Home and the World, The (Tagore), 171n47
homelessness, 128–29
homo, 21–22
Horkheimer, Max, 72n53
horses: Indian reservations and, 202; slaughter plants and, 200–201; surplus, 200–202
HSUS. *See* Humane Society of the United States
HUD. *See* Department of Housing and Urban Development
human-animal binary: beast terminology and, 122–23; commonality and, 11–12; continuities and, 142; dualism and, 11–12; lies regarding, 160
human-animal difference: humans and apes compared, 191–92, *193*; moral sentiments and, *193*; moral values and, 212–13; respond and react and, 33–34; similar possibilities and, 147, 155
humane, oxymorons regarding, 21–22
humane advocacy: Adams and, 10; Cavalieri and, 9–10; context and practicality influencing, 27–29; de Waal and, 11–12; Grandin and, 12;

objectification, 118
Oedipal theory, 176
omnivores, 213–14
O'Neill, Tip, 108
organizing, rules and lessons of, 135
Oshinsky, David, 82
oxymorons: advocacy and, 22–25;
 becoming with and, 17–19; humane
 and, 21–22; matter and, 20–21; species
 and, 19–20

Paine, Thomas, 170n39
Parchman Farm, 82
passion, 24–25. *See also* heat of passion
 defense
penal reform: European, 84–85, 99n49;
 plantations and, 82–83; road building
 and, 83–84
People for the Ethical Treatment of
 Animals (PETA), 14n5; sexually
 exploitative activism of, 132
performative declaration, 38–39, 48n15
PETA. *See* People for the Ethical
 Treatment of Animals
Piaget, Jean, 186
Pinel, Philippe, 71n40
Pitcher, George, 151, 152–53
pity, 168n18
plantations, 82–83
Playing in the Dark (Morrison), 110
policies, animal handling: both sides of
 issues and, 202–3; conclusions about,
 214–15; practical, 207–8; steel analogy
 and, 204; with unintended bad
 consequences, 200–202; vague,
 199–200
politology, 45
Pollan, Michael, 207
Poole, Joyce, 154
poor, 156, 170n39
pornographic fantasies, Gujarat, 164–65
Pornography of Meat, The (Adams), 119, 132
posthumanism, 7, 18; Cavalieri's, 9–10;
 cultural studies and, 4–5; rights
 discourse vs., 15n18; Wolfe's, 5, 9, 15n18
prevention of suffering, 208, 209–10
primitive shame: anthropodenial and,

157–60; defined, 157; denial and, 160;
 group subordination and, 158; human
 infants and, 157–58
"Principle of Reason, The: The University
 in the Eyes of Its Pupils" (Derrida),
 37–38, 41–43, 45

question of the animal: Derrida and, 13n1,
 45–46; perspectives on, 1–8

Race, Rape, and Lynching (Gunning), 88
racism: Darwin and, 75–76, 96n6; Freud
 and, 96n6; (in)humane whiteness and,
 93–96; interlocking oppressions
 and, 121–22, 125; juridical discourses
 and, 84–87; lynching and, 87–93; race
 of races and, 81; as sexualized, 125;
 WBUZ and, 112–13, 115–16
rape: beast language surrounding, 122–23;
 black and white womanhood and,
 123–24; black bucks and, 123; Estrich
 and, 122; interlocking oppressions and,
 121–22; *Race, Rape, and Lynching*, 88; as
 torture, 89–90; white man's property
 and, 123
Rawls, John, 68n7
real man, stereotype of, 160–61
reason: Derrida and, 37–38, 41–43, 45;
 judgments and, *193*
reciprocity, 184
Reconstruction, 88
Red Record, A (Wells), 91
representational man, 43
respond and react, 33–34
responsibility, 39–40, 46–47
retributive emotions, 174, 181
retributive kindly emotions, 182, 188n18
retrograde humanism. *See* humanism,
 retrograde
revenge, 182; delayed, 173–74; system,
 174
Revlon, 204
Ridley, Matt, 180
rights: discourse vs. posthumanism, 15n18.
 See also animal rights; disability rights
 movement; *Vindication of the Rights of
 Women, A*

United Nations Educational, Scientific and Cultural Organization (UNESCO), 50

university: advocacy and, 44–47; animal question and, 45–46; freedom and, 38–39; humanities role regarding, 43–44; knowledge and learning and, 41–43; performative declaration and, 38–39, 48n15; "The Principle of Reason" and, 37–38, 41–43, 45; reason and truth and, 37–38; responsibility and, 39–40, 46–47; sociology or politology and, 45

"University Without Condition, The" (Derrida), 38–39, 40–41, 43–44

Upheavals of Thought (Nussbaum), 144, 150

Vardaman, James K., 82

vegans: activism of, 127–28; diet benefits of, 128; reactions to, 126–27; sexually exploitative activism and, 132

vegetarian, 59, 103, 128, 211–12. *See also* feminist-vegetarian theory

Vehmas, Simo, 71n47

Vindication of the Rights of Women, A (Wollstonecraft), 58

visual thinking, 197–98; ethics and, 198–99

vivisection: American Antivivisection Society, 79; James and, 93–94; lynchings and, 96, 102n84; SPCA and, 94

vouch, 23

Waldrep, Christopher, 100n63

wedding vow, 48n15

Weininger, Otto, 161, 171n42

welfare, animal: auditing, 196–97; cooperative activist behavior and, 49–51; Grandin vs. abolitionists, 208; horse slaughter plants and, 200–202; movement defined, 49, 68n1;

movement history, 77–80; progressive intellectuals and, 50; rights and, 207; visual thinking and, 198–99. *See also* humane advocacy; humane reform

Wells, Ida B., 89, 91

Westermarck, Edward, 173, 174; disinterestedness and, 182–83; Freud and, 175–76; incest and, 175–77; Lévi-Strauss and, 175, 176; moral emotions and, 181–83, 188n18, 191; nature *and* nurture and, 177

Westland Hallmark, 204, 205

"What's Your Opinion?" (radio talk show), 110–13, 115–16

When Species Meet (Haraway), 5–6

white female trash, 125

White Hero, Black Beast (Hock), 123

White Over Black (Jordan), 89

White Women, Black Men (Hodes), 88

Whitman, Walt, 139, 143

Williams, George, 179

Williams, Mary Lee, 107–8

Winston, George, 89

Wolf, Arthur, 175–76, 187n4

Wolfe, Cary, 5, 6, 9, 15n18; *Zoontologies: The Question of the Animal*, 4

Wollstonecraft, Mary, 58

women: black and white womanhood and, 123–24; Muslim, 164, 171n46; political women's movements, 59, 70n33; *A Vindication of the Rights of Women*, 58; white female trash, 125. *See also* feminism; feminist-vegetarian theory; misogyny

Worse Than Slavery (Oshinsky), 82

Wright, Robert, 180

Žižek, Slavoj, 65–66

Zoographies: The Question of the Animal for Heidegger to Derrida (Calarco), 2

Zoontologies: The Question of the Animal (Wolfe), 4